ALFRED STIEGLITZ

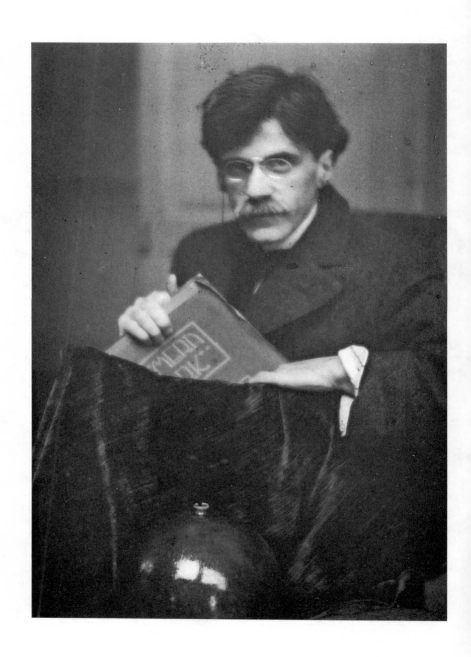

Alfred Stieglitz

Taking Pictures,

Making Painters

—◆—

PHYLLIS ROSE

Yale

UNIVERSITY

PRESS

New Haven and London

Yale University Press books may be purchased in quantity for
educational, business, or promotional use. For information, please e-mail
sales.press@yale.edu (U.S. office) or sales@yaleup.co.uk (U.K. office).

Frontispiece: Edward Steichen, *Alfred Stieglitz*, 1907. (Alfred Stieglitz
Collection, 1955. Image copyright © The Metropolitan Museum of Art.
Image source: Art Resource, NY. © 2018 Estate of Edward
Steichen/Artists Rights Society [ARS], NY.)

Picture Research by Laurie Platt Winfrey, Carousel Research.

Set in Janson OldStyle type by Integrated Publishing Solutions.
Printed in the United States of America.

Library of Congress Control Number: 2018955013
ISBN 978-0-300-22648-5 (hardcover : alk. paper)

A catalogue record for this book is available from the British Library.

This paper meets the requirements of ANSI/NISO Z39.48-1992
(Permanence of Paper).

10 9 8 7 6 5 4 3 2 1

To Mary Ryan, art dealer,
and to David Schorr, artist and educator

CONTENTS

Prologue

SHORTLY AFTER his father died, Alfred Stieglitz, writing to a friend in his fluent German, praised Edward Stieglitz as a *kunstmensch*, an art man. He was celebrating his father's cultivation, from which his own derived. Edward Stieglitz had emigrated from Germany to the United States in the wake of the European political upheavals of 1848. He made his living as a wool merchant but focused his home life on art. A serious weekend painter, the elder Stieglitz was the kind of man, rare now but more common in the nineteenth century, who looked forward to retirement as the fullest stage of life. When it seemed to him that his sons could not get a proper education in the States, he sold his business and moved the whole family back to Germany.

Alfred Stieglitz emerged from a middle-class European cultural tradition that may have been a high point of civilization. Men like his father, born in 1833, read Schiller, Goethe,

and Shakespeare. They studied works by Rubens, Rembrandt, and Leonardo, followed contemporary art, read philosophy, and attended the theater. They were comfortable in several languages, played musical instruments, and enjoyed live performances of music in their homes. They educated their children to love music, art, and literature and to regard them as necessary components of their lives. I think of this period as the age of Ruskin, because Ruskin articulated the belief that art was a moral force, a belief that underlay and justified all this cultural activity. Art made people better; it was a force for the good—an idea dealt a terrible blow by World War I and another when the land of Beethoven became the land of Dachau.

Alfred Stieglitz spent close to ten years in Europe, from the ages of seventeen to twenty-six, studying engineering and chemistry, falling in love with photography and mastering the process. Most of all, he learned to live like a European. He loved Berlin for its cultural excitement and for the intellectual camaraderie he found there. When he first returned to America, he was miserable. The streets of New York seemed dirty and unpleasant, the people unsympathetic. Only the performances of Duse, the comedy of Weber and Fields, and the working horses he photographed made the American city bearable. He saw nothing but materialism, luxury, wastefulness, and self-satisfaction in American culture, and he feared that this blight would spread and infect his beloved Europe. Nevertheless, he was an American, born in New Jersey, and his fight, like the fight of Thoreau, Whitman, Emerson, and Lincoln, was to mold America's spirit. For Stieglitz, the route to human emancipation was via the visual arts, and his goal was to show how people could derive from art the values that give life significance. He deployed this atheist's religion in combat for the soul of America. His brother told him they had three rabbis in their ancestry. That didn't surprise Alfred, who always regarded himself as a teacher, spreading the word that art helped good prevail.

By the time he was sixty, accomplished and famous as a photographer, he had more or less given up photography and devoted himself to selling art which, for him, meant promoting art. His galleries, first 291, then the Intimate Gallery, and later An American Place, were not dealerships so much as open universities. There he stood, day after day, talking to whoever walked in. Like an ancient philosopher holding forth in a marketplace, he expounded his ideas, using the art on the walls to illustrate his points.

His contempt for conventional art dealers and collectors was fierce. Dealers were interested only in making livings for themselves, not in helping artists. Collectors never went for the greatest pieces but for the cheapest. He loved to tell stories of people passing up chances to buy masterpieces. At one point the trustees of the Metropolitan Museum of Art had refused a group of Rodin's watercolors at what Stieglitz considered a ridiculously low price, on the grounds that they couldn't afford it. Now the watercolors could not be bought at any price. "It was as if the Museum had been offered a thousand twenty-dollar gold pieces for a thousand dollars, and had a directors' meeting and decided they could not afford the purchase," Stieglitz said.

He liked to talk about the career of Arthur Dove, who had been earning $15,000 a year doing illustrations for magazines like *Collier's* but had given it up to devote himself to painting. Dove's father, a brick manufacturer, remarked that if his son could afford to give up that large an income, he didn't need anything his father could give him and cut him off without a cent in his will.

Stieglitz often compared artists to apple trees. As it was in the nature of apple trees to produce apples, it was in the nature of artists to produce art. "Is there any trick about the tree's taking up sap from the ground and bearing apples? The artist is like that. . . . What the men shown in this room are putting down is feeling, life itself, a thing Americans are trying to run

away from." If artists were like trees and plants, Stieglitz's job was that of husbandry, the cultivation of the bounty of nature.

When Stieglitz discovered John Marin, he was working in two styles, etchings in an imitative Whistlerian style, which were saleable, and etchings and watercolors in a different style, that we would come to think of as Marin's, which were not as marketable. Stieglitz encouraged Marin to work in the more original style. Marin's father came to see Stieglitz and asked if it would not be possible for his son to make saleable things in the morning and devote the afternoon to his other work. Stieglitz replied that if Mr. Marin had a daughter who could be a prostitute in the morning and come home a virgin in the afternoon, then Marin could do what his father wished.

A young man who said he wanted to be an art critic visited the gallery, and Stieglitz asked him what kind of critic he wanted to be. Did he want to be a Berenson who declared which works were fake and which were real? He, Stieglitz, knew which works were real because he had seen them from their birth. He knew them as he knew the trees of Lake George or Central Park. He had no need to surround himself with fakes and fakery, only with "true things." Berenson was in fact something of a bête noire to Stieglitz. The two men were about the same age and both were prominent in the art world, but how differently they operated! Berenson helped the rich acquire; Stieglitz helped artists survive.

A poorly dressed girl walked into the gallery in 1926 hoping to buy a John Marin. Stieglitz asked how much she wanted to spend, and she replied that $50 was the highest she could go, but that at the moment she had only $5. Stieglitz showed her Marins worth $175, $250, and $350, but the one she wanted was especially fine and cost even more. Stieglitz gave it to her for a down payment of $5 without even asking for her name or address. "That's what's called a sale here," Stieglitz said to his assistant. Later, the girl came back and paid another $5. She told

Stieglitz she found the Marin more beautiful every day. Acquiring it was one of the greatest things that had ever happened in her life. Stieglitz replied, "It was one of the finest things that has happened in my life, too."

Not everyone responded positively to Stieglitz's parables and anecdotes, and most recent writing on Stieglitz has little patience for him in this mode, trying to refocus attention on him as a visual artist only. But for many people in his lifetime Stieglitz's commitment to art was contagious. O'Keeffe called the experience in his galleries erotic. Others called it religious. People caught his idealism and were moved, sometimes to tears.

Jewish on both sides of his family, Stieglitz never struck later observers as especially Jewish, probably because of his association with Georgia O'Keeffe, whose thoroughgoing midwestern and southwestern persona has dominated their identity as a couple. But in his time, people were quite aware of his Jewishness. As late as 1935, an art critic called him "a Hoboken Jew without knowledge or interest in the historical American background." Stieglitz's mentoring of photography and of modern art in general was perceived by some at the time as typically brash Jewish behavior. He was not Jewish like the good German Jews of Park Avenue and Wall Street—the Loebs, Kuhns, Lehmans, and so on—but a "Hoboken Jew," utterly without class. This was as inaccurate as it was spiteful. The Stieglitz family was in many ways closely allied to and socially completely at home with the Park Avenue crowd. However, Jews who sponsored modernism in the arts, like Stieglitz and the Steins, were to the world of art what Bolsheviks were in the political realm, unwelcome disrupters of the status quo. Many Europeans and Americans saw the two activities as arms of the same dangerous revolutionary spirit, which they regarded as typically Jewish.

Thinking of Stieglitz as Jewish highlights some different aspects of a life that has been examined repeatedly. How, for ex-

ample, did his family deal with anti-Semitism? The faculty of the City College of New York in the 1870s was notoriously anti-Semitic, like a great deal of the world of American higher education, and this could have been another reason Edward Stieglitz preferred to have his sons educated in Germany—Germany, to avoid anti-Semitism! The story of Stieglitz's romance with Georgia O'Keeffe also gains in freshness from being seen through the lens of Portnoy rather than that of Pygmalion.

Considering Stieglitz as Jewish foregrounds his Old Testament, Victorian stance as prophet of art. But even some of his photographic work looks different if you think of him as an outsider, not wholly at home in the New World, a man with a temperamental affinity to Europe, and no image more so than his best-known photograph (and also his personal favorite), *The Steerage*.

How this photograph came to be made is known in detail. Stieglitz was traveling to Europe with his wife, Emmy, and daughter, Kitty, in the summer of 1907 aboard the SS *Kaiser Wilhelm II*. They traveled first class, as Stieglitz's wealthy and thoroughly bourgeois wife expected. One day Stieglitz looked across from the first-class section of the ship to the third-class, or steerage, at the front of the ship. The two classes were separated by an open space so that some steerage passengers were below him. The image took shape in his mind: passengers, mostly women and children, some wearing bright shawls or dresses, on the lower steerage deck; a darker group on the upper deck, mostly men, with one man, wearing a light straw hat, looking down; a gangplank and a ladder connecting the two sections; the thick vertical form of a mast and the slashing horizontal of a boom.[1]

As he ran to get his camera, which was back in the stateroom, Stieglitz had two thoughts. One was "Rembrandt." The other was fear that the man in the straw hat would move.

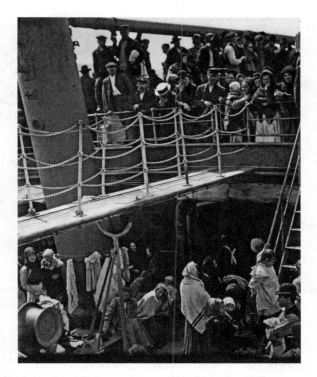

Alfred Stieglitz, *The Steerage*, 1907. (Alfred Stieglitz Collection, 1933.
Image copyright © The Metropolitan Museum of Art.
Image source: Art Resource, NY.)

It's been known for a long time that this image does not represent the huddled masses yearning to breathe free as they land in America. Whatever their motives, these people are leaving America, not arriving. The ship was bound from New York to Bremen. Perhaps they were rejected at Ellis Island and had to return to Europe against their will. Perhaps things hadn't worked out for them in America. Perhaps they had come to the States only to make money but preferred to live in Europe. In any case, Stieglitz looks at these people not with pity for their poverty but with appreciation of their humanity and

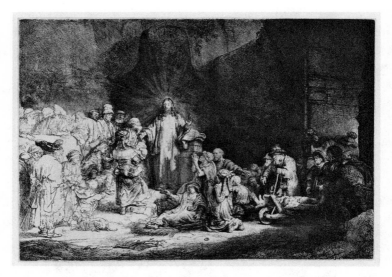

Rembrandt Harmensz van Rijn, *The Hundred Guilder Print: Christ Healing the Sick.* (H. O. Havemeyer Collection, Bequest of Mrs. H. O. Havemeyer, 1929. Image copyright © The Metropolitan Museum of Art. Image source: Art Resource, NY.)

envy of their authenticity. To him, they represent warm vitality as opposed to the sterile conventionalism of his wife. He is an old-fashioned peasant-lover, as his early genre pictures show, and the people on the *Kaiser Wilhelm* are urban peasants. They may be poor Jews, Swedes, or Germans. It doesn't matter. He responds to them as Rembrandt did to the crowds in his large etchings with biblical subjects and complex deployment of figures such as *The Hundred Guilder Print: Christ Healing the Sick.*

The Steerage is unusual in Stieglitz's oeuvre because he rarely, at this period or later, photographed people in groups. The sudden thought of Rembrandt and his suffering masses was probably the key.

Ironies abound in *The Steerage*, not only the oft-cited one that it depicts people rejecting America rather than embracing it. We know that the ship was bound for Bremen, but Beaumont

Newhall determined, on the basis of the light, that the photograph was made in Plymouth, England, when the ship was in port at anchor and facing west. The shawl seen near the bottom of the photograph, which many mistake for a prayer shawl, leading *The Steerage* to be identified with Jews, is not a prayer shawl at all. Moreover, people persistently read the upper deck as holding first-class passengers looking down on the steerage passengers, but both upper and lower decks formed part of the steerage section in the boat's bow. The photograph seems to illustrate the deceptiveness of photography, its very ambiguity making its image of immigration all the more powerful. Who is going where? Is America reinvigorating Europe, or is Europe helping to create America? Is immigration a blight on America or its strength? Is the greater source of energy first class or steerage? Are immigrants vulgar and dangerous outsiders or the heart and soul of a culture, banished at great risk to the banishers? Is the upward mobility of American society a movement upward in any spiritual sense? These are some of the questions raised by this astonishing photograph.

Had Stieglitz given us just his own photography, it would have been enough. Had he merely shaped photography as an expressive medium and persuaded the public to accept it as a fine art, that would have been enough. But he was also responsible for bringing the work of Matisse, Picasso, Rodin, and Brancusi, among others, to America and for promoting contemporary American art—the work of John Marin, Arthur Dove, Marsden Hartley, and Georgia O'Keeffe. His life offers material for many biographies, and many have been written. The photographer, the theoretician of photography, the promoter of photography, the gallerist, the propagandist for modern art, the collector, and the patron, lover, and husband of Georgia O'Keeffe have all received attention. My goal is to tell the story of his complex achievement for readers who may value the art of photography but nonetheless confuse Stieglitz

(pronounced STEEG-litz) with Steichen (pronounced STY-kin). Like Homer's Odysseus, Stieglitz was *polytropos*, a man of many turns, a many-sided man: a photographer producing his own distinctive body of work while husbanding, in the old sense of nurturing, not just O'Keeffe but a whole generation of American artists. I want others to appreciate him, as I do, for his versatility and also for the rarity and the depth of that versatility. Few people are able to do what he did: both to make art himself and to channel creativity in others.

1

Continental Divide

ALFRED STIEGLITZ's father left Germany at a good time, in 1849, when crop failures, depression, and political upheaval narrowed the future for young men all over Europe. Jews in Bavaria and the other German states were especially hampered by restrictions on travel, marriage, and business. Edward Stieglitz was among many thousands who moved to America. Not quite sixteen years old, he had an easier time than most because his two older brothers, Marcus and Siegmund, already had an established business in New York making precision instruments. Edward, his name changed from Ephraim on arrival, went to work for them until he could start his own business, importing and trading wool, with a friend. He soon had enough money to marry. The woman he chose, Hedwig Werner, had come to America from Germany as a child. She belonged to a cultivated family: her father a rabbi, her cousin a professor of German

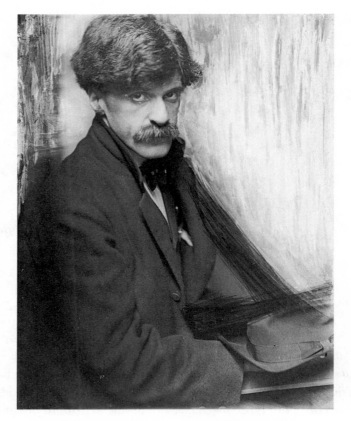

Gertrude Käsebier, *Alfred Stieglitz*, 1902. (Library of Congress, Washington, Gift of Mina Turner, 1964.)

language and literature at the fledgling College of the City of New York.

Edward and Hedwig lived in Hoboken, then a port in the countryside, the arrival and departure point for transatlantic liners, and a major terminal for the ferries that brought people to New York City, since there were no bridges across the Hudson River linking Manhattan with New Jersey and the western beyond. A journey from Chicago to New York City by train ended in New Jersey, with a transfer to the ferry. More than half

the residents were, like Edward and Hedwig Stieglitz, German immigrants, Jews and non-Jews. The Germans were convivial, forming clubs for every activity; they especially liked music and picnics in the parks. There were beer halls, song contests, and singing groups, to one of which Edward Stieglitz belonged.

Alfred, the oldest of six children, was born on the first day of 1864. His father was doing well in wool brokerage. He had served in a German-speaking regiment of New Yorkers at the start of the Civil War, doing his duty to his new country, but fortunately there was almost no fighting where he served, and no one in his regiment was killed or wounded. When his three-month tour was over, he paid $300 to be replaced, as was then permitted, and returned to Hoboken.

Mr. and Mrs. Stieglitz ran a lively and hospitable home. They were always glad to have people stay with them, especially Germans, especially visiting artists and musicians. One painter from Germany, Fedor Encke, stayed with them for over a year. Their Sunday lunches were renowned.

When Alfred was seven, the Stieglitzes left Hoboken for Manhattan. By then Alfred had twin brothers and three sisters, and Hedwig's sister, Rosa Werner, had joined the household to help with the children. This ample family Edward installed in a townhouse he had had built at 14 East 60th Street, by no means as self-evident an address as it is now. The city was still based below 23rd Street. Fifth Avenue was not even paved as far north as the Stieglitzes lived. Unpaved streets were dusty in summer and muddy the rest of the year. Central Park, recently completed, was still scruffy, and the train line from the north to Grand Central Terminal had yet to be covered, planted, and turned into livable Park Avenue. Nevertheless, some adventurous souls like the Stieglitzes were starting to pioneer the city's northern reaches. The Metropolitan Museum was founded in 1872. The Upper East Side as a center of wealthy residences and cultural institutions began to take shape.

Like all textile merchants, Alfred's father prospered in the Civil War. Soldiers needed uniforms. With southern cotton unavailable, wool became particularly important. Later, Stieglitz cornered the market in wool just before Chicago burned to the ground, forcing everyone in the city to rebuild and restock. By 1881, he was able to sell his share of his company, Hahlo and Stieglitz, for $400,000, equivalent to about $9 million today.

In many ways, Edward Stieglitz's trajectory was like that of the founders of the great German Jewish fortunes Stephen Birmingham described in the classic *Our Crowd*. The path from rags to riches usually led from peddling to retail to banking, along with a geographical movement from America's frontier towns to the business hub, New York. Edward Stieglitz was ahead of the game in that he didn't have to peddle—he had his brothers' business to start with—and he was already in New York. He quickly reached a point of success. Had he wanted to make one of the great American fortunes, he probably could have. When Kuhn and Loeb opened their banking partnership, they did it with $500,000, not all that much more than what Edward got for his share of Hahlo and Stieglitz. But while other German Jews set about the business of making serious money, founding banking and brokerage houses and creating the American capital markets, Edward Stieglitz, at the age of forty-eight, retired. He chose the life of the "amateur," a word that had more prestige then than it does now, signifying the transcendence of the profit motive, the pure dedication of the artist. Nothing he did made a bigger impression on his eldest son, who saw that his father made money not for the sake of money but for the sake of art and the good life.

In addition to the New York townhouse, Edward Stieglitz bought a huge summer estate on the shores of Lake George in the Adirondack foothills, north of Albany and Saratoga Springs. He loved horse racing and owned a thoroughbred. He painted and supported other artists. He had made enough to support

Alfred Stieglitz, *Edward Stieglitz—Lake George*, 1888. (Gift of Mrs. William Howard Schubart, 1968. The Philadelphia Museum of Art/Art Resource, NY.)

his six children (even Alfred, who needed more than the usual amount of financial help), to maintain the houses in the country and the city, to travel when he wished, and to entertain. He suffered when the stock market went down—at times his fortune shrank by as much as half—but he had enough to get by on for the rest of his life.

With the move to Manhattan, Edward Stieglitz's circle increased and broadened. His friends were now journalists and editors, including the founder of the humor magazine *Punch* and the editor of *Harper's Weekly*. Alfred and his brothers were

enrolled in a fine private school, the Charlier Institute, where students were required to speak and write in French. The fabulous Sunday lunches for which the Stieglitzes were known resumed. Alfred was allowed to stay with the men when they withdrew after lunch to smoke, drink, play billiards, and talk about, among other things, racehorses. Horses became one of Alfred's passions (billiards and baseball were others), his favorite game a race between little lead horses whose jerky moves were determined by the roll of dice. Alfred was so attached to these little horse figures that, in the summer of 1873, when the family was at Lake George, he took them to the local tintyper to be immortalized.

Tintyping was a cheap alternative to photography. No negative was made. The image was exposed directly onto a thin metal plate and the plate was usually colored by hand. When Mrs. Stieglitz took her children to be photographed, she patronized a proper studio photographer in New York, who made a glass negative from which a detailed paper print could be made. For little Alfred's tin horses, however, the Lake George tintyper, Mr. Irish, was good enough. In both cases, the boy was interested in the process, asking to follow the photographer into the darkroom. Not one to hold back his aesthetic opinions, even as a child, Alfred advised Mr. Irish to stop hand coloring the portraits.

According to Richard Whelan, Stieglitz's excellent biographer, the young Alfred was so taken with photography that he asked his father for a camera and darkroom, but his father said no.[1] The process in use for most of photography's first century, wet-plate collodion, was tricky and sloppy. Alcohol and silver nitrate were among the necessary chemicals. No more than fifteen minutes could elapse between preparation of the plate and its processing. Splashes were inevitable, and silver nitrate stained. It's no wonder Edward Stieglitz didn't want that going on in his beautiful new townhouse.

Hedwig and Edward doted on their first-born. Alfred was always singled out. Not only was he permitted to attend his father's all-male gatherings, he even traveled alone with him for one whole summer, scouting out a family base outside New York City. The other children assumed that Alfred was special —and so did he. However, he was not as good in school as his younger brothers, and when Edward Stieglitz had to arrange his sons' higher education, it was as much for the twins' sake as for Alfred's that he decided to move the family to Germany for several years so that the children might be educated there. The twins were drawn to science, and Germany was the best place in the world for studying science.

There is no evidence that Edward Stieglitz gave his sons any religious education. But while religion seems to have meant nothing to him, he was willing to identify himself as a Jew. When the Jewish Hospital (renamed Mount Sinai in 1866) had a fund-raising gala, Edward headed one of the committees.[2] He boasted of being the only Jewish member of the Jockey Club, and while the boast was untrue, it shows he was proud of his status as a Jew making his way in society. His circle of friends was not exclusively Jewish, and he had no problem sending his sons to a school that, while claiming to be nondenominational, nonetheless aimed to turn its students into good Christians. The Stieglitz boys were educated to be European gentlemen: to speak French and German, to enjoy good food, wine, and conversation, to revere Goethe, Heine, Shakespeare, and Schiller, to love music, to respect science, and to know a good horse. Edward Stieglitz did not expect them to suffer for being Jews.

In 1877, Joseph Seligman, the man who had bankrolled the northern army during the Civil War, personal friend of Lincoln and Grant, was turned away from the Union Hotel in Saratoga, where he had often stayed before, on the grounds that a Jewish guest would cause the hotel to lose more desirable

clients. This was the beginning of a "restricted" hotel policy in America that lasted in some places until the 1960s. The Seligman incident struck home hard with Edward Stieglitz because he himself used the Union Hotel as his base whenever he went to the Saratoga races. He and Alfred had stayed there in 1872 during their search for a summer homestead.

The sudden social exclusion of Jews in America in the 1870s led to blatant anti-Semitism by the 1880s, especially at colleges.[3] In German-speaking countries, in contrast, the second half of the nineteenth century was a golden age for Jewish culture. Prussia, Austria, and Hungary emancipated their Jews in 1867, allowing them freedom of movement, and they moved to the cities. When Bavaria joined the German Empire in 1872, even that most reactionary of German states had to liberate its Jews. Berlin then rivaled Paris and Oxbridge as a seat of learning, looking especially desirable to Edward Stieglitz's generation of Jewish German Americans, who had now reached the age of arranging the education of their sons. With anti-Semitism on the rise in America, they could exempt their sons from it by educating them in Germany.

Berlin was paradise for Alfred, who arrived there in 1882 when he was eighteen years old. His parents had first sent him to school in Karlsruhe for a year to improve his German. His brothers stayed on in Karlsruhe for more college preparation, and his sisters studied music in Weimar. His parents and Aunt Rosa traveled, staying at splendid hotels all over the continent, and the children joined them for vacations and summers, often in the Black Forest or the Bavarian Alps. Alfred had total freedom in the city, with an allowance of $1,200–1,300 per year— enough to do whatever he wanted, with plenty to spare. At first he boarded with Erdmann Encke, a sculptor, cousin to the painter who had stayed with the Stieglitzes in Hoboken. Later he shared accommodations with two other young Americans

studying in Berlin. He had his own room with his own favorite pictures on the wall, a piano, and his high-wheeled bicycle in the corner. He was not the kind of young man we read about in nineteenth-century French novels who goes to the city and gets carried away by fast living and ends up in debt. His wants were fairly modest. "I had no desire to drink or to eat rich food. I harbored no social aspirations and was devoted, above all, to photography. I was crazy about billiards and racehorses, but this neither complicated my life nor interfered with my work. . . . I frequented cafés, mainly the Café Bauer, which was open day and night. There were no set times when I had to do anything. If tired, I slept; if hungry, I ate. When I wanted to read, I read."[4] An hour before any performance, he could buy cut-rate tickets—for the opera, the theater, concerts, and even for the races.

Ostensibly, he was in Berlin to study mechanical engineering. His father thought him suited for this field, though Stieglitz himself could never understand why. As a child, he had no interest in taking things apart and putting them together again. He didn't consider himself good with his hands. But, dutiful son that he was, after his year in Karlsruhe, he enrolled in the mechanical engineering program at the Technische Hochschule, the engineering school or polytechnic.[5] He could also attend lectures at Berlin University at Unter den Linden, which Wilhelm von Humboldt had founded early in the century. Professors at the university were paid directly by students, so lectures were open to all, and Stieglitz got to hear some of Germany's most distinguished scientists lecture on their specialties. It was a high-level science education—some of it too high-level for Stieglitz. For example, he found the physics lectures of Hermann Von Helmholtz, the inventor of the field of ophthalmology, incomprehensible, and he stopped attending the course, although another American, the brilliant physicist Michael Pupin, found what Helmholtz was saying basic enough.

It would be good to know exactly how Stieglitz came to take up photography, but this is one of the stories on which he contradicts himself. Certainly it happened in Berlin in the early 1880s. In one version, Stieglitz saw a box camera and some developing equipment in the window of a store in Berlin and impulsively bought them, along with a booklet that taught him exposure, developing, and printing. For a darkroom, Stieglitz pushed back a door to the corner of his room, creating a tiny triangular space, just big enough for a man and a chair, which served as his table. In this three-sided darkroom, he put trays for developer, fixer, and water. Printing, done the day after the negatives dried, he learned from the person who sold him the sensitized photography paper. Quickly he became obsessed and photography was the most important thing in his life. One day in class he learned from another student that the distinguished chemist Hermann Wilhelm Vogel was lecturing at the polytechnic on photochemistry as well as on aesthetic theory applied to photography. Stieglitz immediately went to the registrar to extract himself from the mechanical engineering program and transfer to chemistry in order to study photography with Professor Vogel.

In a second version, Stieglitz, bored with mechanical engineering, happened to hear there was a course in photography being offered at the polytechnic by Professor Vogel and arranged to take it. He began experimenting obsessively in the school laboratories under Vogel's guidance and then, sometime later, bought his first camera.

What difference does it make which version is true? Ultimately, very little, but the first version, in which Stieglitz impulsively buys the camera and experiments on his own, is more self-aggrandizing and should therefore be more suspect than the second, in which he is merely the student of a master teacher, beneficiary of his wisdom and his well-equipped laboratory.[6]

Alfred Stieglitz, *Professor Vogel*, 1886. Platinum print, 4 13/16 × 3 9/16 in. (The J. Paul Getty Museum, Los Angeles, Gift of Edward and Joyce Strauss.)

Stieglitz was lucky to find Vogel and he knew it. "I looked on that man as a perfect god," he said later.[7] His first great portrait is of Vogel, looking very much the genius and large soul that Stieglitz thought him. Although his field embraced all chemical reactions stimulated by light, including photosynthesis, the chemistry of photography interested him most, and he had made a crucial contribution to its advance just ten years before Stieglitz studied with him in Berlin. In the early years of photography, the emulsions on photographic plates were oversensitive to blue and violet, slightly sensitive to green, and undersensitive to other colors, especially red. This meant that the colors of the world were not convincingly represented by the gray tones of a photographic print. German chemistry was making incredible strides at the time with dyes (TNT began as a yellow dye), and Vogel discovered that by adding certain dyes to the light-sensitive silver compounds, he could make them more sensitive to a broader spectrum of colors. Thanks to Vo-

gel's "orthochromatic" compound, an extended range of tonal expression in black-and-white photographs was possible.[8]

If Vogel was a master teacher, Stieglitz was a master student, energetically testing all of Vogel's principles, challenging the limits. If Vogel told his students to wash the plates well before flowing on the collodion, lest it later peel, Stieglitz would wash the plates until Vogel had to stop him, saying that the perfection Stieglitz sought could not be achieved outside a sealed chamber: he had to compromise. ("Compromise!" said the mythopoeic Stieglitz in later life, looking back on these times. As if he would ever, even as a young man, have done such a thing!) If Vogel set his students to photograph a white plaster copy of the Apollo Belvedere draped in a black velvet cloth, trying to show them the impossibility of getting both the velvety blacks and the shaded whites well represented in the same picture, Stieglitz would expose—as he later claimed—hundreds of plates attempting to do what Vogel said could not be done. If Vogel said photographs had to be made with large quantities of natural light, Stieglitz took a camera to the basement of the polytechnic and arranged an exposure, by feeble electric light, of a power generator. The exposure took twenty-four hours, but the image was clear, proving that if the exposure was long enough, you didn't need bright light to make a photo.

Because Vogel began his course with an introduction to the camera and to lenses, allowing his students to make pictures only later, after they understood the physics involved, Stieglitz felt totally comfortable with his instrument, completed by it. As he continued his experiments, the lectures meant less and less to him. But Vogel had singled Stieglitz out and worked with him personally, teaching him more about controlling lighting and focusing. Thanks to the new building's state-of-the-art labs, Stieglitz now had excellent darkroom facilities, and he volunteered to work there as a supervisor so the labs could remain open day and night, always accessible to him.

Stieglitz was also lucky to have arrived in Berlin at a moment when photography was still more science than art: first because he got such a thorough grounding in the physics and chemistry of photography, and second because his father accepted that he was merely moving from one area of scientific study to another and continued to support him. Nevertheless, Edward harbored hopes that photography would have some kind of commercial payoff for his son. Vogel's research, as we have seen, was particularly concerned with translating colors into nuanced tones of black and white, and it's likely that what Vogel ultimately sought was a process for color photography, the Holy Grail of early photochemists. It's important to appreciate Vogel's concern with color because it underlines an aspect of Stieglitz's career that is often overlooked—the time he spent working on color photography, whether lantern slides or autochromes—and it may explain, too, why his father continued to believe in the commercial applications of Alfred's studies. He hoped his son would work in mass-produced color reproduction of images as others would do in the 1890s. He did not think of photography as an art form. Few people did.

Even for Vogel, the camera was first and foremost a recording instrument, a device that saved engineers the work of drawing existing machines, which was why photography existed in the curriculum of the polytechnic in the first place. But the camera could also usefully record works of art. No longer did a person have to go to Florence to see Michelangelo's David or to Venice to see the Bellinis. Reproductions were possible, more accurate and lifelike than the engravings that had served this purpose before. Printed on postcards and in books, photographs could bring art to the masses.

One of Stieglitz's earliest photographs, made in his own room with his own camera, is a picture of studio photos of himself made by his landlord and sculptor friend Erdmann Encke. He wanted to see how well his negative could reproduce the

ALFRED STIEGLITZ

Alfred Stieglitz, *My Room in Behrenstrasse 1, Berlin*, 1885. (Alfred Stieglitz/Georgia O'Keeffe Archive, Yale Collection of American Literature, Beinecke Rare Book and Manuscript Library. © Yale University. All rights reserved.)

qualities of another photograph, although the image also serves as powerful evidence of Stieglitz's youthful concern with identity, his self-dramatization, his self-absorption, and his excellent sense of composition. Encke's sculpture of Queen Louise in the Tiergarten was another early subject for experiment. Vogel had said that one of the most difficult things to get right was sculpture against a natural background—the problem of maintaining detail in both highlights and shadows. Stieglitz did it. Like his photograph of his own room, these are examples of the camera as recording device.

Vogel had many artist friends interested in photography as a way of reproducing and publicizing their work. He arranged for Stieglitz to show them what he could do, and several wanted to hire him to photograph their paintings. According to Stieglitz,

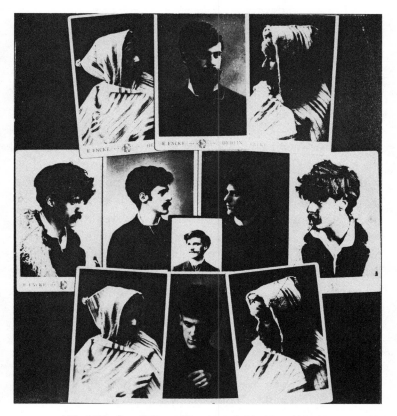

Alfred Stieglitz, *Collage of Portraits of Alfred Stieglitz*, 1883.
(From the Collection of Dorothy Norman, 1969. The Philadelphia
Museum of Art/Art Resource, NY.)

one of the artists said that it was a shame he had not done the pictures he showed them "by hand." In that case they would be fine art. But because he used a mechanical device, they were not. This comment, real or invented, figured essentially in Stieglitz's myth. From that moment, he said, he was determined to fight to make photography accepted as an art in its own right, the camera no more a mechanical device to a photographer than a paintbrush to a painter or a chisel to a sculptor.

In good weather, whenever he could, Stieglitz hoisted his thirty-odd pounds of equipment and went out into the countryside on jaunts that combined hiking and photography. He had many friends to travel with. Other young men from the States were getting their education in Berlin at that time, many of them, like him, second-generation Americans, the sons of German-born Jews.

He had met Louis Schubart and Joseph Obermeyer on the ship coming over to Europe in 1881. They were traveling without their parents, and kindly Hedwig Stieglitz took them under her wing, including them in her own brood's activities. They later met up with Alfred in Berlin and even shared rooms with him. Another friend, this one from childhood, was Frank Simon (Sime) Hermann, whose family lived near the Stieglitzes on East 60th Street. Now Sime was in Munich, studying art. Another good friend of Stieglitz's age was Morris Loeb. His father, Solomon, co-founder of Kuhn, Loeb, had wanted his eldest son to follow him into banking, but when Morris proved to be more interested in science and literature, he was sent to Harvard and then to Berlin for graduate work in chemistry.[9]

In 1886, Stieglitz—with Loeb, Obermeyer, Schubart, Hermann, and his twin brothers, Leopold and Julius—celebrated the Fourth of July at Freienwalde, a spa town near Berlin, cavorting in the countryside and immortalizing their outing in a souvenir album of photos and rhyme. Alfred manned the camera and Morris described their high jinks in doggerel echoing *The Mikado*, which had opened in London the year before:

> Eight little boys from School are we
> Happy that our Country's free
> Eight little boys from school.
> One's taking care of the Camera's works
> Outside of the picture he therefore lurks.[10]

The snapshots from Freienwalde are little better than Loeb's verse, but one, probably taken by Obermeyer, who was also a photographer, shows Stieglitz standing next to his view camera, mounted to eye level on a tripod. He already sports the mustache by which he had chosen to define himself and which he wore the rest of his life. He holds a pistol, fired to call his subjects to attention. In all the photographs of him from this period, Stieglitz looks extremely handsome, with his angular face, tall, lanky body, intense eyes, and romantic shock of dark hair. He did not consider himself attractive, though; he was overconscious of a broken nose that had never been set.

We can date the beginning of Stieglitz's serious career as a photographer from 1886, when he was twenty-two. He was no longer merely mastering techniques but exploring what it meant for photography to be an art form. His first unsophisticated notions of this involved subject matter. One of his earliest writings on photography advised artistic photographers to head to Gutach in the Black Forest or to Katwyck on the Dutch seashore, as these were places where industrialism has not yet sullied the people or the scenes.[11] His models included the fashionable painters of the time, like Millet and Carolus-Duran, whose works featured agricultural laborers, but a larger influence, less known to posterity, was one of the German artists his father sponsored, Wilhelm Hasemann, who specialized in genre scenes set in Gutach.

In the summer of 1887, on another of those wonderful walking tours with his pals along to help carry the equipment, Stieglitz searched for both the picturesque and the sublime. They went south from Munich into northern Italy and stayed for several days in a *pensione* in Bellagio. The sublime he depicted in *The Approaching Storm*, an image of clouds massing over Lake Como, taken from his window in Bellagio. Clouds and lakes were a combination of particular force to Stieglitz— the thing itself, essential nature—and *The Approaching Storm*

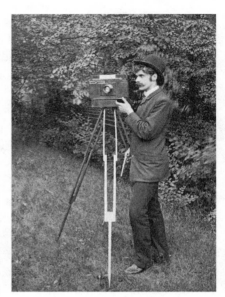

Alfred Stieglitz, *Self-Portrait, Freienwalde a O.*, 1886. (Alfred Stieglitz Collection. © Board of Trustees, National Gallery of Art, Washington.)

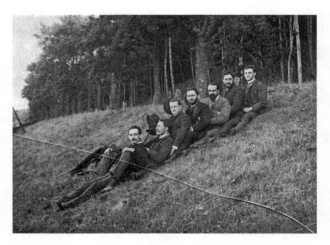

Alfred Stieglitz, *Freienwalde a. O.*, 1886. (Alfred Stieglitz Collection. © Board of Trustees, National Gallery of Art, Washington.)

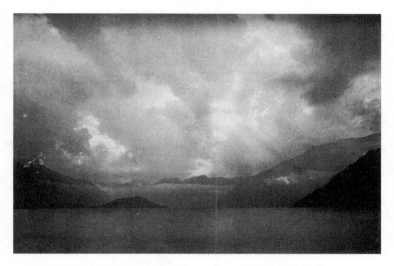

Alfred Stieglitz, *The Approaching Storm*, 1887. (*Photographische Rundschau* 5 [1888]: 7. Image courtesy of Fine Arts Library, Harvard University.)

could have been made only with Vogel's orthochromatic plates. Previous emulsions could not have distinguished the clouds from the sky or the various shades of the water in the same exposure. Consequently, Stieglitz was especially proud of this photograph. He submitted it to a German photography magazine, which published it, his first work in print.

Bellagio's poor he found picturesque: he photographed them in doorways, asleep, on stairs, in a group. To some of the photographs he gave narrative titles like *The Truant* or *The Last Joke*, echoing the narrative style of Victorian genre painting and of some British art photography, like that of Henry Peach Robinson. The influence on Stieglitz's early work of Peter Henry Emerson, the British photographer of agricultural workers and fisherfolk, is also clear. Stieglitz had seen the work of both Emerson and Robinson in *The Amateur Photographer*, a British magazine that began publishing in 1884, and they made an impression, although he later came to despise Rob-

inson's artificial combination printing of his staged and stagy scenes.

It was Emerson, not much older than Stieglitz, who awarded him his first prize, 2 guineas and a silver medal, in a contest run by *The Amateur Photographer*, for a picture of children sharing a laugh with a woman drawing water from a well. *The Last Joke*, according to Emerson, had a spontaneity rare among the submissions, and it's true that within its genre, *The Last Joke* is unusual in presenting a group of working-class people laughing rather than stoically enduring their fate. The freshness of Stieglitz's work is obvious compared to a staged scene like Henry Peach Robinson's *When Day's Work Is Done*. Stieglitz commented at the time that winning the contest made him happy for his father's sake, because it proved that he was not wasting his time with photography, but he didn't think his competition could have been very stiff. The remark seems just.

What would prove to posterity to be the most important photograph from Stieglitz's Berlin years is *Sun Rays—Paula*, also called *Study in Light and Shade* and *Sunlight and Shadows*.[12] An elaborately dressed woman who looks like she is just about to go out, hat on her head and gloves in her lap, sits at a table writing. She faces a window whose venetian blinds separate the daylight into strips of brightness and dark. Tacked against the flocked wallpaper are photographs of the same woman: posed outdoors in white summer clothing, and lying in bed, unposed, her hair down. Completing the wall collage are three paper valentines and a picture of Alfred as well as two copies of his photograph *The Approaching Storm*. A metal birdcage holding two birds is hung against the wall. On the table next to the writing pad, we see what looks like a newspaper and a candle in a candlestick. A second print of one of the photos of Paula sits vertically in a horizontally aligned oval frame into which it does not fit.

Alfred Stieglitz, *The Last Joke, Bellagio,* 1887. (Alfred Stieglitz Collection.
© Board of Trustees, National Gallery of Art, Washington.)

Henry Peach Robinson, *When Day's Work Is Done,* 1877.
(The J. Paul Getty Museum, Los Angeles.)

Alfred Stieglitz, *Sun Rays—Paula*, 1889, printed 1916. (Alfred Stieglitz Collection. © Board of Trustees, National Gallery of Art, Washington.)

Evoking Victorian narrative painting as much as Vermeer, *Sun Rays* is astonishing in its depth of reference. It is the first of the great photographs, in a line with *The Steerage*, the New York snow scenes, and the photos of Georgia O'Keeffe, among others, where Stieglitz's genius is mobilized in an instant that transcends or bypasses his thinking. He makes a photograph whose implications, aesthetic and narrative, will take him years to understand.

The photograph is in the first instance a valentine, like those incongruous paper hearts tacked up on the wall, a love letter to Paula. She is presented in several aspects, outdoors

and indoors, formally and casually. The picture of her in bed is a warm acknowledgment—if not a boast—of intimacy. Including Stieglitz's own picture on the wall makes the photo a record of the two of them, lovers whose love is doomed, trapped by convention like the two lovebirds are trapped in their cage. The bars of the cage are visually amplified and the point underlined by the stripes of light and shade that cross Paula's body. Clouds are on the horizon, a storm approaching. She is not someone he can marry. They must part.

Most writers who have tracked Paula through the footnotes of Stieglitz's biography agree that she was his mistress in Berlin in the summer of 1889. They lived together in his rooms at Kaiser Wilhelmstrasse. When he left Germany, he continued to give Paula an allowance to "keep her off the streets"—an exaggeration. He always referred to her as a "prostitute," usually adding something like "but as clean as my mother" or "noble" or "more respectable than many bourgeois ladies I know." She served, in his narrative of his own life, to prove his scorn for middle-class morality.

The iconography of the fallen woman in this photograph echoes but reverses Victorian paintings like Holman Hunt's *The Awakening Conscience*, in which the kept woman rises from the lap of her protector, hearing the call to a higher way.

Every detail in Hunt's picture has moralistic significance. The cat who has just killed a bird? Her lover, who has ruined her life. The morning glories on the mantle? A flower of short duration. The discarded glove? Cast aside as she will be when he is tired of her. This invitation to read the picture through its symbols was reintroduced in a heavy-handed fashion by Victorian painters, who in turn encouraged some photographers.

Stieglitz's photograph of Paula could be seen in this tradition, but the fallen woman here is calmly and competently searching the newspaper, probably the want ads, looking for a decent job.

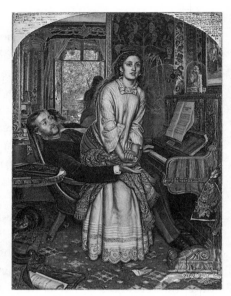

William Holman Hunt, *The Awakening Conscience*, 1853. (Presented by Sir Colin and Lady Anderson through the Friends of the Tate Gallery 1976. © Tate, London/ Art Resource, NY.)

Stieglitz told his nieces and nephews later in life that he had his first sexual experience at twenty. He had a relationship, which he often mentioned, with a peasant woman in Munich. So we know of at least two women he bedded in Germany, the peasant in Munich and Paula in Berlin. He fathered a child, although we do not know which woman was the mother or if it was another woman entirely, and afterward sent payments to support the child, a girl, until she died as a young woman. Georgia O'Keeffe, who knew about this, told Stieglitz's estate lawyers the woman's family name was Bauschmied.[13]

The photograph of Paula proclaims that she and Stieglitz were lovers, but the emotional valence is debatable. It could be a tender farewell tribute to Paula, rendering permanent, as photography so often does, that which is dear and transitory. On the other hand, the very fact of photographing Paula shows a kind of disrespect: he wouldn't be alone in a room with a marriageable woman of her age, to say nothing of showing pic-

tures of her in bed. The bars that cross Paula's body, which suggest "heart-wrenchingly" to Richard Whelan how Paula is caged by her life, could also be read as Stieglitz's crossing her out, barring her from his future, or outright eliminating her: good-bye and good luck. Or they could be his reminder to himself that he *must* cross her out of his life—that he must put behind him his whole wonderful life in Berlin: the cozy interiors, the available women, the walking tours, the companionship with other artists, the work with Professor Vogel, the light itself.

Sun Rays—Paula is a technical tour de force. The hardest thing to achieve in a black-and-white photograph is detail both in the highlights (the bright parts) and in the shadow. As the bands of darkness and brightness stream across this image, traversing the heavy brocade tablecloth, Paula's skirt, her face, her hair, her lace collar, and her feathered hat, the flocked wallpaper, the caned back of the chair she sits in, the photographs, and the birdcage pinned to the wall, as the streams of light and shadow bend at the end of the small room to define it, Stieglitz demonstrates his mastery of tone. He relishes all the textures and his ability to suggest them in darkness and in light, the way a Renaissance painter might relish his mastery of texture. Only a couple of areas are unreadable, like the dark blotch on the valentine to the right, probably because it was a red ribbon. For the same reason—the emulsion's undersensitivity to red and oversensitivity to green—the lovebirds, which had green bodies and red heads, look as though they have white bodies and black heads (see plates 1 and 1a.) Paula's dress, too, was probably much brighter than it appears. Since so much of Stieglitz's student work explored chromatic rendering, this could be considered his graduation piece.

Like a Vermeer, *Sun Rays—Paula* shows a woman bent over a task by a window and, like a Vermeer, it celebrates light. In Vermeer's paintings, the light from a window at the left bathes

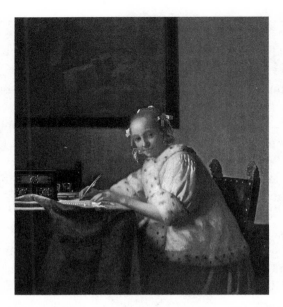

Johannes Vermeer, *A Lady Writing*. (National Gallery of Art, Washington; Gift of Harry Waldron Havemeyer and Horace Havemeyer, Jr., in memory of their father, Horace Havemeyer.)

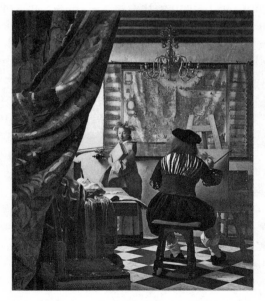

Johannes Vermeer, *The Art of Painting*. (KHM-Museumsverband, Vienna.)

women playing musical instruments, reading, writing, pouring milk.

The light in Stieglitz's photograph doesn't bathe Paula so much as dissect her. Her calm concentration seems all the calmer for the patterned busyness all around her. Vermeer often paints a map on the back wall. On the wall behind Paula is the collage of heads and hearts and a birdcage, and behind the birdcage, a large piece of paper that may be a map. In a Vermeer, what is on the wall usually stays in the background, but in the Stieglitz image, the eye is drawn from the figure of Paula to the photographs behind and in front of her.

The key fact about the photographs on the wall behind Paula is, as Rosalind Krauss first suggested, their reproducibility: there are two copies of *The Approaching Storm*, two copies of Paula leaning on her arm in the white dress.[14] *Sun Rays—Paula* presents us with a definition of photography as an art whose catalyst is light, in which colors are translated into shades of black and white, and which can be almost endlessly and accurately reproduced and printed. Vermeer had his *Art of Painting*.[15] This can be seen as Stieglitz's *Art of Photography*.

Alfred was called home to the States in 1890. His sister Flora had died in childbirth, and his parents wanted their other children around them in their grief. They allowed Leopold (Lee) to stay in Berlin because he was close to getting his medical degree. Julius had already received his PhD in chemistry. Alfred had no degree of any kind. He was still just Mr. Stieglitz, not Dr. Stieglitz, on his return. Of the three Stieglitz boys, he seemed the least accomplished. As he realized, it was generous of his father to continue to support him in the absence of progress comparable to his brothers'.

As Stieglitz and his writer friends later constructed the myth of his life, from the moment he encountered photography, he had an inner certainty about himself and his goals in

life that had eluded him before. Before, he had felt purpose-less and parasitical. Now, as a photographer, he felt he had a "right to life."[16] From buying his first camera in 1883 to gaining international fame as a photographer took Stieglitz only seven years. By the time he went home, he was exhibiting in shows, winning prizes, publishing in photo magazines, and serving on photo show juries. But only from a future vantage point in which his stature as a photographer is known does his early accomplishment seem impressive. The inner certainty a much older Stieglitz ascribed to himself at twenty-five was probably the very thing the twenty-five-year-old longed for.

2

---◆◆◆---

City of Ambition

BACK IN AMERICA, living once again in his parents' house, Stieglitz later said that he cried every night from loneliness and despair.[1] No more love nest. No more nurturing professor, interesting artists, cafés open twenty-four hours a day. The abrupt cessation of the freedom and richness of student life is difficult for everyone, but Stieglitz was also feeling the loss of European civilization. New York seemed to him a city without culture, without beauty, with no tradition of excellence in anything, devoted only to money.

His father, eager for Alfred to grow up, get a job, and start a family, urged him to go into business with his friend John Foord, the editor of *Harper's Weekly*. Foord had invested in a commercial printing company called Heliochrome, and it was not doing well. Foord and Edward Stieglitz, also an investor in Heliochrome, hoped that Alfred, with his world-class training in photochemistry, might be able to help. If they could

find a way to print halftones in color, they could make serious money.

When we think about the technological revolutions of the nineteenth century—the steam engine, railroad, telephone, telegraph, automobile, electric light bulb, and photography itself —we don't, perhaps, pay enough attention to the revolution wrought by changes in printing, especially lithography and its descendents, which enabled the mass reproduction of images.

Halftone printing translates images into a grid of dots and, by varying the size of the dots, conveys the illusion of shape and tonality in monochrome. We all know that magazine illustrations looked at under a magnifying glass reveal themselves to be patterns of dots, and the concept of a binary matrix is familiar to us also from computer printing's pixels. Above a certain density, our eyes no longer see the dots but only masses. This illusion is called optical mixture, and our visual culture depends on it. Although the British photographer Fox Talbot had the idea for using a dot screen to reproduce photographs earlier, the first commercial halftone was not produced until 1881. People worked on the process throughout that decade, improving both the making of the dot screen and its actual inking and printing.

Stieglitz's teacher Professor Vogel was deeply involved in this research. As he had succeeded in increasing the sensitivity to color of black-and-white emulsions, he also hoped to invent a way of reproducing color photographs. Already in the early 1880s, he was printing three-color images using halftone plates and letterpress, but the quality was not good. Photographer William Kurtz bought the American rights to Vogel's "three-color process" and with the help of Vogel's son, Ernst, applied it to halftone printing.

The race to publish the first color halftone was intense. Professor Vogel's magazine, *Photographische Mitteilungen*, published Kurtz's color image of a bowl of fruit in its January 1,

1893, issue. It was soon reprinted in the American magazine *Engraver and Printer*. But the best solution to color printing was found by a lithographer in Berlin who added black as a fourth color, making four-color separations.[2]

This was the business Edward Stieglitz wanted his son to enter, and it might have been a good one. Color halftones would transform advertising. But while Alfred liked experimenting with his camera, he was not an inventor like his teacher Vogel. So the Heliochrome Company limped along without a technological breakthrough and without much business. The goal for most photomechanical printing was to cater to a mass market, to bring reproductions out quickly and cheaply. This was never a goal Alfred could embrace. He held the German ideal of fine craftmanship along with an ethic of responsibility to his workers. He insisted on paying the printers well, even for sick days and holidays, despite their rarely having any work to do. He assumed his generosity would win their loyalty, and they would repay him through their work.

Heliochrome went bankrupt in 1891. Alfred should have gotten out. Unfortunately, his father insisted on buying the equipment for him and setting him up as the head of the business along with his two friends from the Berlin days, Joseph Obermeyer and Louis Schubart. The name of the company was changed to Photochrome, but the staff remained the same.

When the company finally did get some work, the printers, instead of showing their gratitude for having been carried through lean times, demanded a 10 percent raise. Alfred gave them the raise they demanded but stopped paying for sick days and holidays—a net loss to the workers of 6 percent. He was not entirely lacking in business sense. But he stopped believing that a desire to produce high-quality work united workers with managers, at least in America. After three years, he quit Photochrome, leaving his shares in the company to the employees. He had never taken a salary. Edward, who lost a great deal of

money in a stock market crash in 1893, was now ready to abandon his plan to launch Alfred as a businessman. It cost less to support him out of business than in it.

The commercial venture was not entirely wasted time for Alfred, however. At Heliochrome and Photochrome, which continued in business and printed much of his magazine work, he mastered photogravure, his favorite way of printing photographs in large runs.

Those first years back in the States were not happy ones for Stieglitz, but in them he produced two of his greatest photographs, *Winter—Fifth Avenue* and *The Terminal*, both inspired by bad weather, horses, and the theme of work. Those years also allowed him to establish himself at the center of America's photographic enterprise.

Soon after his return to New York, he joined the Society of Amateur Photographers. The word *amateur* signified "artistic" as opposed to "commercial" in the nineteenth century and did not carry the connotation of dilettante it does today. The Society of Amateur Photographers was for beginners as well as experienced photographers like Stieglitz, but not for people who tried to make a living from photography. The club's headquarters on 35th Street off Fifth Avenue became one of the bases of Stieglitz's life, along with his parents' home uptown and his Photochrome office on Leonard Street, just north of City Hall. He used the camera club's darkroom facilities and socialized in its rooms. He showed lantern slides at the society's weekly get-togethers and discussions and shared his considerable knowledge of photographic techniques.

One of his fellow club members, William B. Post, had bought a handheld camera fitted to take four-by-five-inch plates. Serious photographers were snobbish about handheld cameras. Many, Stieglitz included, looked upon them as sneaky devices meant to invade privacy. They were sometimes called

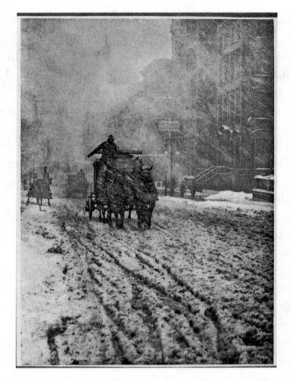

Alfred Stieglitz, *Winter—Fifth Avenue*, 1893, printed 1905. (Digital Image © The Museum of Modern Art/Licensed by SCALA/Art Resource, NY.)

"detective cameras." But Post, a serious photographer, loved his portable camera and offered to lend it to Stieglitz, who was still using a tripod-mounted view camera, a cumbersome piece of equipment to haul around the city.

On February 22, 1893, a blizzard brought fifteen inches of snow to New York. Stieglitz took advantage of the conditions to test Post's camera, having been assured that it was water-proof. He went out into the storm, his energy mobilized, as always, by a technical challenge. It had been thought that there was not enough light to make photographs in bad weather, but Stieglitz believed that with the new faster dry plates and with

Post's camera, he could do it. He chose a spot at the corner of Fifth Avenue and 35th Street facing north. He found the lighting and the lines he wanted. He always liked to find in a scene steep diagonals leading the eye to a central subject. Then he waited three hours for the central subject to appear in the right spot, a coach making its way against the wind-driven snow, the driver urging on the horses.

When he mounted his camera on a tripod, Stieglitz considered it unsporting not to print the entire plate that resulted. He had plenty of time to get a clean shot. But working with a handheld camera in adverse conditions was sporting enough. He may have had only one prepared plate with him at a time, one chance to make his shot. Negatives produced so sportingly he allowed himself to crop.

The cropping of *Winter—Fifth Avenue* is especially interesting, as it shows Stieglitz working toward emotional intensity through close focus on the horse and carriage. The original negative was horizontal, but almost every print Stieglitz made from it was vertical, cutting out pedestrians to the left and right, eliminating as many signs of life as possible, with the effect that the snow seems heavier and the horse and driver more isolated in the storm. The railroad ties visible at the left of the original image were laid down on snowy days so passengers could alight from carriages more easily. As Stieglitz printed and reprinted this negative over the course of years, he got rid of these entirely, until in the 1920s or 1930s, his aesthetic changed and he printed the whole negative horizontally, including all the random details his early taste had rejected. Aside from Henry James, who rewrote novels for the New York Edition of his complete works printed at the end of his life, it's hard to find such a good example of an artist working over the same material at different ages. These early New York images were Stieglitz's companions for decades, changing as he changed.

On the night in 1893 when he made the exposure of *Winter*

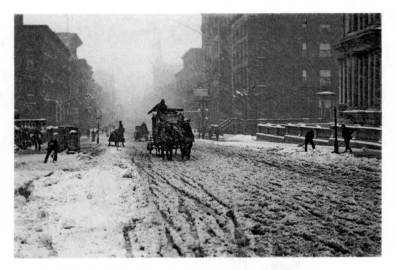

Alfred Stieglitz, *Winter on Fifth Avenue*, 1893, printed 1920s.
(From the Collection of Dorothy Norman, 1997. The Philadelphia
Museum of Art/Art Resource, NY.)

—*Fifth Avenue*, he took the plate to the club darkroom to develop. He knew that he had something special. He thought at first that something special was the technical breakthrough. This photograph would extend the "season" for photography into the winter months. It also showed that with faster plates and the proper lens, the falling snow would register as snow and not print as a whiteout. It took him longer to see the artistic power of the photograph, its emotional depth, the way it expressed something of what he was feeling, his sense of the wind blowing against him in life, his making his way through a storm.

The next day he went out again with Post's camera, and the result was *The Terminal*. He walked from his office on Leonard Street to the post office, an imposing structure that used to stand at the southern tip of City Hall Park. Here the horse-drawn trolleys of the Harlem Line turned around to go back

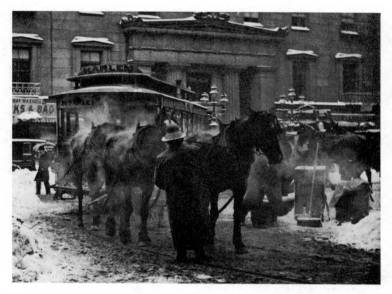

Alfred Stieglitz, *The Terminal*, 1892. (Digital Image © The Museum
of Modern Art/Licensed by SCALA/Art Resource, NY.)

uptown. The snow had stopped falling, but there were piles of
snow on the ground, and it must have been hard for the horses
to pull the trolleys through the slush. As a driver in rubber
raingear watered down his team, steam rose from the horses'
sweat-soaked bodies.

Stieglitz was touched by the driver's concern for his horses.
Later in life, when he became only too adept at interpreting his
own work, Stieglitz saw the man's gesture as reflecting his own
determination to nurture the arts in America. Others have seen
in it his desire to be nurtured himself. Allegory and projection
aside, what ties this image to *Winter—Fifth Avenue* is a love of
atmospheric effects. Whether it is snow or rain, smoke from a
train, steam from an engine, vapor from horses, a naturally oc-
curring blur excited Stieglitz at this stage of his career, espe-
cially in the context of the city, otherwise so linear and hard-

edged. Just as clouds over Lake Como attracted him, so did steam effects, reflections on water, rain on paved streets. Transition states, in which borders break down and create ambiguous forms, appealed to his compositional eye.

Again, in printing *The Terminal*, Stieglitz cropped the negative to eliminate passersby, focusing on the horses and driver, making them appear larger and more heroic. Graphically, *The Terminal* is even more interesting than *Winter—Fifth Avenue*, with every flat mass interlocking neatly with every other and yet seeming to head in another direction in a deep suggested space.

Stieglitz soon bought himself a handheld camera and made many more photographs of New York, liking the city more as he refashioned it according to his own tastes. He photographed Central Park in the snow. He photographed an asphalt paving machine, steam rising from it, rendering machine and worker as veiled and mysterious as Salomé. He intended to make one hundred photographs of New York, but he was swept away by other goals and never did.

His work at and for the Society of Amateur Photographers became more intense. He contributed articles to its magazine, the *American Amateur Photographer*, some about chemical matters, such as "Uranium Toning of Platinotypes," some reviews of members' work or exhibitions, some about the aesthetics of photography. Camera clubs were popular all across America at the time. Every city had a camera club that put on exhibitions, sponsored contests, and put out a magazine. Photographers used camera clubs both to train themselves and to make themselves known. The exhibitions hung chosen works and gave prizes to the best in categories like landscape, portrait, marine, and instantaneous. Stieglitz personally sponsored a medal for photographers who had not yet won medals. It wasn't merely through making great photographs that Stieglitz advanced the

cause of photography: this institutional work—the meetings, the letters, the articles, the controversies and negotiations, the judging, the hanging of shows—was also important, although his involvement often came at the expense of his own creative work.

When he spoke at the society, he was introduced as a star, the person whose knowledge of the technical side of photography was unsurpassed and whose work had won more medals than any other photographer's. In the spring of 1893 he joined the masthead of the *American Amateur Photographer* as editor. Though the magazine was almost entirely in his hands, he accepted no salary. He was still technically working for Photochrome, which printed many of the magazine's illustrations.

Stieglitz loved running the magazine. His devotion is evident from the quality of the writers he brought in, the depth of his involvement, and from the experiments he tried, although some of these were ill advised. Most embarrassing was the printing in the January 1894 issue of a hand-colored photograph. Even as a child, Stieglitz had disdained hand coloring of photographs, as we saw in his rebuke to the tintyper Mr. Irish. But now he was so eager to enter the competition for photo-mechanically reproduced color, so keen to show how well his own company, Photochrome, could do, that he printed his photograph of farmworkers in the Ampezzo Valley in a tacky, hand-colored version (see plate 2). He acknowledged in an editorial note that hand-colored photographs were generally "crude and inartistic." Nevertheless, he thought that this one might interest readers as an example of color printing. His uncharacteristic lapse in taste suggests that he was much more involved in Photochrome's success or failure than is usually supposed. At the end of the year, in the December issue, he printed another specimen of Photochrome's color work—this one not colorized, happily, but not nearly as successful as the Vogel-Kurtz color picture of a bowl of fruit with which it was in direct competition (see plates 3 and 4).

Every month for two years Stieglitz published a substantial and sophisticated magazine. The articles covered both technical and aesthetic matters. An excellent series, "The Beginner," introduced readers to the basics of photography, and a dictionary of photographic terms ran regularly. Some of the definitions are complete explications of essential photographic matters. The magazine fully reported on the lectures and competitions not only at the Society of Amateur Photographers in New York but at clubs all over America. Issues included pleas for photography to be regarded as an art, instructive essays, lists of medals awarded at the various shows, and sometimes reviews.

Stieglitz liked reviewing. He issued an invitation to all readers to send in their work in order to receive a free critique. He was not a kind or subtle critic, however, issuing abrupt and unexplained judgments of "mediocre" or "not good." Readers protested. "Criticism should be corrective and not merely denunciatory," said one. The monthly notations that "'Mr. So-and-so has sent in a number of prints which are technically very good—pictorially worthless,' can not be of any particular use to Mr. So-and-so." Part of the problem was that Stieglitz's vocabulary wasn't suited to useful criticism. He still invoked the "picturesque" qualities of a photograph—a tautology that meant no more than that he found the subject worthy of a picture. He rarely discussed technique or composition. The quality of the reviewing increased noticeably when George Davison, the noted British photographer, took it over.

Part of Stieglitz's value to his club and to photography in America lay in his friendships with photographers on the other side of the Atlantic. His contacts with the British photographic establishment, which was considered the strongest in the world, were especially good. He knew Davison, Peter Henry Emerson, J. Craig Annan, and A. Horsley Hinton, and he persuaded Hinton as well as Davison to write for his Ameri-

can magazine. As he advanced the stature of his club and the cause of photography, he strengthened his own reputation; in strengthening his own reputation, he advanced the cause of photography.

Stieglitz's handling of his private life was an entirely different matter.

Many people devote themselves to a search for Mr. or Miss Right, but many others say to themselves, "Oh, this one will do as well as any." Stieglitz was not especially attracted by Miss Emmeline Obermeyer, sister of his good friend Joseph. When he first met her in Germany, where she was being schooled, he thought her spoiled and difficult. She was not beautiful. The only thing in her favor was that she would not expect him to support her. She and her siblings had inherited their family brewing business, Obermeyer and Liebmann, which gave her an income of $3,000 a year, the equal of Stieglitz's annual allowance from his father. It may be too harsh to say that he married her for her money, but as he told a friend later, he would certainly *not* have married her if she had been unable to pay her own way. He was terrified of supporting a woman. You could say he decided to marry her so as to have a wife without taking on the burden of responsibility for one.[3]

Stieglitz was in his twenties, still significantly influenced by his parents and his school friends. Joseph Obermeyer was pressuring him to marry his sister. Perhaps because their parents had died, Obermeyer took his role as her protector extremely seriously, ever alert for situations in which Emmy might be "compromised." On the way back from a day excursion up the Hudson, Emmy fell asleep with her head on Alfred's shoulder. Her brother took this as a sign that the two must announce their engagement immediately. When Alfred went to call on Emmy and spent several hours with her, her brother again insisted his sister had been compromised. Why would Alfred not

do the manly thing and marry her? Alfred tried to negotiate: he would consider himself engaged to Emmy for five years, but either of them could back out at any time. That did not sit well with anyone. Soon they were formally engaged, and both families, the Obermeyers and the Stieglitzes, were delighted.

They were married in November 1893. The wedding dinner, held at the fashionable restaurant Sherry's, was a showcase for Gilded Age expectations. Blue point oysters preceded turtle soup, which preceded bass and filet de boeuf and chicken à la Demidoff, with foie gras aspic. Chrysanthemum sherbet and quails were served with the salad before the ice cream, cakes, and bonbons. The wines included muscatel, liebfraumilch, and Roederer champagne. A wedding like this ritually celebrates a couple's commitment to bourgeois values as much as to each other. The newlyweds did not buy a place of their own but lived in rooms at the Savoy Hotel at 59th Street and Fifth Avenue, near Stieglitz's parents' house. They postponed the honeymoon until the summer, when they might go to Europe. They also postponed having sex. Emmy was timid and prudish and Alfred, for whatever reason, did not push the matter. Perhaps he wanted children even less than he wanted a wife. Perhaps he was repelled by her prudishness.

Freud formulated what he called "the most prevalent form of degradation in the erotic life," whereby if a man respected a woman he could not desire her and if he desired a woman he could not respect her. Stieglitz, in contrast, idealized the women he had sex with and scorned women, like his wife, who left him cold. The result was the same, however: erotic fulfillment was not to be found in marriage. As his relationship with Georgia O'Keeffe would later show, he was stimulated by a difference in background but shared values and pleasures. With Emmy there was a shared background but a profound difference of spirit. Stieglitz's photographs of Emmy highlight this lack of attraction. They tend to be taken from a distance. There

are no respectful, close-up portraits such as he did of Professor Vogel, his mother, and his father. There are no pictures of her lying in bed, hair spread across a pillow, as he made of Paula in Berlin. There are certainly no infatuated photos, such as those he made later of Georgia O'Keeffe. The man who made love with his camera never used it to make love to his wife.

He tried to allay his frustration by playing the piano. In Berlin he had loved to play Wagner themes and Beethoven sonatas naked, late at night. But Emmy found Beethoven's music loud and upsetting. She asked him if he could not play a waltz. He responded by having the piano removed. The two were constantly at loggerheads, her asking him to mute his personality, he asking her to stop being so conventional, or "frivolous," as he called it.

Their European honeymoon in the summer of 1894 underlined the distance between their interests and expectations. This was Alfred's first time back to Europe in four years. He wanted to see old friends and do photography in the rustic places he favored, the Bavarian village Gutach, the Dutch fishing town Katwyck. Emmy found Katwyk grubby and disliked the fishermen's smell. Poor people in general offended her. She wanted to be in Paris, dining in fine restaurants and shopping in good stores. Alfred noted that her mood improved according to the quality of the hotel in which they stayed.

Traditionally, biographers have treated Alfred's frustrations with more respect than Emmy's. One yearns to hear her side of the story. She behaved as a woman of her class and background was expected to behave, and if she wanted to spend money, it was her own—she had every right to spend it on fine food and clothing in Paris. She wanted a devoted protector as her husband; she was no one's free-spirited companion. It was her bad luck to be stuck with a self-righteous and disapproving husband who dragged her to the least amusing places in Europe. When he tried to get her to climb in the Alps with him, she got hys-

terical and said he was trying to kill her. Continually pressed to do things she found both unpleasant and frightening, she felt bullied and harassed. The only way to get relief from Alfred was to hole up in the hotel. He, at least, could go away—and he did. He went to see photographers all over Europe. He arranged for his work to be exhibited in the fall shows. Photography was now not just his passion but his escape from a terrible marriage.

He came back from the honeymoon with several images that were to be among his best known and most respected in the early years of his career: *Mending Nets*, *The Incoming Boat*, *Scurrying Home*, and *Gossip*, all made in Katwyck; a couple of scenes of Venice; a photograph of Paris in the rain. When he was not setting himself a technical goal, like photographing in low light, he had a hard time finding a distinctive subject. Categories of competition determined to some extent his early photographic subjects: if "Venice" and "Marine" were categories set by the camera clubs, photographers shot Venice and boats. An unannounced competition also existed between the more ambitious photographers like Stieglitz and painters. Who was better at reflections on Venetian canals or at Paris streets? Whose image of stoic peasants was more moving? Stieglitz was inviting comparison not just with other photographers but with Millet and Whistler. By contemporary standards, which expect a photographer to develop his or her own distinctive subject matter, Stieglitz's early photographic work looks all over the map, although his style is consistent: he angles and simplifies to accentuate the monumental and heroic, whether his subject is a coachman in New York or a net mender in Katwyck.

More and more, the business of photography—entering and judging contests, writing, lecturing, organizing, connecting, and propagandizing—became central to him. It meant a lot to him to be elected, one of the first two Americans to be

so honored, to the exclusive British photographers' club called, with fin-de-siècle Arthurian mysticism, the Brotherhood of the Linked Ring. Besides giving him valuable contacts in Britain, his election signified his place among the elite of international photographers. To the photography establishment abroad, Stieglitz was America's leading photographer.

Compared to the camera clubs of Paris, London, and Vienna, those in America were second rate, and it became important to Stieglitz to raise their quality. To this end, he pushed for a merger between two of New York's clubs, the Society of Amateur Photographers and the New York Camera Club. The Society of Amateur Photographers had more prestige, but the New York Camera Club had more money. It was composed largely of men who took to the camera as they might to other social leisure activities such as tennis, rowing, or bicycling. The union of the two clubs combined the one's prestige, with the other's resources, and Stieglitz used the new Camera Club, New York, to found another, more ambitious magazine, the quarterly that would become the celebrated *Camera Notes*.

Noticing that the Camera Club had an annual budget of $250 for its occasional newsletter, Stieglitz undertook to produce a beautiful quarterly magazine for the same amount of money by selling ads for photographic equipment. He promised to include in each issue at least two examples of "pictorial photography" reproduced by photogravure. This was a departure from the *Amateur American Photographer* and a landmark in Stieglitz's career as a publisher.

As a way of reproducing photographs, photogravure is outstanding for the richness of the blacks it can achieve and the delicacy of the midtones. It is an intaglio process, which means ink is pushed into depressions on a metal plate and then transferred to paper under pressure. The ink left on the paper conveys different degrees of darkness according to the depth of the incised image. Other photomechanical processes at the

time worked by relief, not intaglio: the image was raised, all at one level, and ink rolled onto the surface, making the resulting impressions flatter than photogravure. But photogravure was time-consuming. Each plate had to be inked separately, passed through a press, and then reinked for the next impression. With some reason, Stieglitz considered each photogravure a unique work of art. No two inkings were exactly alike. Each photogravure in *Camera Notes* was individually mounted and inserted into the rest of the magazine, protected by a cover sheet. Often Stieglitz himself did this work.

Camera Notes, more than merely the organ of the Camera Club, New York, became the means through which Stieglitz pushed to present photography as an art. The photographs he published covered a wide range of styles. Early photographers, who had emerged from science, sought clarity and focus in every detail. Later experimenters promoted soft focus, or at least differential focus, making some things sharper than others, arguing that this was not only scientifically correct (we do not see everything in detail in reality) but also more artistic. Absence of hard outlines was painterly, and for some, the closer a photograph came to a painting, the more artistic it seemed. While *Camera Notes* published some sharp-focus work, it became known for its promotion of the style of photography eventually called pictorialist.

The goal of avant-garde photographers in the 1890s became what they called *simplicity*. Less was more. Even in genre scenes, such as Stieglitz made at Katwyck, a new aesthetic is evident, different from the one that guided *Sun Rays—Paula*, for example. Backgrounds crammed with detail went out of fashion. A pleasing overall balance of dark and light in the image was desirable, a taste that came from Japanese aesthetics. Japan's influence on the art world was strong, funneled to many Americans artists through the vogue for Japanese prints in Europe and, closer to home, the teachings of Arthur Wesley Dow

at the Pratt Institute and the Art Students League in New York. Dow's teachings, codified slightly later in his book *Composition*, located beauty in the interplay of dark and light: "Synthetically related masses of dark and light convey an impression of beauty entirely independent of meaning."[4] Dow in effect codified graphic appeal, and although he was addressing painters, what he had to say proved of tremendous importance to photographers, whose medium was monochromatic and who had only masses of darkness and light to compose with. Gertrude Käsebier studied painting with Dow, and perhaps it was she who brought his ideas to the photographers of the Camera Club.

The eighty-seven photogravures published in *Camera Notes* between 1897 and 1903 have been seen as making "the first cohesive argument for photography as a fine art in the United States."[5] They also constitute a museum without walls for early pictorialism, not yet including many of the finest examples but with enough and of sufficient quality to establish an aesthetic. In the photogravures of work by Käsebier, Clarence White, Edward Steichen, and Stieglitz himself, among others, published in *Camera Notes*, a common style can be seen. People who disliked it then called it blurred or murky. People who dislike it now are likely to call it painterly. But those who respond to pictorialist photographs, as I do, find among them some of the most beautiful photographs ever made.

The images of his own work Stieglitz chose to present in *Camera Notes* range from the Katwyck pictures to atmospheric photos of New York at night, in snow, or in rain. *Mending Nets*, from Katwyck, was his own favorite work of this period.

A massive female form is seen against a neutral background, in profile, absorbed in her task. There are no boats on the horizon or windmills. All detail is eliminated. Stieglitz said that the photograph captured "the endless poetry of a most picturesque and fascinating lot of people, the Dutch fish folk,"

Alfred Stieglitz, *Mending Nets*, 1894. (Alfred Stieglitz Collection, 1949.
The Art Institute of Chicago, /Art Resource, NY.)

locating the interest in the subject, not in the composition or
style, as he would later learn to do.

Having shot it in 1894 on his honeymoon, he printed the
negative of *Mending Nets* over and over again, experimenting
with different processes and papers. His favorite print was plat-
inum because of its delicacy and permanence, but for *Mending
Nets* he chose to make a carbon print enlargement: he felt that
the image needed to be big. He exhibited it in London in 1895,
Berlin in 1896, Hamburg in 1897, and finally in New York in
1898, as both a carbon and a platinum print. From 1895 on,
it was reproduced in photography magazines and so was well
known even before he printed it as a photogravure in *Camera
Notes*. In his photographs from this period, Stieglitz favored

monumentality, emphasizing the dignity of human figures by graphic means. Later he would come to feel that these early, highly cropped images were labored, and he reprinted them to make them look more like snapshots.

Scurrying Home, which shows two old women of Katwyck walking toward a church (it was also called *Hour of Prayer*), had an exhibition history similar to that of *Mending Nets* and was, if anything, even more popular. Included in a portfolio of best photographs from the London salon of 1895, it was published in *Camera Notes* in 1899. Stieglitz printed this image, too, as a platinum print and a carbon, but for *Scurrying Home* and for much of his early work, he paid equally close attention to the photogravures for the magazine, going so far as to have some of his photographs printed in Europe by his favorite German and English printers and shipped back to the States for binding in the magazine. The photogravures of *Scurrying Home* were on the steamship *Paris* when it ran aground off Cornwall in 1899. Fortunately, the prints in the hold were undamaged.

For viewers who have seen Lartigue's stop-action photographs of Parisian life at the turn of the century, dogs in midair and women in midglance, or Harold Egerton's photographs of a drop of milk splashing, or high-quality sports photography in newspapers and magazines any day of the week, it may be difficult to see the stately figures of *Scurrying Home* as scurrying. But in the 1890s, the comparison would have been with posed genre scenes, positions people held for minutes at a time. In that context, the ladies of Katwyck seem active, each woman in mid-stride. Within the photograph, too, there is movement, created by the zigzag ruts in the ground. Stieglitz had a gift for creating visual movement on a flat surface. At the same time, even in motion, these figures seem statuesque, like the woman in *Mending Nets*.

Toward the end of the decade, Stieglitz started reviewing his own career, presenting in different forms what were in

Alfred Stieglitz, *Scurrying Home*, 1894. (Alfred Stieglitz Collection, 1949.
The Art Institute of Chicago/Art Resource, NY.)

effect retrospectives. In 1897 he issued a portfolio of his own
work, an unusual thing for a photographer to do.[6] Four im-
ages were of New York: the great but by now almost historic
Winter—Fifth Avenue and more recent pictures of New York
taken at night or in rain. For the rest, there were two images of
Katwyck, two of Gutach, and two from France—a mixed bag

Alfred Stieglitz, *An Icy Night*, 1902. (Repro-photo René-Gabriel Ojéda, Musée d'Orsay, Paris. © RMN-Grand Palais/Art Resource, NY.)

for which he didn't successfully find a theme and which he mis-leadingly titled *Picturesque Bits of New York*.

Two years later Stieglitz mounted a one-man show at the Camera Club. He now saw what use to make of his own early work, creating a narrative in which his own career was the best example of the development of photography as an art. It was important to keep revisiting the early works, however much they no longer reflected his taste. The anonymous reviewer in *Camera Notes*, clearly a mouthpiece for Stieglitz, noted that the show represented "fifteen years of constant and serious labor in the field of pictorial photography." "It does not often happen that the professional career of one man is virtually co-extensive with the life of that art . . . to which he may have devoted himself." Such was the case with Stieglitz, however. Even though Stieglitz himself did not like some of his early

work, the reviewer went on, he hung it to show "how much higher the standard of photographic excellence is today, . . . a change which Mr. Stieglitz's own efforts have helped materially to bring about."[7] Stieglitz was running his career on two tracks, that of photographer and that of promoter of photography. Pointing out his own lapses as a photographer underlined his success as photography's czar. In effect if not intent, he was hedging his bets on his own career.

Some grumpy members of the Camera Club saw *Camera Notes* as mere self-promotion for the Stieglitz crowd. But the fact was, Stieglitz was the leading light of American photography, as his right-hand man, Joseph T. Keiley, proclaimed. Stieglitz in turn praised Keiley's work, and in due course, Käsebier, White, and other members of the inner circle received praise in *Camera Notes*. Stieglitz's taste was so central to *Camera Notes* and *Camera Notes* was so central to photography in America that by the end of the 1890s Stieglitz and his coeditors were being lampooned—a sure sign of who is establishing the discourse. Stieglitz reran the parody in *Camera Notes*.

Almost all his time was spent at the Camera Club. He advised people working in the darkrooms and kibitzed with people reading magazines in the library. In the evenings his wife sometimes came with him, and she always attended the big events, like the annual auction, where she showed her good nature by paying $2 for a parody of her husband's Katwyck picture *Gossip*. Because Stieglitz later tried to write her out of this part of his history, it's worth nothing Emmy's presence and the degree to which she was engaged in his life as a photographer.

Visitors to New York were starting to seek Stieglitz out at the club's rooms. One such visitor in 1900 was a young artist from Milwaukee who had saved enough money from commercial work in advertising to spend a year in Paris studying painting. His name was Edward Steichen. A man of tremendous energy, ambition, and charm, he was trained as a painter and

lithographer but had been doing photography for five years. Having designed ads for pork packers, among others, using formulaic painted representations of pigs in the ads, Steichen got the idea of going out to the stockyards, photographing actual pigs, and using realistic images in the ads. Clients loved the result. In his off time, Steichen explored the pictorial noncommercial uses of photography. He began submitting work to salons and exhibitions, and so came to the attention of Clarence White of Ohio, one of the photographers Stieglitz at that time admired. It was White who told Steichen to introduce himself to Stieglitz in New York before he sailed for France.

Steichen was fifteen years younger than Stieglitz, just twenty-one when they met. The day Steichen arrived at the Camera Club, Stieglitz was busy hanging a member's exhibit, but he stopped to talk to Steichen and look at his work. Showing the instinct for talent that would make him one of the great collectors of all time, Stieglitz bought three of Steichen's prints, paying $5 each. Steichen was thrilled—he had never gotten so much money for his work. "I am robbing you at that," replied Stieglitz. One print was a highly stylized full self-portrait in an elongated format and two were landscapes, ponds and trees at night, moody images that are almost impossible to "read," registering as pure painterly gesture.

In his early efforts to have photography accepted as art, Stieglitz had special respect for photographers who were trained as painters like Steichen, Gertrude Käsebier, and Frank Eugene. He believed that such painter-photographers would prove his case for photography as art. In Steichen he found a photographer with an incredible gift for painterly effects, so enamored of soft focus and reduced detail that he would intentionally move his camera during exposure or wet the lens to cut the representational quality of the image. The landscape photos he showed Stieglitz in 1900 he had done in the woods

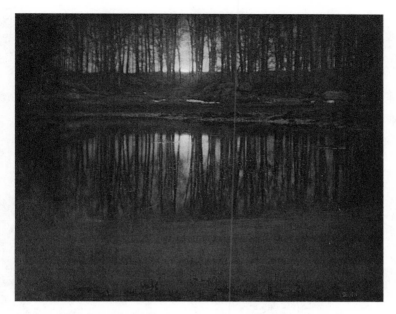

Edward Steichen, *The Pond—Moonrise*, 1904. (Alfred Stieglitz Collection, 1933. Image copyright © The Metropolitan Museum of Art. Image source: Art Resource, NY. © 2018 Estate of Edward Steichen, Artists Rights Society [ARS], New York.)

outside Milwaukee at dawn and at dusk, times of day he especially loved because outlines blurred and "things disappear and dissolve into each other." These were the prints Stieglitz most responded to.

Although Stieglitz was only thirty-five, he was already the grand old man in his field and slightly tired of the burden. He was on the lookout for someone to take over the fight for pictorial photography, someone articulate, energetic, charismatic, and supremely talented. When he went home that night after meeting Steichen, he said to Emmy, "I think I've found my man."[8] Steichen was too dedicated an artist and too focused on his own career to become the successor Stieglitz hoped for, but

the two of them had, for a time, a powerful and extraordinary partnership.[9]

In the fourth winter of his marriage to Emmy, Alfred developed pneumonia and was so ill that they moved into his brother Lee's house on East 65th Street in order that Lee, now one of New York's leading physicians, might take care of him. Alfred seemed on the verge of death and did not seem very eager to live. Emmy promised him that if he did live, she would be "really a wife to him." He pulled through, and Lee ordered the couple to Florida for restorative warmth and rest. Here the marriage was finally consummated. But Florida was having a cold snap and so, as Stieglitz later put it, emphasizing the chill of his relationship with Emmy, "There was ice on the orange blossoms."[10]

Around Christmas of 1897, they conceived a child who was born in the fall of 1898, a girl named Katherine, called Kitty. By now they were living in their own apartment at 1111 Madison Avenue at 83rd Street. They had quite an establishment, complete with cook and governess—all, by agreement, paid for by Emmy.

Stieglitz's snapshots of Kitty are as numerous as those of any besotted amateur photographer–father. Baby sleeps. Baby eats. Baby sits up. Baby walks. Every moment is recorded. He began a project he called "Photographic Journal of a Baby," and he even submitted some of his photographs of Kitty to salons and exhibitions.

The best pictures of Kitty were taken by Steichen when she was seven, and they show her together with her father. Kitty resembled her mother, and her face usually lacks animation in the photographs. In one Steichen photograph, her father looks away from her as she possessively loops her arm through his, reining him back. In another his body faces her but his face is turned toward the camera. She stands alone, resignedly. These

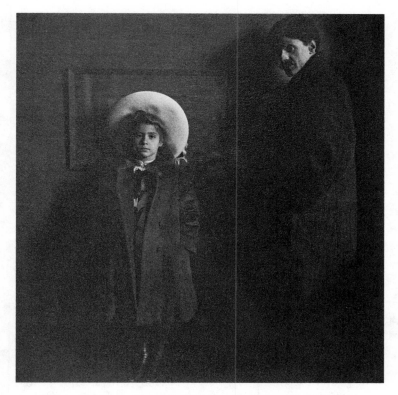

Edward Steichen, *Kitty and Alfred Stieglitz*, 1905. (Alfred Stieglitz
Collection, 1949. The Art Institute of Chicago/Art Resource, NY.
© 2018 Estate of Edward Steichen, Artists Rights Society [ARS], New York.)

are not conventional depictions of affection between father and
child. It was Stieglitz who drew all eyes. He was the magnetic
figure, the one people wanted to be near, and he would be the
subject of great portraits throughout his life. It was hard to co-
star with him, as Kitty discovered. She moved more and more
into her mother's sphere and away from her father, whose pho-
tographs of her after babyhood are few and uninspired.

Stieglitz successfully used the camera club movement and
photography magazines to raise the level of photography in

America—and to establish, in the process, his own ascendancy. But he was still enmeshed in the petty politics of the Camera Club, an organization with a diffuse membership. Fed up with the philistines and their accusations of elitism and favoritism, Stieglitz created a new organization to shelter that elitism and favoritism—which he considered, with some justification, good taste. In 1902, he withdrew from the editorship of *Camera Notes* and began to create an American version of the Brotherhood of the Linked Ring, a selective group of serious photographers. European artists were always forming alternative groups and mounting *salons des refusés*, antiestablishment shows. There were so-called Secessions in Munich, Berlin, and Vienna that abjured the mainstream. Following the practice of such rebellious European movements, Stieglitz called his group the Photo-Secession. The word *secession* suggests withdrawal, but in Stieglitz's mind it was a bold advance.

Seizing on an invitation from the National Arts Club to organize a show of pictorial photography, he put together an exhibition called *American Pictorial Photography, as Chosen by the Photo-Secession*. It consisted of the work of his favorite photographers, Käsebier, White, Steichen, Eugene, Joseph Keiley, Anne W. Brigman, Alvin Langdon Coburn, J. Craig Annan, Adolph de Meyer, Robert Demachy, and Heinrich Kuehn. F. Holland Day, a competing photography impresario and photographer in Boston, was invited to show but refused to participate. Stieglitz gave the inaugural lecture. None of the chosen ones knew why they had been selected. Gertrude Käsebier asked Stieglitz if she was a Photo-Secessionist, and he replied that if she thought she was, she was. Although the Photo-Secession was rebelling against the Camera Club, many of its associates maintained their club memberships because of the magnificent darkroom facilities, without which they would have had no place to work.

As the Photo-Secession evolved, it became principally a

means of supplying work, chosen by Stieglitz, to exhibitions in America and abroad. Instead of soliciting individual artists, the exhibition organizers requested works by Photo-Secessionists chosen by Stieglitz alone. This gave him enormous control over what was sent out as representing American photography. In 1904 alone, he sent collections of Photo-Secessionist photographs to exhibitions in Paris, Vienna, Dresden, The Hague, Washington, and Pittsburgh. When organizers bypassed his autocracy by soliciting additional entries, Stieglitz was furious.

In a fairly typical negotiation, in 1902 Stieglitz was asked by the director of the Metropolitan Museum, General Louis Palma di Cesnola, to send a collection of Photo-Secessionist work to an international exhibition in Turin. Cesnola was acting at the specific request of the Duke of Abruzzi, patron of the exposition and a photography enthusiast. Stieglitz took advantage of his power to demand that when the prints returned from Italy they be exhibited at the Metropolitan Museum and received into its permanent collections. He was methodically pursuing his next goal for photography—to be displayed as art in an art museum. Cesnola agreed, but unfortunately he died before the collection returned to New York, and nothing written enforced the agreement. However, the collection, sixty prints assembled within twenty hours at a time when the very best prints were reserved for the National Arts Club show, won a special medal from the king of Italy as the best collection of prints exhibited in Turin.

Once again Stieglitz turned to a magazine as the most effective way of promoting his views. He had honed his skills as editor and publisher at two publications now over the course of a decade, each magazine an advance on the one before. The third, *Camera Work*, was more beautiful and splendid than its predecessors, including several photogravures per issue as well as finely printed halftones and duotones. As he had done before, Stieglitz obsessed over the quality of the photogravures.

The writing, by critics like Sadakichi Hartmann and Charles Caffin, was of an even higher quality, and the design, by Steichen, was magnificent. Each of Stieglitz's favored photographers had an issue featuring his or her work with a portfolio of photogravures, beginning with Gertrude Käsebier, then Steichen. Steichen personally hand-toned all the copies of the photogravures of his work.

The fifty issues of *Camera Work* have become legendary. The photogravures are collected now as though they were limited-edition prints, even though the magazine's run was a thousand. The most important photography magazine of its time, it has maintained its cachet for a hundred years. With *Camera Work*, Stieglitz established his absolute dominance of American photography. But the work was grueling. Issues had to be conceived, writers found, text edited, photographs chosen and reproduced, advertisements secured, layouts done. No sooner was one issue wrapped up than the next had to be started. He was producing four issues a year now instead of twelve. Still, the stress of magazine publishing was constant and multifaceted.

3

The Everlasting Yea

In the summer of 1904 Stieglitz returned to Europe for the first time since his honeymoon ten years earlier. He was now a middle-aged man with wife, child, and the child's governess in tow. He hoped to meet old photographer friends and make new ones. He wanted to view exhibitions and do photography. He had worked hard to establish art photography in America. This was his time to relax. But as soon as he arrived in Europe, he fell apart and was confined to a clinic in Berlin for a month.

He announced his hospitalization to his old friends on the staff of the *American Amateur Photographer*: "Here I am in Berlin in a private hospital, paying the penalty for years of incessant strenuousness. I came over here for a rest and pleasure, but on my arrival collapsed completely and am now undergoing a rest-cure which implies complete quiet all summer. And I had looked forward to a European trip for years, only to be imprisoned. I do not think I deserve it, do you?"[1]

Modern accounts of his recurrent illnesses are likely to differ from Stieglitz's own, in which the notes of pride and self-congratulation cannot be ignored. Richard Whelan takes his scenario from Alice Miller's *Drama of the Gifted Child*. "Afraid he could not be loved for who he was, he resolved to ensure that he would at least be loved for what he did. To that end he would expend a tremendous amount of energy in pursuit of perfection and the highest ideals. But periodically, and with increasing frequency as he aged, his obsessive pursuit would utterly exhaust him, and he would find himself unable to sustain the performance that made him feel worthy of love. He would then fall into a depression, usually accompanied by hypochondriacal symptoms, until he regained the strength to resume his perfectionist labors."[2]

Thanks to Freud, almost all our accounts of creativity lead back to some foundational neurosis, hollowing out the artist's work and turning it into a "performance" he or she engages in to make himself or herself feel loved. The Victorian understanding of creativity was less complex and in some ways more useful. The good life, whether the moral life or the creative life, requires will and self-control. Maintaining one's positive energy takes effort, which now and then flags. One's impulses toward the good then must reassert themselves against the powerful attraction of disintegration—the higher self combats the lower self. This was the drama the Stieglitz family witnessed periodically in its more sensitive members, according to Stieglitz's grandniece and biographer Sue Davidson Lowe. Alfred, his brother Lee, and their sister Selma all excelled at dramatic breakdowns, but Selma, having no professional duties, was the clear family champion, able to "stretch the performance for months at a time." Alfred and Lee both tended to recover from their episodes by the end of summer, when they had to go back to work. "A Stieglitz breakdown was not the psychological trauma known to others, but an affliction borne with

extravagant endurance by those members of the family whose 'nerves' and 'sensitivity' marked them for special suffering."[3] The dramatic conflict was between the sufferer's sensitivity on the one hand and his or her "brave" self-understanding and "ruthless" will to health on the other. Any Victorian reader of Carlyle would have understood this fight between the Everlasting No and Everlasting Yea.

The distinguished British photographer J. Craig Annan was in the United States when Stieglitz's letter from Berlin was published, and he reacted with all the sympathy Stieglitz could have wanted. He, too, was attuned to the Victorian struggle between the higher and the lower self and the strain that maintaining the Everlasting Yea involved. "Poor Stieglitz— handicapped by ill-health against which the soul of a very demi-god incessantly strives; struggling ever for the artistically clean, and pure, and right." Moreover, the suffering demi-god was surrounded by lesser men who resented his work on their behalf. "We say again, poor Stieglitz!"[4]

Yet however demanding and however combative, Stieglitz's devotion to photography and to the establishment of photography as a respected art form seems more of a pleasure for him than an act of will, more a source of energy than a drain. In fact, he left the clinic to attend an art exhibition in Dresden. The Photo-Secession (that is, Stieglitz) had sent a small group of photographs, and Stieglitz wanted to see how they measured up against European photographs and how both did against paintings and sculptures. "Hardly out of the sick bed, and against the express instructions of my physicians, the ruling passion asserted itself," was how he put it. "The attraction was more than I, in my enfeebled condition, could resist."[5]

In Dresden, he found something to get angry about— which was always good for him. Photography had not been given a place equal to painting and sculpture as promised; it was shunted off to a side exhibition space. Nevertheless, when

he calmed down, Stieglitz was happy to see that the work of his Americans compared favorably to the best work of the Europeans and that the photographers as a group compared favorably to the painters. He especially liked the work of the Austrians, Heinrich Kuehn, Hugo Henneberg, and Hans Watzek, who stood out as "powerful, daring, . . . masterful in their knowledge of multiple-gum technique." The large scale of the Austrians' work, he said, made the American pieces look tiny. Nonetheless the Americans, working in a wider variety of media, showed versatility, charm, delicacy, and spirituality.

Entering the Berlin clinic allowed Stieglitz to leave behind his domestic baggage—his wife, daughter, and governess stayed with German relatives while he was restored to health. In effect, the breakdown excused him from his family. Safe in the clinic, he could relax into German professionalism and be energized by photography. Gertrude Stein famously said one should be bourgeois in one's life in order to be daring in one's art. With Stieglitz it seems to have worked the other way: he needed to be daring in his work in order to support the bourgeois nature of his family life.

When he finally left the clinic, he went to Igls in the Tyrolean Alps near Innsbruck, where he stayed at a spa hotel, the Igler Hof. Reunited with Emmy and Kitty, he was also accompanied by his friend and physician Felix Raab, Dr. Raab's vivacious daughter "Miss S. R.," whom he would photograph, and his old friend Frank Eugene, now professor of photography and graphic arts in Dresden. Most pleasantly, he got to spend time at last with the Austrian photographer Heinrich Kuehn, who lived in Innsbruck and whose work he so admired.

Kuehn and Stieglitz were both tall, good-looking men with a Teutonic sense of personal style—monocle and mustache. Both were the sons of wealthy fathers who used family money to advance their photography. Both were splendid examples of the new educated bourgeoisie of the late nineteenth

century whose religion was culture. They had been friends by correspondence. When they finally met in Igls, beginning a warm friendship that continued for years, they took the opportunity of photographing together. Kuehn chose the first scene, a gently sloping hillside with a stand of trees, the kind of thing he used as a basis for his large gum bichromates. Both men made exposures, then Kuehn photographed Stieglitz mopping his brow after the effort.[6] No wonder the effort tired him. His camera was enormous, and he was not using a tripod. Neither considered the results from this session interesting enough to exhibit.

On another joint outing, they picked a subject closer to Stieglitz's tastes and style: a farmer, a plow, a team of horses, a furrow in a field. Here the difference between the two men's vision is distinct. Basing the image on a strong diagonal thrusting into the distance, Stieglitz includes some detail of plowman, furrow, and horses, creating an image of heroic labor. Kuehn's photograph dissolves the subject into a pattern of dark tones spattered by light, sparkling highlights on the hard-to-read, poetically rendered darkness. His print is conspicuously more painterly than Stieglitz's. Stieglitz is more attuned to energy in space, more interested in making the eye of the viewer move within the photograph's frame. In that sense, his photograph is more narrative than Kuehn's.

Stieglitz was never as much of a pictorialist as the photographers he championed. Arguing for photography as a fine art, he emphasized the painterly skill that could be called upon in the printing process and gave special status to printing methods, like gum bichromate and the glycerin process, that displayed the painter's touch. Frank Eugene might scratch a negative in his search for artistic effects, outraging camera club conservatives who considered the negative sacrosanct. Joseph Keiley and Gertrude Käsebier, among others, used glycerin brushed on a developing platinum print to suppress or enhance

Heinrich Kuehn, *Pflügender Bauer*, 1904.
(Courtesy George Eastman Museum.)

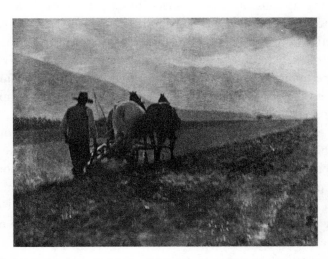

Alfred Stieglitz, *Ploughing*, 1904. (Photography by Erik Gould, courtesy of
the Museum of Art, Rhode Island School of Design, Providence.)

certain areas and add brushlike texture. When Theodore Dreiser interviewed him about art photography in 1902, Stieglitz said the gum and glycerin processes were essential to artfulness in photography.[7] He was being a spokesman here, not an artist describing his own work. Although he showed a few gum bichromates at the Camera Club in 1899, he then abandoned the photographic technique closest to painting that was almost the defining technique of pictorialism. By contrast, some of Steichen's most beautiful works are gum bichromates, born of his love for darkness and brushwork.[8]

Gum bichromates tend to revel in darkness, and Stieglitz was an artist of midtones. His own favorite printing method, early and late, despite meticulous experiments with other processes, was the platinum print, which has an extremely wide tonal range as well as very deep blacks. Since the emulsion is absorbed into the paper, the image is in the paper, not on it, and platinum, like gold, is very stable, so platinum prints will never fade. Its elegance and permanence made platinum the king of photographic printing methods and Stieglitz's method of choice, as indeed it was for many photographers until World War I made platinum prohibitively expensive. That more was in the chemistry and less in the brush no doubt appealed to Stieglitz, who was confident in himself as a chemist but not as a painter.

Of his best-known and best-loved images from around 1904, some are notable for their delicacy, like *Spring Showers—The Street-Cleaner* and *Spring Showers—The Coach*. These photographs play with foreground and background, with dark and light, with soft and hard elements, but they are all quite detailed. Stieglitz experiments with an elongated format and with the juxtaposition of natural and man-made forms, but the only manipulation is in the formatting, and the overall impression is of lightness and grace, not darkness and drama. Both these

Edward Steichen,
The Black Canyon, 1907.
(Photo: Patrice Schmidt,
Musée d'Orsay, Paris.
© RMN-Grand Palais/
Art Resource, NY.
© 2018 Estate of Edward
Steichen, Artists Rights
Society [ARS], New York.)

Heinrich Kuehn, *Sirocco*, 1899–1901. (Alfred Stieglitz Collection, 1933.
Image copyright © The Metropolitan Museum of Art.
Image source: Art Resource, NY.)

Alfred Stieglitz, *Spring Showers—
The Street-Cleaner*, 1900. Photogra-
vure, 6 1/8 × 2 1/2 in. (The J. Paul
Getty Museum, Los Angeles.)

prints show how much Steichen's Whistlerian early work had
stayed in Stieglitz's mind.

When Stieglitz returned from Europe in the fall of 1904,
he threw himself into the work of the Photo-Secession. Pro-
ducing *Camera Work*, on which he worked closely with Joseph
Keiley, a man he respected and admired, taking his photogra-
pher friends for boisterous lunches, Stieglitz may have been
the happiest he ever was before he fell in love with Geor-
gia O'Keeffe. Stieglitz and other Secessionist photographers

Alfred Stieglitz, *Spring Showers—The Coach*, 1899–1900. (Gilman Collection, Gift of The Howard Gilman Foundation, 2005. Image copyright © The Metropolitan Museum of Art. Image source: Art Resource, NY.)

maintained their memberships in the Camera Club to use the superb darkroom facilities, and outside the darkrooms, the clubby surroundings made for a pleasant, privileged atmosphere of largely masculine conviviality.

Of all the photographers who gravitated to Stieglitz in those days, Steichen was by far the most important to him and became his closest friend. The younger man came back to the States in 1902 after a two-year stay in Paris with a European elegance and a wide acquaintance in the art world. He'd crossed the Atlantic in steerage with a friend from Milwaukee and rid-

den to Paris on a bicycle loaded with his photographic equipment, but before long he was visiting Rodin on a weekly basis. He made a point of photographing art stars all over Europe: G. F. Watts, Franz von Lenbach, Franz von Stuck, Maurice Maeterlinck, Paul-Albert Besnard, Albert Bartholomé—a roster of celebrities as eager to take advantage of Steichen's photographic skill to get publicity as Steichen was keen to get publicity by photographing famous people. He had gone to Europe intending to study painting, and he did briefly attend the Académie Julian, but he became convinced that the formal education of the academies was useless to him. He learned more about painting from his photography, he said. Steichen managed his own career astutely. He had to make a living through photography, as Stieglitz did not. He could not afford to be offended by art's commercial value.

He memorably photographed Rodin in front of his sculpture of Victor Hugo. A few weeks later, he even more memorably combined that photograph with another of *The Thinker*, making a composite in which the artist seemed to contemplate his own creation. It thrilled Rodin. He recognized in Steichen the person who could best communicate the spirit of his work to the public. Steichen would later show himself worthy of Rodin's faith even more brilliantly with the series of photographs of the sculpture of Balzac in the moonlight.

Upon his return to New York, Steichen opened for business as a portrait photographer and was enormously successful, sought after by the wealthy and the celebrated. In one remarkable day, he photographed both J. P. Morgan and Eleanora Duse. In 1903 he married Clara Smith, who had modeled for him—a marriage undertaken, on his side, in the same spirit of dutiful subjection to the demands of adulthood that had motivated Stieglitz's marriage, and one that would prove just as unfortunate.

Stieglitz benefited from Steichen's taste and ideas in every

aspect of their work together. Steichen designed the elegant art nouveau cover of *Camera Work* and chose the typeface. Stieglitz had the inspired idea of printing the advertisement, almost always for Eastman Kodak, in the same style on the back cover, making it less an ad and more an extension of the magazine's mission. Steichen understood that this mission was to support the members of the Photo-Secession and to increase respect for their work, and he knew that Stieglitz considered him the brightest star of the group. "The whole d——m business 'photo-pictorially' rests between us two," Steichen wrote to Stieglitz. "I don't think another one of the whole movement big or little really grasps *what* you are driving at and *how*."[9] Each of them got what he needed from the other: Stieglitz a great artist whose work he could use to prove photography's aesthetic potential, and Steichen the incredible benefit of Stieglitz's gift for publicity. Both savored the pleasure of having a friend working at the same level in the same field.

The idea of opening a gallery to showcase photography came from the energy between them. When Steichen left his studio at 291 Fifth Avenue for larger quarters next door, he suggested that the rooms would make a good space for a gallery. Stieglitz was not initially enthusiastic, telling Steichen that "there wasn't enough important photography being done throughout the world to keep up a continuous exhibition."[10] But Steichen suggested that the gallery could show not just photography but also painting and sculpture to further their goal of placing photography alongside the other fine arts. "As we had not succeeded in getting photographs hung with paintings in any art gallery, we should try the opposite tack and bring the artists into our sphere."[11]

In the fall of 1905, Stieglitz signed the lease. The rent was $50 a month, and he spent another $300 on carpentry and lighting. Membership in the Photo-Secession cost $5 a year, which brought in about $300, but all the other expenses of the

gallery—rent, utilities, hanging, shipping, insurance—were borne by Stieglitz himself. Steichen designed the rooms and got his wife to sew the curtains covering the storage space. He and Steichen worked together on arranging shows and hanging the artwork. What was called officially the Little Galleries of the Photo-Secession and later became known simply as 291 was a joint creation of Stieglitz and Steichen.

The opening show displayed the work of thirty-nine Photo-Secession photographers, including Stieglitz, Steichen, Käsebier, White, Keiley, Coburn, Eugene, Brigman, and Herbert French. French, one of the least known now of this distinguished group, was a Procter and Gamble executive as well as a photographer and one of many wealthy enthusiasts who would prove so helpful to Stieglitz in his promotion of photography. Steichen had eleven prints in the opening show, more than anyone else, followed by White with nine, Käsebier with eight, and Stieglitz and Keiley with seven, out of a total of one hundred prints. Later, Stieglitz mounted a show of French photographers, a joint show for Käsebier and White, a show of the British and then of the Germans and Viennese, and a solo show for Steichen.[12] Sixty-one prints were sold in the first season at an average price of $46 per print, almost ten times the amount Stieglitz had paid Steichen for those first three prints. Stieglitz was boosting the prices being paid for photographs, but he himself was the heaviest buyer, starting almost inadvertently to amass a stupendous collection in the process of encouraging other photographers.

The Little Galleries of the Photo-Secession followed the path of *Camera Work*, which had started publication two years earlier. Käsebier, who shared with Clarence White the first nongroup show at 291, had been the first photographer featured in *Camera Work*. After Stieglitz himself, she was the best known of the Photo-Secession photographers, with a reputation abroad that startled Stieglitz on his 1904 visit. Her

image of a mother and infant, *The Manger,* sold for $100 in 1900, matching the highest price ever paid for a photograph, as Stieglitz, always sensitive to price as a measure of respect, boasted in print.[13] This remarkable woman managed to get an art education and establish herself as a photographer while raising three children in an unhappy marriage. Sympathy, the hallmark of her portraits, accounted for her tremendous success as a portrait photographer. Her portraits of Emmy Stieglitz, for example, show an appreciation of Emmy as a woman that is rarely shown by other photographers.

In her eyes, every woman had a unique bond with her children; every woman participated in the archetype of Maternity. Her elegant sense of composition, beautiful lighting, and special response to women and children made her work popular and influential, but her need to make money from her photography and her desire to control her own career eventually drove her apart from Stieglitz.

Clarence White, with whom Käsebier showed, was a gifted Ohio bookkeeper who did loving, somewhat Pre-Raphaelite images of his wife and her sister that shared some of the sympathy for women evident in Käsebier's work. Both of them would later devote themselves to educating other photographers.

To some extent, the gallery and *Camera Work* reinforced one another, with the magazine acting as catalogue for the shows. Steichen starred in the second issue of *Camera Work*, as his exhibition followed that of Käsebier and White at 291. But since the shows stayed up only for a few weeks and the magazine came out once every three months, the gallery was even more demanding than the magazine of continual new material.

Steichen was awed by the time and energy Stieglitz was willing to give to 291. "With only a brief interruption for lunch, he stood on the floor of the Galleries from ten o'clock in the morning until six or seven o'clock at night. He was always there talking, talking, talking; talking in parables, arguing, ex-

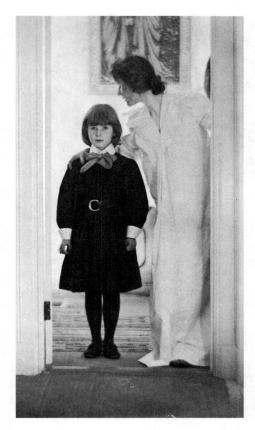

Gertrude Käsebier, *Blessed Art Thou Among Women*, 1899. (Library of Congress, Washington, Gift of Mina Turner, 1964.)

plaining. He was a philosopher, a teacher, a preacher, a father-confessor. There wasn't anything that wasn't discussed openly and continuously in the Galleries at 291. If the exhibitions at 291 had been shown in any other art gallery, they would never have made an iota of the impact they did at 291. The difference was Stieglitz."[14]

Steichen, now with a child as well as a wife to support, could not afford to spend all day at 291 even if he had wanted to, which seems unlikely. But Stieglitz let his own photography take second place to the project of photography. From 1905 to

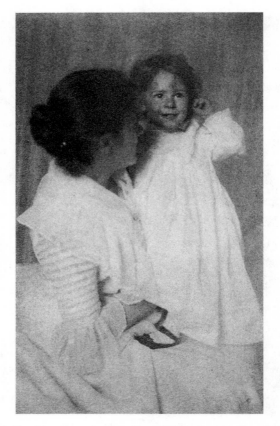

Gertrude Käsebier, *Emmeline Stieglitz and Katherine Stieglitz*, 1899–1900.
(The Clarence H. White Collection. Princeton University Art
Museum/Art Resource, NY.)

1917, in the twelve years he was running the gallery along with
Camera Work and the work of the Photo-Secession, he made
only 225 finished prints, compared to over 300 in the next four
years.[15] Only two subjects continued to draw him, the faces of
his own artists and the face of New York City.

Stieglitz's photographs of New York, begun in the 1890s

and continuing in different forms for the rest of his career, helped Americans see the great city in the process of being built. It was in his eyes a city of skyscrapers and steamships, railroads and paved roads, a cathedral of modernity, with smoke and steam rising from chimneys and funnels like clouds of propitiating sacrifices to the gods, linking earth and heaven, the hard and the ineffable. When he returned to New York from Germany as a young man, he had found the city charmless. What caused him to turn into such a fan of urban growth? In part, the city itself changed, metamorphosing from squalid to imperial: the Brooklyn Bridge, the Statue of Liberty, and the first skyscrapers appeared. Central Park gave the city a new focal point. Thinking about the meaning of the changes he witnessed, Stieglitz saw the new construction and new forms of transportation as energy and power materialized.

One object inspired both Stieglitz and Steichen, a tall building erected on a wedge-shaped piece of land a few blocks away from the Camera Club and 291. The Flatiron Building was not the tallest building in New York when it was built in 1902, but it was perhaps the most distinctive. Its steel frame allowed the building to soar up at the same width for its entire height, emphasizing its reach to the sky. Freestanding, seeming to defy gravity, it towered over everything around it. Its triangular shape, designed to fill the odd-shaped lot on 23rd Street where Fifth Avenue and Broadway converge, added to its metaphoric resonance. It could be seen as a flat iron (as opposed to a mangle) but more poetically it could be an urban rock face or the prow of a ship.

Stieglitz did not photograph it as it was going up and later wondered why. Buildings in the process of construction mobilized his imagination. When the Flatiron was finished, Stieglitz saw it as a ship plowing into the future. He photographed this astonishing structure over and over, from Madison Square

Park or from Fifth Avenue, often in the snow. He recalled years later that his father came upon him once when he was at work.

> "Alfred," he said, "how can you be interested in that hideous building?" "Why, Pa," I replied, "it is not hideous, but the new America. The Flat Iron is to the United States what the Parthenon was to Greece." My father looked horrified.

His father, he continued, saw neither the incredible lightness of the structure, given its size, nor the simplicity and strength of the design, while Alfred saw the bones through the body and could appreciate how beauty was showing itself in a new form. It gratified him when his father said of the final image, "I do not see how you could have produced such a beautiful thing from such an ugly building."[16]

The beauty of Stieglitz's photograph is bracing, not embellished. It savors geometry. It plays with the juxtaposition of the foreground tree's verticality and the verticality of the strange structure in the background, the stand of trees no more than knee-high against the giant building, the band of benches providing a human scale in contrast to the scale of nature and the unprecedented scale of the skyscraper. One critic refers to this photogaphs's "stripped-down formal perfection" in comparison to "the baroque splendor" of Steichen's images of the Flatiron dated two years later.[17] Steichen's photographs of the Flatiron certainly show how much further in the direction of a poetic rendering of the building it was possible to go. Tree branches cross the facade like decorative elements, bows on a package. The building's height is exaggerated by being mirrored and extended on the rain-wet street. Steichen made three gum bichromates from the same negative, varying the contrast and color in a gorgeous and bravura display of painterly photography. The one he hung in the opening exhibit at 291 was "a showstopper," a moody evocation of urban glamour.[18]

Steichen did not photograph the evolving new world of the

Alfred Stieglitz, *The "Flat-Iron,"* 1902, printed 1903. (Gift of J. B. Neumann, 1958. Image copyright © The Metropolitan Museum of Art. Image source: Art Resource, NY.)

Edward Steichen, *The Flatiron*, 1904, printed 1909. (Alfred Stieglitz Collection, 1933. Image copyright © The Metropolitan Museum of Art. Image source: Art Resource, NY. © 2018 Estate of Edward Steichen, Artists Rights Society [ARS], New York.)

city with the dedication of Stieglitz, and Stieglitz, although he responded to the city viscerally, distrusted his enthusiasm intellectually. This ambivalence is perfectly expressed in his great image of a railroad yard, *The Hand of Man*. No urban photograph of this period is more powerful than this, in which a locomotive heads directly toward the viewer, putting out black smoke, seeming to push through telegraph poles and shanties into a foreground of railroad-track arabesques. Stieglitz took the picture of the locomotive from the back of another train as it pulled into the railroad yard in Long Island City. The engine's power is suggested by that strong dark column of smoke rising from the locomotive, but the locomotive itself is positioned so that it occupies very little space on the image. What dominates instead are the tracks, occupying the bottom third of the photograph, and the telegraph poles thrusting up through the middle ground of sheds and smokestacks into the well-rendered cloud-filled sky. Is this an image of ugliness or beauty? Ruskin would have said ugliness. Stieglitz's photograph says beauty. He published a photogravure of the image in the first issue of *Camera Work*, describing it as an attempt to awaken people to "the pictorial possibilities of the commonplace."[19] The title, *The Hand of Man*, however, suggests desecration. "Everything is good when it leaves the Creator's hands," wrote Rousseau in the opening lines of *Émile*. "Everything degenerates in the hands of man."[20] Traditionally, the hand of man blights. Here it might be seen as creating—not only railroads and skyscrapers but cameras and photographs to help people see the strange new world for the wonderful spectacle it is. Or is it this blight we see through the camera's lens? Between the title and the romantic image, Stieglitz covers his bases.

Stieglitz called another memorable image of a railroad yard from this period more straightforwardly *Snapshot—In the New York Central Yards*. Taken from the 48th Street cross bridge over the train yard at Grand Central Station, it deploys the

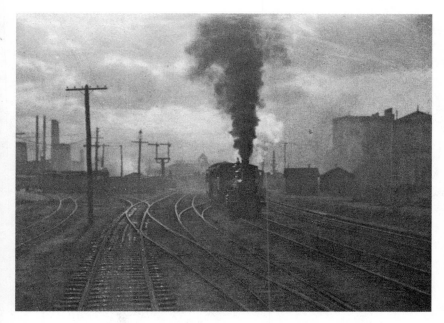

Alfred Stieglitz, *The Hand of Man*, 1902. (Repro-Photo René-Gabriel Ojéda,
Musée d'Orsay, Paris. © RMN-Grand Palais/Art Resource, NY.)

same elements as *The Hand of Man*—truncated locomotive,
enormous cloud of smoke, curving tracks, outbuildings, and
atmosphere—and mixes them into a different but equally har-
monious arrangement. These pictures perfectly capture Stieg-
litz's impulse to meld hard-edged reality with pictorialist soft-
focus and balanced masses of darkness and light.

Steichen still wanted to paint, which to him meant living
in France, and in the fall of 1906, he took his little family back
to Paris. The partnership of Stieglitz and Steichen continued
in a transatlantic way, with Steichen scouting European artists
whose work might then be shown by Stieglitz in New York. By
letter and in person when Stieglitz later came to Europe, the
younger man educated the elder about painting and cultivated
his taste, especially leading him to some of the more newly ap-

Alfred Stieglitz, *Snapshot—In the New York Central Yards*, 1903, printed 1907.
(Gift of J. B. Neumann, 1958. Image copyright © The Metropolitan
Museum of Art. Image source: Art Resource, NY.)

preciated painters, including Van Gogh, Cézanne, and Monet,
nudging him toward more challenging art.

Left alone in New York, Stieglitz impulsively decided to
hang an exhibit of watercolors by Pamela Colman Smith in
January 1907. It was the first nonphotographic show at the gal-
lery. According to Steichen, who never forgave Stieglitz for
doing this without consulting him, they had always planned to
show paintings as well as photography at 291. Again according
to Steichen, his promise to secure Rodin's drawings for the first

nonphotographic show persuaded Stieglitz to sign the original lease. If this is true, Stieglitz's high-handed assignment of the plum to someone Steichen did not even know is indeed hard to forgive.

Pamela Colman Smith appeared one day at 291 without appointment and with a portfolio of her work. She was a tiny, vibrant woman nicknamed Pixie; people liked her. Her watercolors were fin de siècle, symbolist in style, somewhat like the pastels of Odilon Redon. She had established herself in London as an illustrator and theater designer and had made quite a place for herself in the city's Bohemian world.[21] Considering the stature of the artists Stieglitz would show later—O'Keeffe, Marin, and Hartley, to say nothing of Picasso, Matisse, and Rodin—Pamela Colman Smith seems a feeble beginning for his career as a gallerist. His enthusiasm for her, his rushing to give her a show—at the cost of offending Steichen and perhaps Rodin—suggests how open he was to being swept off his feet by a woman artist.

The Camera Club of New York and the Photo-Secession had many women members. Women got shows at 291 and were featured in *Camera Notes* and *Camera Work*, not just well-known artists like Käsebier, Brigman, and Eva Watson-Schütze, but women whose names have faded: Emilie Clarkson, Alice Boughton, Sara Sears, Emma Spencer, and Mathilde Weil. Stieglitz was not the disinterested mentor of women that both Clarence White and Gertrude Käsebier were among the pictorialists, but in his own way, he was a mentor to women.

As it turned out, Stieglitz was either lucky or he had perfectly gauged the taste of the time: the Colman Smith show got a terrific review in a major New York newspaper, collectors flocked in, and the exhibition sold out.

Steichen, however, was outraged. As he later told the story, he composed a terse telegram to Stieglitz: "Do you still want Rodin drawings?" But with telegrams costing so much, he de-

cided to save money by cutting the word *still*. His telegraphed query—"Do you want Rodin drawings?"—gave posterity the impression that he had gotten the idea of supplying European art to 291 after Stieglitz had begun showing nonphotographic art with the work of Pamela Colman Smith when, according to him, the idea had been his all along. His irritation comes through his account of the episode written more than fifty years later and reveals the kind of competitiveness that was rife in the Stieglitz circle. In a functioning friendship, uncertainty about who exactly had what idea is a sign that the two together are more creative than the one alone. But when the pair chemistry fades and ego comes to the front, it's hard for a friendship to survive. Happily, that stage was still in the future for Stieglitz and Steichen.

The real problem for 291 in 1907 was not tension between Stieglitz and Steichen but funding. In the fall of 1907 the stock market crashed, losing half its value in a matter of days. The Knickerbocker Trust Company, the third-largest bank in New York, failed, causing a run on banks all over America. It was a full-fledged panic, and Edward Stieglitz lost half his fortune.[22] He and Hedwig had to move into less expensive quarters, and Alfred's allowance was reduced. At the same time the lease of the 291 rooms was up for renewal, and the landlord was raising the rent. Stieglitz decided to let it go. He could no longer afford to run a gallery.

Then a savior appeared in the form of Paul Haviland, a wealthy young photographer and Harvard graduate who represented his French family's porcelain business in New York. He was as uninterested in Haviland china as Stieglitz had been in Heliochrome and, like him, was working only to please his father. Haviland helped Stieglitz enormously in the coming years, and thanks to his generosity, Stieglitz was able to renew the gallery's lease for three years.

While continually alienating some associates with his high-

handedness, Stieglitz never had trouble attracting new ones. His energy, idealism, and warmth drew people to him, and although Käsebier, White, and even, eventually, Steichen would distance themselves from him, he acquired new friends and colleagues like Haviland, Marius de Zayas, Adolph de Meyer, and Max Weber.

Stieglitz's trip to Europe in the summer of 1907 was arguably the most productive excursion of his life, his voyage of the *Beagle*. He accomplished work in the space of months that he continued to mine for years. This was the transatlantic crossing from New York to Bremen on the *Kaiser Wilhelm II*, on which he shot *The Steerage*, of which he would say toward the end of his life, "If all my photographs were lost and I'd be represented by just one, *The Steerage*, I'd be satisfied."[23]

That this image survived, carried in an undeveloped emulsion on a glass plate, is something of a miracle. As soon as he reached Paris, Stieglitz went to Eastman Kodak, assuming the company would have a darkroom where he could develop the photo. But Eastman Kodak had none and gave him instead the name of a local photographer whose equipment he might use. That unnamed man proved helpful, refused payment, and called it an honor to facilitate Stieglitz's work. Once the negative image on the plate was fixed, Stieglitz still had to get it safely through three months of travel in Europe. He kept the plate in its holder as a way of protecting it, and it never broke.

Stieglitz's mythicized account of this, "How *The Steerage* Happened," does not explain why, if he recognized the importance of this image, he left it unprinted. He was in Europe for months. He spent time with Steichen, Eugene, and Kuehn, any one of whom could have printed a proof for him or found him a darkroom in which to print it himself. Possibly, despite what he said about it decades later, the image had no special importance to him then.[24] In the summer of 1907 his mind was on other things.

He and all his photographer friends in Europe were crazy about color. The brothers Lumière, based in Lyon, had recently invented the autochrome process, and in June 1907 the first autochrome plates were put on the market in very limited release. Color photography was possible for the first time in a relatively simple form. One of the Lumières demonstrated the process at the Camera Club of Paris, and Stieglitz and Steichen planned to go together, but Stieglitz got sick, so Steichen went alone. He managed to get a batch of plates for himself and a batch for Stieglitz.

Steichen worked with the plates for days, trying to master the process himself, and by the end of the week, he had gotten better results than the Lumières had. Everyone agreed that the Lumières' own slides were interesting but Steichen's were dazzling. "This was the first practical, direct color photographic process to become available. The results were extraordinary," he wrote.[25] The process involved potato starch, dyes, and a yellow filter, and it produced positive images that had to be held up to the light to be viewed or projected through a slide lantern. Viewed up close or under a magnifying glass, the varicolored dots were visible, making the image resemble a pointillist painting. Autochromes do not transfer well to print, so it is hard to see the effect they produced, but it was amazing to people like Stieglitz, who had been dreaming for years of producing color images.

Obsessed by color since his student days, Stieglitz had long since concluded that a simple method of making color photographs was impossible. So he was astonished by what he saw that summer. "The pictures themselves are so startlingly true that they surpass anyone's keenest expectations." He loved to describe the effect to skeptics and then show them the transparencies, watching them become "positively paralyzed, stunned." "Soon the world will be color-mad, and Lumière will be responsible," Stieglitz wrote.[26]

Frank Eugene, *Eugene, Stieglitz, Kuehn and Steichen at Tutzing*, 1907.
(Alfred Stieglitz/Georgia O'Keeffe Archive, Yale Collection of American
Literature, Beinecke Rare Book and Manuscript Library.
© Yale University. All rights reserved.)

Later in the summer Stieglitz, Steichen, Kuehn, and Eugene met in the Bavarian town of Tutzing with the single purpose of experimenting with the new color plates. There is a wonderful picture of the four of them looking at Frank Eugene's work: Eugene himself holding the rubber bulb and tube to release the shutter from a distance, Stieglitz and Kuehn with their German mustaches and pince-nez, and the clean-shaven and elegant Steichen.

Twenty of the autochromes they made at Tutzing survive, and they prove how exuberant the atmosphere was. The men photographed each other playing chess and drinking beer. They photographed Alfred and Emmy, Kitty and Alfred, Kitty alone, Emmy alone. We may highlight 1907 as the summer of *The Steerage*, but for Stieglitz it was the summer of color. Indeed, it's hard to see that Stieglitz did anything *but* take color

photographs from then on for quite a while. He photographed Kitty with apples in her lap. He photographed his sister Selma Schubart in a rust-colored Fortuny dress with red flowers. The whole process seemed magical, and red particularly amazed him. He was enchanted by the world in color. (See plates 5, 6, and 7.)

When Stieglitz returned from Europe, he called a press conference at 291 to show the autochromes made by Steichen, Eugene, and himself. His enthusiasm for color photography was so great, his wonder at it so compelling, he was bursting with the news. Brand new in France, autochrome plates were unknown in America. But again he stepped on Steichen's toes. Steichen had been the one at Lumière's demonstration, the one who pushed the process to its limits, who acquired the plates as soon as they were released. He had even taken some auto-chrome plates to England and photographed in color luminaries like Bernard Shaw and Lady Ian Hamilton, while Stieglitz was using autochromes only for family snapshots. From Steichen's point of view Stieglitz was grabbing the spotlight and denying him proper credit, so it's worth noting that before even leaving Europe, Stieglitz arranged to have Steichen's autochromes from England printed at the Munich firm of Bruckmann for inclusion in a special supplement of *Camera Work*.

On the way home on the *Kaiser Wilhelm II*, Stieglitz had a moment of feeling that dreams were coming true. "I experienced the marvelous sensation within the space of an hour of marconigraphing from mid-ocean; of listening to the Welte-Mignon piano which reproduces automatically and perfectly the playing of any pianist (I actually heard D'Albert, Paderewski, Essipoff and others of equal note while they were thousands of miles from the piano); and of looking at those unbelievable color photographs!"[27] Telegraph, player piano, color photography—wonders of the modern world. Stieglitz, like Kuehn, was autochrome sick, a disease characterized by temporary loss of interest in black-and-white photography.

Still, experimenting with color was not all he did in Europe that summer, and again, it was thanks to Steichen that he stretched himself. Beginning in 1907, and then in two subsequent summers in Europe, 1909 and 1911, Steichen gave Stieglitz, whose orientation was German rather than French, scientific rather than artistic, the art education he had never had, showing him many of the exciting things that were happening in the art world in France. He introduced him to Rodin and Brancusi, showed him "any number of Van Goghs and Renoirs," took him to meet Leo Stein, who first mentioned Picasso to him, and Sarah and Michael Stein, who collected Matisse. He convinced Stieglitz that a show of Matisse's drawings would be perfect for 291. He introduced him to the art dealers Vollard and Bernheim and showed him Auguste Pellerin's enormous collection of Cézannes. Confronted with Cézanne's watercolors, Stieglitz at first reacted crudely. He saw nothing in them but "empty paper with a few splashes of color here and there."[28] It took him two years to see the work as beautiful and original, Steichen in the meantime having arranged to send a selection for exhibit at 291. When the watercolors arrived in New York, Stieglitz unpacked them and was stunned by how realistic they now seemed to him. He came to take on faith, at Steichen's suggestion, a great deal of modern art he didn't understand but later learned to appreciate.

Stieglitz went from promoting photography to promoting modern art in general, but before we follow that change, one life marker that happened somewhat later needs to be inserted here. For Stieglitz to feel that he had done what he had set out to do on behalf of photography, he wanted a major art museum to sponsor an exhibition of photography, presenting it as respectfully as it would paintings. This finally happened in the fall of 1910, when the Albright Art Gallery in Buffalo hung a large show of photographs Stieglitz had selected. Like all museum shows, it was a long time in the planning, begun

in 1908 under a director of the Albright Gallery who died in 1909. Alvin Langdon Coburn, passing through Buffalo, visited the new director, Cornelia B. Sage, and suggested she revive the idea. She went to New York, met with Stieglitz, felt she had found a soul mate, and scheduled the show, which was announced in the April 1910 issue of *Camera Work*.

This show was very much Stieglitz's baby, and that aroused the usual resentment in the photographic community, both from conservative photographers who had no chance of being included and from art photographers not in Stieglitz's circle. He worked throughout the spring, summer, and fall of 1910 to solicit and select what he considered the very best examples of pictorial photography, judging the entries submitted to the open section, and preparing a catalogue. "The reputation not only of the Photo-Secession, but of photography is at stake and I intend to muster all the forces available to win out for us," he wrote a friend, displaying the urgency he brought to all his battles.[29] Accompanied by Clarence White, Max Weber, and Paul Haviland, he went to Buffalo a week before the opening to hang the show. Finding the galleries unsuited to photography, they lowered the ceiling, diffused the light with scrims, and covered the walls with cheesecloth. Weber did most of the hanging, but Stieglitz hung his own prints and Steichen's. Stieglitz chose twenty-nine of his own prints, including *Mending Nets* and others from 1894, but not *The Steerage*. For him, this was a summation of his career up to that point, and *The Steerage* was not yet mythologized as a turning point. His work, along with that of David Octavius Hill, Annan, Steichen, Coburn, George Seeley, and de Meyer, hung in the center gallery. The invitational section contained 500 photographs by thirty-seven artists, while the "open" section contained 124 by thirty photographers, including then-unknowns Karl Struss and Arnold Genthe.

Stieglitz was pleased with the show. "The Albright Art Gallery is the most beautiful gallery in America and also one of the

most important," he wrote to a German friend, translating the prices into marks. "The exhibition made such a strong artistic impression that the management bought 12 pictures for 1200 marks (catalogue value 2400 marks) and has dedicated a beautiful gallery to these pictures. This gallery will be maintained permanently for artistic photography. In short the dream I had in *1885* in *Berlin* has been realized—*the full recognition of photography by an important art museum!*"[30]

The triumph was not quite as neat as Stieglitz portrayed it. Buffalo's museum was not as important as New York's Metropolitan Museum or the Boston Museum of Fine Arts, both institutions whose sponsorship Stieglitz had tried unsuccessfully to obtain. Nor did the museum in the end dedicate a gallery to photography. And in strong-arming photographers to sell their work cheaply to the Albright Gallery so he could claim that a museum had bought them, he profoundly alienated Gertrude Käsebier. But none of that was important. With this achievement, Stieglitz felt that he had done as much for photography as he had ever hoped to do, and now he could leave it to fend for itself. The show at the Albright Gallery was his parting gift to the photographic community. After that he allowed his relentless focus on photography to broaden into a more complicated interest in modern art.

It is interesting to compare Stieglitz's achievement at this point in his life with that of another man important to the history of photography, George Eastman, whose goal, almost the opposite of Stieglitz's, was to bring photography to the masses. He had begun by inventing dry plates, but he realized that dry plates were just a step. His larger goal was to make photography easy. The light-sensitive emulsion needed to be on something more flexible and lighter than glass. He developed a way of putting onto rolls of paper a light-sensitive gelatin which, after exposure, could be separated from the paper and fixed as a negative. This was so much better than glass plates that he ex-

pected all photographers to switch to film, but serious photographers did not. Eastman then realized that his target audience was the general public rather than photography professionals. He devised a way of spreading the habit of photography by manufacturing a simple box camera that came preloaded with a roll of film. In 1888 this camera sold for $25 and took one hundred shots. When you finished a roll, you returned the whole camera, film inside, to the Eastman Kodak company in Rochester. It developed the film and sent you the prints along with a reloaded camera for $10.

"You press the button, we do the rest." Kodak's advertising slogan positioned photography as a pastime for a mass market, infuriating Stieglitz. Not only did he have to fight people who saw the camera as a mere recording device for scientists and engineers, he also had to fight against those who viewed it as an artifact of family life no more artful than a toaster. But the fact is, both Eastman and Stieglitz were successful. By 1910 photographs were hanging in an art museum and also pasted into albums in homes all over the globe.

4

Creator of Creators

THE YEARS OF 291's existence were Stieglitz's glory days. Always seeking communal cover for his ego, he was supremely happy with the way this hybrid—part gallery, part school, part arts foundation—abstracted his identity. Everyone knew that 291 meant Stieglitz, as *Camera Work* had meant Stieglitz, as the Photo-Secession had meant Stieglitz. To fuel his fights, Stieglitz needed to feel he was fighting for others. At first his fight at 291 was on behalf of photographers, but then it became a fight for European modern art and finally a fight for American art.

In a space no larger than a one-bedroom apartment, on the top floor of an unimpressive, unheated building whose elevator could fit no more than three passengers at a time, Stieglitz gave America its first look at the work of Picasso, Matisse, Rodin, Cézanne, Brancusi, and other great European artists. History has come to accept Stieglitz's high opinion of the European modernists' work as well as the work of many of the American

artists he championed, including John Marin, Marsden Hartley, Arthur Dove, Max Weber, Paul Strand, and, of course, Georgia O'Keeffe. But at the time Stieglitz showed these works, their value was questionable. They were unlike anything that had been called "art" before and seemed to many people without beauty or meaning. Despite or perhaps because of that, Stieglitz was so successful in drawing attention to the art he championed that in the gallery's first seven years, an average of twenty-four thousand people a year came to see what this hideaway held. That's four thousand visitors a month for a six-month season. New shows went up six to ten and often even more times a season.[1]

The fragile elevator deposited visitors in a hall where one carefully chosen piece of art always faced them. Off the hall, a small alcove provided supplementary display space and led into the main exhibition area, itself only about fifteen feet square. To create more wall space, the room was set back from the building's front windows by a hallway, making a room within a room, lit both by electric lights and by natural light filtered through a skylight and a dropped screen of muslin. A square table in the center under the light scrim featured a large brass bowl or a piece of sculpture if sculpture was on exhibit.

The walls were covered in neutral burlap and a very shallow cupboard ran around part of the square, its top for display of small pieces, the storage space below hidden by olive gray sateen curtains that Clara Steichen had made. The simplicity of the décor and the overall lightness of the space, unusual in a time featuring galleries with red plush walls, felt quite modern. The emphasis on selection and careful placement of the works, framed identically and simply, was also modern. But however airy it seemed compared to Victorian galleries, 291 would feel dark and intimate compared to the stark white walls and vast spaces we expect now in art galleries.

Wall space was so limited that only works on paper or

Alfred Stieglitz, *291—Picasso/Braque Exhibition*, 1915. (Alfred Stieglitz Collection, 1949. Image copyright © The Metropolitan Museum of Art. Image source: Art Resource, NY.)

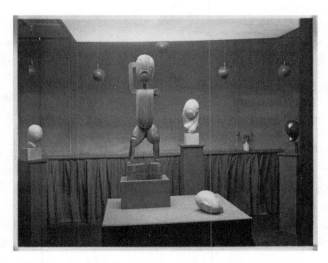

Alfred Stieglitz, *Brancusi Exhibition at 291*, 1914. (Gift of Charles Sheeler. Digital Image © The Museum of Modern Art/Licensed by SCALA/Art Resource, NY.)

small canvases and sculptures could be shown. We can see the main room in installation photos of the Picasso/Braque exhibit, the Brancusi exhibit, and the African sculpture exhibit of 1914, showing ever more sophisticated hanging and, in cases where Stieglitz himself took the photos, his remarkable feel for composition, so that the installation shots themselves are examples of the modernist aesthetic 291 was promoting.

291 was also Stieglitz's office and daytime home. Of the three rooms on the floor, two were leased to him and one, the largest, to a decorator, Stephen B. Lawrence, who traveled frequently and allowed Stieglitz to use it when he was gone. This room contained the coal-burning stove that provided the only heat for the floor. It was the room Stieglitz used for work with his coeditors, Paul Haviland, Joseph Keiley, J. B. Kerfoot, and Dallett Fuguet, on issues of *Camera Work*, spreading out photos and text on the decorator's ample work table. Occasionally he did some developing and printing of photographs in a makeshift darkroom in the bathroom.

What Stieglitz hung at 291 was what interested Stieglitz, sometimes the work of artists whose names are now unknown, sometimes giants like Matisse and Picasso, sometimes the work of artists who came to him cold, portfolio in hand, and sometimes the work of artists armed with an introduction from Steichen or another of the talent scouts he trusted. Sometimes he hung work that he didn't even like, saying he needed to look at it a while to understand it. He was always open to new ideas about art. He liked to think of 291 as a laboratory, a space for experiment. When his good friend the painter Abraham Walkowitz suggested showing the art of children, Stieglitz arranged it. The exhibit was intended to test the idea, so often expressed in confrontations with the new abstract art, that a child could do it, but it also reflected the modern movement's passion for the intuitive and unschooled. For the same reason, he later mounted a show, the first in America, of African sculp-

ture. He knew that the best way to get attention for his shows was by framing them in a way that attracted the attention of the press. The press would do the work of advertising for free. Stieglitz and Steichen thought of some of their shows as "Red Flags"—shows like those of Rodin's drawings of nudes, Picasso's work, or the children's art show that generated outrage and therefore attention. They would sometimes alternate work they considered "understandable" with "Red Flag" shows, not so much to give people a rest from the new and revolutionary as to stimulate discussion about the nature of art.

The first year of 291 was all photography, in step with *Camera Work*. But gradually both gallery and magazine began to focus on new trends in painting. This change of direction outraged most of the early subscribers to *Camera Work*, and subscriptions to the magazine plummeted. Moreover, photographers who felt that 291 had been promised to them as a showcase for photography believed Stieglitz had betrayed them. But Stieglitz saw the movement of interest from photography to painting and sculpture as having an inner necessity. Photographers needed to see what avant-garde painters were up to so that they did not go on merely perpetuating pictorial styles of the past. Also, at a deeper level, he believed there were questions about the relationship between photography and painting that should concern them. Could photography move, as painting had, beyond representation to the same kind of essential confrontation with reality, toward a kind of abstraction? Could photography, without losing its distinctive tie to the visual world, become anti-photographic?

Through 291, Stieglitz got an art education second to none, learning most from his own artists. Max Weber taught him to appreciate cubism (see plate 8). Arthur Dove introduced him to abstraction. From Marsden Hartley, Stieglitz learned about German expressionism. Hartley also introduced him to Kandinsky's book *On the Spiritual in Art*, a manifesto for the new

nonrepresentational art. Steichen, who taught him more than anyone and brought him to the appreciation of so much of what he came to love, introduced him to Gertrude, Leo, Michael, and Sarah Stein, who in turn brought him Picasso and Matisse.

Stieglitz was educated also by the young art critics he published in *Camera Work*, a cosmopolitan group including Sadakichi Hartmann, son of a Japanese mother and German father, Benjamin De Casseres, a Sephardic Jew descended from Spinoza, and Charles Caffin, an Oxford-educated Briton who had moved to New York. De Casseres went on to become one of the best-known critics of the early twentieth century, writing for Mencken's *The Smart Set* and the major New York newspapers. Caffin was the art critic of the *New York Sun*. Among Stieglitz's close advisers, too, was the invaluable Marius de Zayas, who came to New York to escape Porfirio Díaz's dictatorship in Mexico. De Zayas, who had a wide-ranging knowledge of contemporary art and incisive views, was a caricaturist, the Al Hirschfeld or Saul Steinberg of his day, a talented artist who was also literary enough to create visual satire. Stieglitz, always open to new ideas, displayed his work as serious art. In return, de Zayas saw it as his responsibility to keep Stieglitz informed, and he actively combed Paris for talent on Stieglitz's behalf, eventually replacing Steichen in that role.[2]

Because Stieglitz made a practice of publishing reviews of all the 291 shows in *Camera Work*, the pages of the magazine provided a lively debate between those in favor of the new art, like Caffin, De Casseres, Hartmann, and de Zayas, and the newspaper critics, who were by and large dismissive. In the issue covering Max Weber's show at 291, for example, Sadakichi Hartmann praises Weber's "proud disdain for the cold correctness of academic draftsmanship," while journalists refer to Weber's "alleged drawings and paintings" and maintain it is "difficult to write of these monstrosities with moderation." To

read these reviews now reminds us that the modernist artists first endured an outraged rejection far different from the flattering embrace of posterity.

For Stieglitz, an intellectual with no intellectual companionship in his marriage, the stimulation 291 provided was precious. Mornings, when few viewers came by, was the time for artists to visit. They talked about whatever was on display and about each other's work. They discussed the pieces in the magazine, which tended to be philosophical and loosely political, unlike the more technical pieces that had run in *Camera Notes*. The poorest artists tended to arrive just before lunch in the hope, often rewarded, of getting a free meal. Stieglitz hosted almost daily lunches or dinners at restaurants—Emmy's treat: she gave him a special fund for this. The discussions at these gatherings were wide-ranging. It was a floating seminar on art and society.

Stieglitz claimed to have no interest in artists who produced the same kind of piece over and over, and he questioned the artists about what in their work was new, where it was heading. He believed the work had to be going somewhere, changing, growing, in order for him to take it seriously. In this he was he was very Bergsonian.

Henri Bergson was the most celebrated philosopher of the time, so popular that when he visited New York from his home base in Paris and lectured at Columbia in 1913, he is said to have caused Broadway's first traffic jam. His influence may be compared to that of Foucault or Derrida much later in the century. While the deconstructionists taught a generation to be skeptical about values, to distrust linguistic assertions and cultural ideals, Bergson preached a more optimistic faith to a post-Victorian generation, urging people to pursue growth. Although superficially his beliefs recalled the Victorian belief in progress, the emphasis was not so much on the arrival as

on the journey. He considered process, evolution, and constant change virtues in themselves. His bestseller *Creative Evolution* introduced the idea of the *élan vital*, a kind of essential energy at the heart of things. The élan vital expressed itself in constantly changing ways, and the keen-eyed cultural observer was always on the watch for it. "That which changes perpetually lives perpetually," as De Casseres summarized Bergson with characteristic snap.[3]

Through the one-two punch of 291 and *Camera Work*, calling occasionally upon Bergson and Kandinsky as theorists, Stieglitz and his friends created a new rhetoric. The purpose of art was to brush aside convention, to make people hear and see freshly, to replace "socially accepted generalities" with individuality and originality, "to bring us face to face with reality itself."[4] The artist's task was not to reproduce objective reality in another form but to express an inner truth. To a large extent, the ideas Stieglitz and associates popularized about the nature and function of art have lasted to our own time. In his tiny gallery, with no financial motive, Stieglitz had an effect on the history of modern art in America out of all proportion to the space and money he devoted to it, his greatest resources being his own passion, his ability to inspire, and his gift of learning from others.

He showed works by Rodin, Matisse, Picasso, and Cézanne —all the first works of these artists to be shown in America. He hung the first Henri Rousseaus ever to be exhibited anywhere, brought to him by Weber, who had befriended the artist in Paris. He was the first to show Toulouse-Lautrec's lithographs in America, hanging a collection of masterpieces he himself had amassed on one of his summers in Europe. He would mount the first show anywhere of Matisse's sculpture, Brancusi's sculpture, African sculpture, and Francis Picabia's paintings. He loved the designation "First Show Anywhere." It formed a regular part of his press announcements and seems

to have successfully called attention to the novelty of what he
was doing.

Along with the Europeans, he was showing young Amer-
ican painters who worked in new ways. Max Weber entered
Stieglitz's orbit when he was in his early thirties, having come
from Bialystock to Brooklyn with his parents as a child. From
teaching, the young man earned enough money to get him-
self to Paris, where he became friendly with many avant-garde
artists and writers, including Apollinaire, Picasso, Marie Lau-
rencin, and Rousseau. When Weber returned to New York,
impoverished, Stieglitz was kind to him, even allowing him
to sleep at 291, often taking him home for dinner with Emmy
and almost daily out for lunch. In return, Weber became a real
friend to Stieglitz, helping him in the gallery, especially with
the hanging of shows. Besides passing on to Stieglitz a great
deal of the knowledge of contemporary art he had acquired in
Paris, he tried to repay him also by giving drawing lessons to
Kitty. But Kitty didn't like him. Not many people in the 291
group did. He lashed out at any painter more successful than
himself, a group from which few were excluded. Having con-
vinced himself that any success involved selling out, he chose
Steichen, who was particularly successful, for special scorn.

After introducing Weber's work in a group show, Stieglitz
gave him a show of his own in 1911. Unable to afford oil and
canvas, Weber painted on cheap cardboard with gouache, pas-
tel, and watercolors, and Stieglitz expected him to set prices ac-
cordingly. But Weber insisted on asking the astoundingly high
price of $1,000 for each piece. The only offer Stieglitz received
for a painting in the show was $500, and he accepted it. Weber
was furious. Had Stieglitz really been on his side, he said, the
buyer would have paid the asking price.[5] His anger at Stieg-
litz was typical of the ingratitude that Stieglitz encountered.
In many cases, Stieglitz mended fences with artists he broke
with or who broke with him, but he never regained his liking

for Weber, and in all the vast Stieglitz collection there was not a single work by Weber.

Stieglitz boasted that 291 was not a gallery in the proper sense because he did not primarily intend to sell the art on display. He saw his role as educational, to create a public capable of properly appreciating art and supportive of it, to allow artists to continue making art. If someone valued a work of art as he believed it should be valued, Stieglitz might consent to let that person buy it. But he did not consider this "selling" so much as "placing" the work, finding the proper steward to see it safely into the future. He was running "an adoption agency for art," in the words of Richard Whelan.

There was a practical reason for insisting on the gallery's educational function. Until the art-loving lawyer John Quinn got the law changed in 1913, there was a 13 percent tariff on imported works of art less than twenty years old. If Stieglitz wanted to show new works from Europe, it was wise to de-emphasize their salability and get them through customs as teaching material. In any case they rarely sold. O'Keeffe said that Stieglitz bought European works from every show he mounted because he was embarrassed to return them to the artists with so few sold and at such low prices.

His financial dealings were anything but transparent. If he sold something and thought the artist could afford it, Stieglitz took a fee of 15 percent to cover gallery costs, but he did not take a commission. (Contemporary galleries routinely take 50 percent.) Sometimes he took a work of art for his own collection in lieu of payment, but more often he bought the work he showed while covering for every show the costs of insurance, installation, gallery staffing, and shipping. Some have considered Stieglitz's lack of interest in selling no more than clever marketing and his high-handed bookkeeping bordering on fraud. His artists and clients were rightly confused and sometimes annoyed by his opaque business practices. But I see no

reason to doubt his fundamental sincerity or his goodwill toward the artists he handled. "What greater pleasure is there," he wrote without irony to Marsden Hartley, "than to create opportunities for those who are deserving?"[6] And Hartley showed his appreciation of his dealer by dubbing him a "creator of creators."[7]

The perennially tormented Hartley came to Stieglitz when he was painting landscapes of his native Maine in an impressionist style but with a deeper palette, showing the influence of Albert Pinkham Ryder. One expert on the Stieglitz group says that Hartley was the best oil painter among them right from the start, his work always rich and vivid, with a feel for the medium that others had to develop over time.[8] Hartley had lived in Paris and knew Steichen, but he went to Stieglitz without a Steichen introduction. He walked into the gallery cold, left his work for Stieglitz to look at, and two weeks later was given a show.

Hartley wanted desperately to return to Europe, and Stieglitz arranged for this, securing help from wealthy patrons. The painter went first to Paris, and his reports back to Stieglitz on the arts scene there were full, lively, and acute. "The season has opened with a flush and there is much to see—I only wish you could see the Rousseau exposition. It is too lovely and so timely for me as this man leaves an indelible impression on me—if ever there was true piety in painting it is in this man."[9] At the same time, Hartley's letters detailed his progress and his poverty—he consistently asked for money—so they also functioned as grant applications.

At first Hartley enjoyed being in a place where culture was taken seriously. "There is an 'aliveness' stirring in the air—a reverence of the people toward beauty which is truly comforting. I do not know that as yet I find the French genius altogether a sturdy one—but it is certainly refined to the highest degree—and one feels one's every sensation sort of pitched to

a truer register."[10] He got to know and like Gertrude Stein, who hung a drawing of his on her wall beneath a Manet and a Renoir and next to a Cézanne watercolor so he could see how it measured up.[11] But Paris began to wear on him. "They are all in a bunch here—talking each other to madness—despising each other's work sipping drinks together and smiling like children."[12] Parisian life was "hectic and overstimulated," lacked "vigor and strength."[13] The longer he stayed there, the more tired he got of all the talking. "It is in a sense an advantage not to know French well as one escapes much." Hartley found all the chatter and aestheticizing unmanly—"If there was ever a more ridiculous lot of males as a clan it is these French men"—and he turned to the Germans "as to the gods."[14] Eventually leaving France for sturdier Germany, he based himself in Berlin, where a thriving gay underground and militaristic pageantry made him feel more at home.

Stieglitz arranged a show for Hartley in 1913, his second one-man show at 291, but insisted the artist had to be in New York while it was up. Reluctant to leave Europe, Hartley made the mistake of reporting to Stieglitz that Gertrude Stein did not think he should go back to America and believed that "someone in New York" should volunteer to give him the $100 a month he needed to live on. Stieglitz tartly reminded Hartley, "Your European trip was made possible by American cash. Cash which was forthcoming because a few people felt you were entitled to a chance. Now I personally don't see why any American should be called upon to give you additional cash without seeing what you have done. Gertrude Stein's opinion is awfully fine. What Kandinsky says and what Koehler thinks, all is valuable. . . . But people who give money without seeing are very rare."[15]

Eventually Hartley did as Stieglitz wanted. The show was a success; work sold; Hartley returned to Berlin; then it was up to Stieglitz to collect from the buyers. Mabel Dodge, for

one, bought a Hartley and months went by before she finally paid. Another buyer never paid at all, but fortunately he had not taken possession of the painting. Stieglitz bought that one himself. The gallery owner Charles Daniel bought several paintings outright for future sale, but there was no contract and he never paid. Hartley was irritated: Stieglitz should have insisted on a contract before parting with the paintings.

Stieglitz seems to have showed extraordinary patience with some of his ungrateful dependents. On the whole he made more shrewd moves than errors in building their careers, and he would never have cheated them out of money. Still, his business style was patriarchal, his decision making one-sided. When he calculated that he had advanced Hartley $1,000, he claimed three paintings for himself. The price he set for Daniel had been $100 a piece, so he felt justified if not generous in paying Hartley $300 for each painting. On none of this was Hartley consulted, however, so one can understand why, grateful as he was to Stieglitz, he might also feel mistreated.

Despite the glitches in his relationship with Stieglitz, Hartley later described it as wonderful and unique: "For here was one man who believed in another man over a space of more than twenty years, and the matter of sincerity was never questioned on either side."[16] Without Stieglitz, Hartley could not have stayed on in Berlin, the city that nurtured his imagination and produced some of his greatest and most original paintings, such as the *Portrait of a German Officer* (see plate 9). This brightly colored, collage-like assemblage of motifs is a tribute to a young man Hartley loved who was killed in the war at the age of twenty-four. Kandinsky's idea that the highest art was created out of "spiritual necessity," along with a certain mysticism he felt he had imbibed among the Germans, supported Hartley's astoundingly free collections of imagery.

The most beloved artist in Stieglitz's stable was John Marin, and theirs was the most untroubled of his professional relation-

ships. Some compared Marin to a leprechaun, others said he had the face of a wizened apple. His looks were certainly distinctive. He was playful, good-natured, and hapless. He never really grew up and it didn't matter. In fact it was probably part of what made him such an original artist. At thirty, he had still not settled in any groove. He had studied art in Philadelphia but done nothing with it. His father sent him to Paris as one would send a lovable child good for nothing else, and there, in the care of a stepbrother, he learned to do etchings in the style of Charles Meryon, tightly realized renderings of well-known buildings. It was at this point, in Paris, that he met Steichen and through him Stieglitz. They took to each other immediately, and their friendship never wavered.

When Marin, probably under the influence of fauvist colors and the loose, expressionist watercolors of Cézanne, began painting watercolors in the dynamic style we think of as distinctively his, Stieglitz encouraged him warmly. Marin's first show at 291 was a joint exhibit with Alfred Maurer, another of Steichen's Paris finds. That was in 1909. The next year, Marin moved back to America from France, and Stieglitz gave him a one-man show—forty-three watercolors, twenty pastels, and eight etchings. By 1912 Marin was selling enough of his art to marry and start a family. From the first his watercolors were as popular as he was. They shared his brightness, free-spiritedness, and joy. Stieglitz himself ended up owning over two hundred of them. He believed completely in Marin. When the painter begged for $1,200 so he and his wife could live worry-free for a year, Stieglitz found the money he needed. A few weeks later, Marin was back, announcing he had used the money to buy a waterless island in Maine. "But," wrote Paul Rosenfeld, "it was impossible to be annoyed at a painter whose water colors—like Schubert's songs—were fresh and lyrical and saturated with the beauty of the world for attempting to start a new continent."[17]

These were just a few of the young artists Stieglitz took on

in the great days of 291. He gave them solo shows and included them in group shows. He supported them himself or mustered support. He allowed them to travel and work in Europe. He arranged introductions. But what Stieglitz did for individual artists was only part of his achievement. In a larger sense, this far-seeing man helped to build a place for art in American culture. If Stieglitz largely stopped doing his own photographic work in the 291 years in order to promote the work of others, the sacrifice may be seen as not entirely disinterested: he was creating a country he wanted to live in, a country as rich in culture as the Berlin he had loved in his youth.

At the time, although some art dealers were in business in New York, there was not the vast range of galleries that exists now in the city and throughout the country, nor were museums the great institutions they have since become. They were certainly not open to contemporary art. Stieglitz repeatedly tried to get the Metropolitan Museum to buy (at what seems like ridiculously low prices) some of the works he showed but repeatedly failed. During the Picasso show of 1911, fifty works hung on the gallery walls and another thirty-three were available for viewing from portfolios. Only two works sold: one, a rather conventional drawing of a nude, to the artist and collector Hamilton Easter Field for $12, now in the Boston Museum of Fine Arts, and the other, also a nude drawing, a cubist masterpiece, to Stieglitz himself, for which he charged himself $65. The remaining eighty-one works he offered to the Metropolitan for $2,000, or about $25 a piece, but the curator declined, saying he was sure Picasso would "never mean anything in America."[18]

While dealers like Duveen and experts like Berenson facilitated the transfer of the great art of the past from Europe to America, Stieglitz was encouraging the growth of a culture in which people think of art viewing as part of the civilized life of the city. Bringing the United States out of a culturally im-

poverished past and turning it into a world center of cultural activity involved building traditions of education and culture that barely existed. Stieglitz stood in the rooms of 291 six days a week from ten in the morning till six at night, talking, talking, talking, explaining, harassing, cajoling, in order to create a tradition of respect for living art. There were plenty of rich Americans to buy the work of the Old Masters—Henry Clay Frick, J. P. Morgan, and Isabella Gardner, among others. But that is very different from the enjoyment of living artists and the commitment to support their work that Stieglitz tried to inspire. It was hard to find patrons who would support artists like Picasso and Matisse, to say nothing of Hartley, Dove, and Marin. But Stieglitz did.

One protégée was Agnes Ernst, a young woman reporter for the *New York Morning Sun* who came to interview him in 1908, when the show of Rodin drawings was up. This was one of 291's most shocking exhibits—pencil drawings, with watercolor washes sometimes added, of nude models in motion that Rodin had made quickly in his studio, as striking in their erotic appeal as in their originality of style. Stieglitz talked to Agnes Ernst for six hours, and she fell under his spell, writing a piece for the paper that reported Stieglitz's ideas about art but never mentioned Rodin. Stieglitz must have fallen under her spell, too. Everyone did. She was tall, blonde, and blue-eyed, a great beauty and a person of intelligence and vitality. Stieglitz took her on and, as she put it, filled her sails with the free air she craved. He convinced her that a trip to Europe was just what she needed. She went to London, saw Asian art for the first time, moved to Paris, studied at the Sorbonne, became friendly with Steichen and the Steins, and enchanted Rodin.

Upon her return to the States, she married the wealthy young financier Eugene Meyer, a man of whom J. P. Morgan said that if others didn't watch out, he would end up owning everything on Wall Street. The Meyers became major patrons

of the 291 artists: it was they who supported Marsden Hart-
ley's stay in Europe; they effectively sponsored the Brancusi
show by paying for the transportation of the sculptures from
Europe; they commissioned Steichen to paint murals for their
home. Because of Stieglitz, they were among the first collec-
tors of African art. All this even though their primary interest
was in Asian art, with which Agnes had fallen in love on her
Stieglitz-inspired year abroad. The couple left New York in
1917 and moved to Washington, where Eugene later purchased
the *Washington Post*, to be inherited in due course by Katharine
Graham, one of his and Agnes's children. They moved far out-
side the little Stieglitz circle at 291, but time spent there was
like a postgraduate education after Eugene's time at Yale and
Agnes's at Barnard. Eugene called Stieglitz's gallery "a safety
valve for repressed ideas" and "an oasis of real freedom."[19] His
emphasis on 291 as a forum rather than an art gallery is telling.

If one of Stieglitz's major goals in the 291 years was to in-
troduce the newest in European art to America, that goal was
fulfilled spectacularly in 1913 with the exhibition that has come
to be called the Armory Show because it was held at the Sixty-
Ninth Regiment's spacious armory on Lexington Avenue be-
tween 25th and 26th Streets. The Armory Show has become
a landmark in history, signaling the arrival of "modern art"
in America. Although Stieglitz had been showcasing the style
for years at 291, the Armory Show introduced modernism on
a scale way beyond what was possible for an individual. There
were over 1,000 works on display at once: 650 paintings, 150
sculptures, and 470 drawings, watercolors, and etchings. High-
lighting the history as well as the current breadth of modern
art, the show included works by artists as far back as Ingres. Yet
it had all begun very simply, as an effort to showcase the new in
American art, in opposition to establishment art.

The grand old man of American art of the time was Wil-

liam Merritt Chase, America's impressionist master. Chase personally and the National Academy of Design institutionally represented the establishment in American art. Upstarts outside of the Stieglitz circle included Robert Henri, John Sloan, George Luks, Everett Shinn, and William Glackens, whose style had evolved to some extent from newspaper illustration. Realism was the new thing in this stream of American painting, with an emphasis on new subject matter, especially urban life and poverty, instead of the sunny scenes of impressionism. Henri's group, along with less realistic painters Maurice Prendergast, Arthur B. Davies, and Ernest Lawson, had a landmark show at the Montross Gallery five years before the Armory Show and had become known as the Eight. Some of them were also known as the Ashcan School.

The Armory Show was meant to highlight the work of these new American artists. But the organizers—the artists Arthur B. Davies, Walt Kuhn, and Walter Pach—did such a good job of gathering talent from Europe that the Europeans stole the show. Although only one-third of the works were by foreign artists, the Europeans—especially Matisse, Picasso, Francis Picabia, and Marcel Duchamp—made a bigger splash in the press than the Americans, and their work represented two-thirds of everything that sold. Here was art that did not pay homage to the traditional ways of filling a canvas with paint. Duchamp's *Nude Descending a Staircase*, which has come in time to look rather like a nude descending a staircase, seemed, when first exhibited in America, like an aggressively meaningless mass of lines, a gesture akin to sticking a tulip into a beer can and calling it a flower arrangement. Compared to this, very little was new about the new American art.

It's been said that Stieglitz resented the Armory Show for stealing his thunder, but he backed it enthusiastically, sometimes too enthusiastically. Arthur B. Davies asked him to give the show some publicity, and Stieglitz complied with a half-

page article in the *New York American*. It was one of his improvisational tirades, recorded by Charles Caffin, the newspaper's art critic. Stieglitz predicted that the Armory Show would "wring shrieks of indignation from every ordained copyist of 'old masters.'" Of William Merritt Chase and Robert Henri, he said recklessly, "The dead don't know when they are dead." And he concluded, lumping together the old representational painting and souvenir photography, "If you would rather art stay dead, then go out with your kodak and produce some faithful imitations." This is likely the true sound of Stieglitz's hectoring, and he himself was horrified when he saw it in print, writing letters of apology to some of the people he had maligned. But it shows that he supported the Armory Show and considered the art on display there the way forward for art. Stieglitz was listed as an honorary chairman of the show, although he did almost nothing for it. His work had already been done, and the Armory Show capitalized on it.

What Stieglitz did *not* say about the Armory Show is as significant as what he said. He did not scold the organizers of the exhibition for excluding photography. That battle was in the past. Instead he took advantage of the occasion to hang a concurrent show of his own photographic work, the only show entirely of his own work he ever mounted at 291. He wanted to match the best photography had to offer (no false modesty) against the best of modern painting. He told a friend that if his work did not stand up to this "diabolical test," it contained nothing vital.[20]

In 1910 Stieglitz had set out to capture the energy and rhythms of New York in photographs, and the 1913 show included many of these recent images, like that of the *Mauretania* leaving port, the ferry and its docks, the Singer Building (*City of Ambition*), an airplane, a dirigible. These were intended to serve as a counterpoint to Marin's exuberant watercolors of New York that were hanging in the Armory Show (see plates 10 and 11).

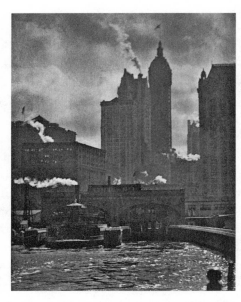

Alfred Stieglitz, *City of Ambition*, 1910. (Repro-photo Hervé Lewandowski, Musée d'Orsay, Paris. © RMN-Grand Palais/Art Resource, NY.)

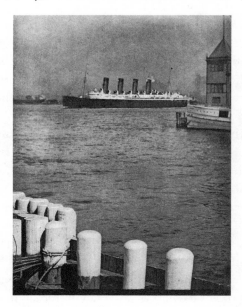

Alfred Stieglitz, *Outward Bound: The Mauretania*, 1910. (Alfred Stieglitz Collection, 1949. Image copyright © The Metropolitan Museum of Art. Image source: Art Resource, NY.)

But Stieglitz also displayed four Katwyck pictures and pictures made in the Tyrol in 1904, which could not have looked very modern or offered any meaningful counterpoint to the paintings in the Armory Show. In fact, this was a retrospective of twenty years' work: thirty prints demonstrating the length and depth of Stieglitz's career, including photographs as far back as the 1890s. Critics praised it accordingly. "If any worker with a camera might have claimed admission for his prints at the Salon of Independents it is Mr. Stieglitz," wrote one critic, noting also that the revolutionary work on view at the Armory Show had first been shown by Stieglitz at 291. "His liberality is a noble trait, and there is no better occasion than this one for offering it a public tribute."[21]

As he often did, Stieglitz was reminding people of the length and importance of his career at the same time that he was taking stock. The self-scrutiny started even before the Armory Show, in the 1911 "cubist issue" of *Camera Work*, which featured, along with texts by Bergson, De Casseres, and Hartmann about instinct and the unconscious and a piece about Max Weber's cubist paintings at 291, sixteen photographs by Stieglitz. By putting his own work into a context of cubism, Stieglitz tried to see how it measured up to that of the radical painters. If his photographic work was as modern as the most modern painting being done, on what grounds was it so? Because it was analytic, seeking form through intellect, as the cubists did? Or because it was intuitive, showing not things but the emotional response to things, as Kandinsky said art should do? It was a problem Stieglitz took a long time to think his way through, if he ever came to the end of it, but in the cubist issue of *Camera Work* he made a beginning.

What *is* modern? Well, New York is modern. He reproduces six of the 1910 images of the city: *City of Ambition, City Across the River, Ferry Boat, Outward Bound: The Mauretania, Lower Manhattan,* and *Old and New New York*—the last an image

of a skyscraper under construction next to a squat building of the past. In another section, he prints some of his finest urban images from even further back: *The Hand of Man*, *In the New York Central Yards*, *The Terminal*, and *Spring Showers*.

However modern the city may be in itself, the image of lower Manhattan he called *City of Ambition* is lushly romantic. Between the cloudy sky and the river at the bottom, the buildings become the visual equivalent of a mountain range. Smoke, clouds, and rippling water counter the skyline's square edges. But the part of Stieglitz that can't stop attacking American materialism gives this romantic piece an ambiguous title, just as he had with *The Hand of Man*. Neither the romanticism nor the moralism of *City of Ambition* is especially "modern," however, and finally Stieglitz realized that the subject of a picture was not the key to its modernity. Modernity lay in the *how*, not the *what*.

At this stage *The Steerage* became a crucial image to him, and he looked at it hard to identify the source of its strength. He printed it for the first time in that 1911 issue of *Camera Work*.

The Steerage leads off a selection of four images that have little in common except a strong lower-left to upper-right diagonal axis, a recurrent feature of Stieglitz's photographs that hardly makes them cubist. *Excavating New York* has some of the spatial complexity of *The Steerage*, but its stubby crane and the horse-drawn cart, intended to show the power of machinery, look quaint. Next in the series is *The Swimming Lesson*, a strange little snapshot of Kitty learning to swim at Lake George. Made in 1906, it seems anomalous in this series of scenes from urban life, and Stieglitz's persistence in singling it out—he also showed it in the 1913 retrospective—is intriguing. The last image, *The Pool—Deal*, features a municipal swimming pool, combining a mass of people and geometric structures—the diving board and slides—and resembles *The Steer-*

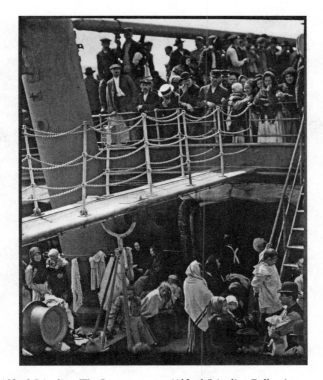

Alfred Stieglitz, *The Steerage*, 1907. (Alfred Stieglitz Collection, 1933. Image copyright © The Metropolitan Museum of Art. Image source: Art Resource, NY.)

age because of its architecture but lacks *The Steerage*'s emotional weight and visual density.

Stieglitz seems to think he is looking for one thing—the ways in which his work is "modern"—while he is actually finding his way to another—his future path. Oddly, the photograph that represents the future may well be the offbeat *Swimming Lesson*. The geometries of *The Steerage* will end up being marginal in Stieglitz's photographic career. Increasingly he abandoned intricate tableaux. The impulse to make "definitive statements," as Greenough puts it, gave way to more intuitive responses to the partial, fleeting, and haphazard.[22]

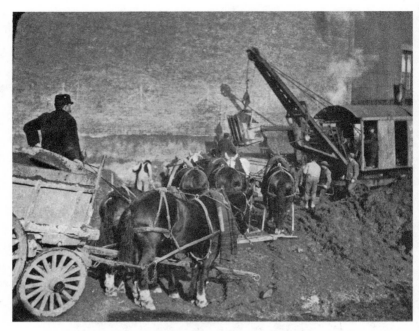

Alfred Stieglitz, *Excavating New York*, 1911. (Gift of A. Conger Goodyear. Digital Image © The Museum of Modern Art/Licensed by SCALA/Art Resource, NY.)

Alfred Stieglitz, *The Swimming Lesson*, 1906, printed 1911. (Gift of J. B. Neumann, 1958. Image copyright © The Metropolitan Museum of Art. Image source: Art Resource, NY.)

Alfred Stieglitz, *The Pool—Deal*, 1910. (Digital Image © The Museum of Modern Art/Licensed by SCALA/Art Resource, NY.)

Stieglitz acquired several pieces from the Armory Show for his personal collection. He seized the chance to buy the single Kandinsky that was on exhibit, *Improvisation #27* (see plate 12), along with a Cézanne lithograph, a sculpture by Manolo, and five Archipenko drawings. The Kandinsky, now one of the treasures of the Met, was too large to display at 291, and Stieglitz never got around to mounting the show of Kandinsky's work he wanted to. But I think it's clear why he liked it so much. Not only is it a rhythmic, musical arrangement of shapes expressing élan vital without much representation, it is also gloriously full of bright color, the one thing photography could not provide and that Stieglitz responded to deeply. Insofar as the Kandinsky has a subject, it is suggested by its other title, *The Garden of*

Love, and the barely discernible motifs of embracing couples, speaking of sex in a hidden way, also appealed to Stieglitz.

The sole American work he bought from the Armory Show was a pastel by Arthur B. Davies, and the purchase of this conventional piece was probably an elegant thank-you to Davies for organizing the extravaganza and a delicate gesture of the two men's friendship: the drawing, of Davies's mistress, was listed as "not for sale" (see plate 13).[23] The two works together, the Kandinsky painting and the Davies pastel, mark the range of the Armory Show and give some idea of how shocking the abstract European works must have seemed alongside the American works. They may also suggest how sexually needy Stieglitz was feeling.

Neediness of another sort prompted Stieglitz to ask his friends to say what 291 meant to them and to publish their replies in a special "What Is 291?" issue of *Camera Work*. His energy for the gallery enterprise was flagging. As the years went by, there were not as many visitors as there had been. "I sat in my room thinking, weighing, what had been done during the year! Had anything been done?" He got sixty-eight replies to his call for reassurance, from, among others, Man Ray, Marin, Picabia, Hartley, Steichen, Mabel Dodge, Djuna Barnes, his secretary, and the elevator operator at 291. Most of them provided high-flying tributes. But Steichen let him have it.

He found Stieglitz's request "impertinent, egoistic, and previous" (by previous, he meant "premature") These tributes Stieglitz had solicited seemed funereal, more appropriate for an end than a beginning. He could not imagine why 291 had spent time on such a project except that it had nothing better to do—the gallery had been marking time for a year or two, accomplishing nothing. Steichen found this all the more egregious at such a grave historical moment (he was writing just after August 1914).[24] The European war posed a direct chal-

lenge to art and artists—what was the point of art in the midst of such a cataclysm? how could artists help win the war?—and 291 was unresponsive. To Stieglitz's credit, he published what he received exactly as written.

Any hope of new beginnings in the realm of art, as in every area of Western civilization, was suddenly and totally destroyed in the summer of 1914 by the outbreak of war in Europe. Many people had felt that a new era was on the horizon and the world about to change, but none imagined it would change in such a catastrophic way, throwing away millions of lives, destroying the youth of France, England, and Germany. The fury and disillusionment were extreme.

Steichen himself had to abandon his house outside Paris, his beloved flower beds, his glass plate negatives, and flee with his wife and daughters just ahead of the German advance.

If, from one point of view, the war made art peripheral, to some artists it made art seem even more essential. Fine sentiments, flowery rhetoric, overblown prose, phrases like "the war to end all wars" and "making the world safe for democracy," juxtaposed with the butchery on the battlefields, made for an impulse toward simplicity and clarity and a feeling that only artists told the truth: politicians and statesmen covered up and lied. Still, from a practical point of view, it was not an encouraging time for either artists or gallery owners.

Some of the people closest to Stieglitz—Agnes Meyer, Marius de Zayas, and Paul Haviland—thought that the problem was with Stieglitz, his haphazard, unbusinesslike way of running a gallery and the fustiness of his instincts as a magazine publisher. They thought they could do better by Stieglitz's artists with a frankly commercial approach, allowing people to buy pieces without having to negotiate Stieglitz's personality. Financed by Eugene Meyer, they opened the Modern Gallery as a more commercial adjunct to 291. At first Stieglitz gave the project his blessing, but increasingly he felt a sense of betrayal.

They also started publishing an elegant magazine called, in homage to Stieglitz, *291*, but intended to be edgier than *Camera Work*, whose subscription list had shrunk from a thousand people to thirty-seven. Both the breakaway enterprises floundered, but not before they helped make Stieglitz feel like a back number.

World War I changed everything for Stieglitz. With his love of Germany and German culture, it was like losing family. And Stieglitz's sympathy for Germany caused a final divide between him and Steichen, who was passionately pro-French and just as passionately anti-German. When America entered the war in 1917, Steichen joined the Signal Corps and put his photographic skills to use refining aerial photography. He showed up at 291 in a uniform, making Stieglitz feel obsolete. He had been suggested for work with a photographic unit but was considered too erratic and, at over fifty, way too old. From the windows of 291, he watched the military parades on Fifth Avenue in despair. Americans, it seemed to him, were using war for excitement when they should be getting their excitement from Matisse.

At this time of greatest tension between them, Stieglitz devoted an entire issue of *Camera Work* to Steichen. His magnificent photographs were reproduced in photogravure of the highest quality. In every way, the glorious issue was a gift from Stieglitz to Steichen. He even printed a poem by Steichen's eight-year-old daughter Mary. But it was a farewell gift. The Stieglitz critical chorus began to relegate Steichen to the past, with "pictorial" or artistic photography. Stieglitz was enthroned with Picasso and Braque, artists of the future. In the words of de Zayas, Stieglitz was "trying to do, synthetically, with the means of a mechanical process, what some of the most advanced artists of the modern movement are trying to do analytically with the means of Art."[25]

World War I brought some French artists to New York,

including Picabia, Albert Gleizes, and Marcel Duchamp. Duchamp was unfit for service because of health issues. Gleizes and Picabia had families able to get them exempted from service, either by financial clout or political pull. Paul Haviland served as translator when necessary, until he himself returned to France.

Picabia and his wife, Gabrielle Buffet, were a dazzling couple, intellectual and stylish, full of the joy of life. They had met Stieglitz at the time of the Armory Show, but during the war they became particularly close to him. Stieglitz liked Duchamp, too, although Duchamp, who arrived in 1915, preferred to spend his time in New York with the more playful Walter and Louise Arensberg, whose apartment he lived in, and Mabel Dodge, the free-spirited heiress. The French brought with them, among other things, a mélange of left-wing politics and iconoclastic thought that appealed to Stieglitz, who had always been something of an anarchist temperamentally. Although his relationship to Dada is complex, in general he welcomed the spirit the French Dadaists introduced into the New York art world.

In 1917 Duchamp registered for a large open exhibition, a kind of sequel to the Armory Show. Under the name of Richard Mutt, he paid the entry fee of $6 and submitted a urinal he had bought from a plumbing supply store. When the exhibition overseers refused to include Duchamp's sculpture, which has since gained the reputation of being the beginning of conceptual art and one of the most significant works of art of the twentieth century, Stieglitz put it on display at 291 and photographed it brilliantly. Conveying the urinal's sumptuousness, he underlined Duchamp's conceptualist point about beauty and the readymade. But he also understood Dadaist antiestablishment and antiwar energies and signaled this by placing the urinal in front of one of Marsden Hartley's military celebrations, *The Warriors*. Stieglitz was no doubt amused by the way the

Alfred Stieglitz, *Duchamp's "Fountain by R. Mutt,"* 1917. (*Blind Man*, May 1917. Image provided by The Metropolitan Museum of Art, New York, Thomas J. Watson Library.)

Marsden Hartley, *The Warriors*, 1913. (Private Collection, Boston. Installation Photograph, *Marsden Hartley, The German Paintings 1913–1915*, Los Angeles County Museum of Art, February 04, 2017–April 30, 2017, photo © Museum Associates/LACMA.)

urinal echoed the central shape in the painting, which itself echoed the shape of a German officer's helmet.[26]

In a series of portraits Stieglitz made of O'Keeffe's friend Dorothy True, trying something different from head shots, he focused on her lower leg. A double exposure resulted in her face being superimposed on her calf, and as soon as Stieglitz saw it, he loved this surrealist work, appropriately the product of accident. Stieglitz's later photograph of the hindquarters of a gelded stallion also seems jazzy and new, akin to the loving close-ups of body parts he would do of O'Keeffe. Called *Spiritual America*, the photograph's title leads off in a different direction, however, in that split typical of Stieglitz, his mind leading him toward ponderous irony, his eye responding to offbeat interest.

Some of the best photographs Stieglitz did in the years before and during World War I are the portraits he made of his artists, showing the extent to which they were the focus of his creativity: the out-of-body gaze of Marsden Hartley, the playful off-centeredness of John Marin, the thought-out elegance of Picabia. Distinctive in their matter-of-factness, filled with telling detail, focused close on the face, often with a fragment of the artist's work creating an abstract background, they reflect, according to the great photography critic John Szarkowski, "a new taste for factuality." Before this, the taste in portraits, as perfected by Steichen, was for "disembodied heads" in a "sea of gloom, thought to be reminiscent of Rembrandt."[27] In Stieglitz's portraits, every space and every detail counts.

With the war on and civilization disintegrating, Stieglitz had few steady buyers at 291, and sales were severely off, but worst of all, from a financial point of view, food restrictions went into effect after the United States entered the war, followed by limits on the strength of beer and the amount of it that could be produced. Beer, being German, was especially targeted. This hurt Emmy's family brewery, the source of her

Alfred Stieglitz, *Dorothy True*, 1919. (Alfred Stieglitz Collection, 1949. The Art Institute of Chicago/Art Resource, NY.)

Alfred Stieglitz, *Spiritual America*, 1923. (Alfred Stieglitz Collection, 1949. Image copyright © The Metropolitan Museum of Art. Image source: Art Resource, NY.)

Alfred Stieglitz, *Marsden Hartley*, 1916. (Digital Image © The Museum of Modern Art/Licensed by SCALA/Art Resource, NY.)

Alfred Stieglitz, *John Marin*, 1921. (Gift of Edward Steichen. Digital Image © The Museum of Modern Art/Licensed by SCALA/Art Resource, NY.)

Alfred Stieglitz, *Francis Picabia*, 1915. (Alfred Stieglitz Collection, 1949. © Board of Trustees, National Gallery of Art, Washington.)

income and, by anyone's accounting but Stieglitz's, his as well. Only magical thinking supported Alfred's belief that he never used a penny of Emmy's money on his own art, the gallery, or his collections. Without Emmy paying all the household bills, he would not have had a penny of his own to spend. After the cut in her income, Stieglitz could no longer afford to keep living as he had been.

He gave up the lease on the gallery. There was a new group of young acolytes around him now, including Paul Strand, Emil Zoler, a painter, and the writers Waldo Frank and Paul Rosenfeld, and they helped him with the physical emptying out of 291. He wanted to leave scorched earth behind. He tore out the shelves, ripped the burlap from the walls, demolished the walls that created the inner room. No one would be able to use the space as a gallery again. This was a holy place to Stieglitz, and he would not see the space desecrated as a commercial gallery.

He took a small room in the same building to serve as an

office and meeting place for friends. The Tomb, as he called it, could hold at the most eight people at a time, packed in. He needed a place where he could hold forth; talking had become his life. Here, too, he moved some back copies of *Camera Work* and other things that were precious to him. He was able to store his books in the basement of his friend Mitchell Kennerley's Anderson Galleries, an auction house in a splendid building at the corner of Park and 59th Street. When he cleared out 291, there were thousands of magazines left, issues of both *Camera Work* and *291*, which he could find no one to buy at any appropriate price.[28] He finally sold them to a ragpicker for $5.80 and gave the money to his secretary, Marie Rapp, to buy a new pair of gloves.

Divorcing him finally from Germany, the war forced Stieglitz to focus his attention on America itself, not on how or what Europe and European art could do for America, but on what was American about American art. The question "What is modern?" metamorphosed into the question "What is American?"[29] By the end of the war, Stieglitz needed to remake his life again. His photographic work had tapered off when he founded 291, but ahead of him lay the most fruitful phase of his photographic career, twenty years of extraordinary creativity. Essential to the next stage of his life and of his work were Georgia O'Keeffe and Paul Strand. But his direction was set before they ever entered his life: he wanted to de-stylize his photography, to rid it of the last vestiges of the sentimental and pictorial. He wanted an American photography—fact-based, detailed, incorporating new energies—and he wanted a distinctively American art.

His work as a gallerist now came to focus on a core of American artists—the painters Hartley, Dove, Marin, and O'Keeffe, and himself and Strand, the photographers. He took on O'Keeffe and Strand in 1916. He folded both 291 and *Cam-*

era Work in 1917, but he could not abandon his mission and opened another little gallery, which he called the Intimate Gallery, or the Room, in 1925. In 1929, in its final incarnation, his gallery got the mock-humble combative name that only Stieglitz could have conjured up, An American Place.

Plate 1. *Lovebirds*. (Image © JerryWay. Image source: Dreamstime.)

Plate 1a. *Lovebirds*, approximating black and white of early emulsions.

Plate 2. Alfred Stieglitz, *The Last Load*, 1890, printed in color by the Photochrome Engraving Company. (*American Amateur Photographer*, January 1894: frontispiece. Image provided by The Metropolitan Museum of Art, New York, Thomas J. Watson Library.)

Plate 3. The Photochrome Engraving Company, *Photographic Reproduction from Nature*. (*American Amateur Photographer*, December 1894: 536. Image provided by The Metropolitan Museum of Art, New York, Thomas J. Watson Library.)

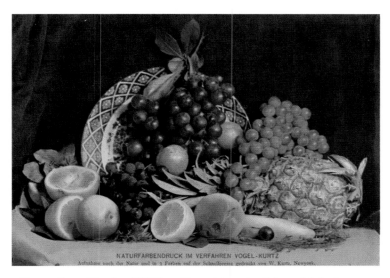

NATURFARBENDRUCK IM VERFAHREN VOGEL-KURTZ
Aufnahme nach der Natur und in 3 Farben auf der Schnellpresse gedruckt von W. Kurtz, Newyork.

Plate 4. Ernst Vogel and William Kurtz, *Example of Natural Color Printing*. (*Photographische Mitteilungen*, January 1893, reprinted in Hermann Wilhelm Vogel, *Das Licht im Dienste der Photographie* [Berlin 1894]. Image source: Princeton University Library.)

Plate 5. Alfred Stieglitz, *Frank Eugene at Tutzing*, 1907. (Alfred Stieglitz/Georgia O'Keeffe Archive, Yale Collection of American Literature, Beinecke Rare Book and Manuscript Library. © Yale University. All rights reserved.)

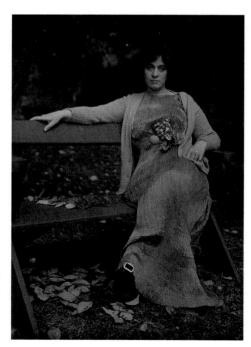

Plate 6. Alfred Stieglitz, *Mrs. Selma Schubart*, 1907. (Alfred Stieglitz Collection, 1955. Image copyright © The Metropolitan Museum of Art. Image source: Art Resource, NY.)

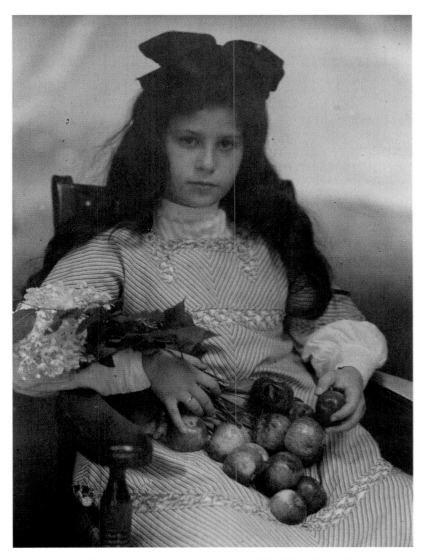

Plate 7. Alfred Stieglitz, *Kitty Stieglitz*, 1907. (Alfred Stieglitz Collection, 1952. The Art Institute of Chicago/Art Resource, NY.)

Plate 8. Max Weber, *Athletic Contest*, 1915. (George A. Hearn Fund, 1967. Image copyright © The Metropolitan Museum of Art. Image source: Art Resource, NY. © Estate of Max Weber, in Memory of Joy Weber.)

Plate 9. Marsden Hartley, *Portrait of a German Officer*, 1914. (Alfred Stieglitz Collection, 1949. Image copyright © The Metropolitan Museum of Art. Image source: Art Resource, NY.)

Plate 10. John Marin, *Brooklyn Bridge*, 1912 (Alfred Stieglitz Collection, 1949. Image copyright © The Metropolitan Museum of Art. Image source: Art Resource, NY.)

Plate 11. John Marin, *St. Paul's, Manhattan*, 1914. (Alfred Stieglitz Collection, 1949. Image copyright © The Metropolitan Museum of Art. Image source: Art Resource, NY. © 2018 Artists Rights Society [ARS], New York.)

Plate 12. Wassily Kandinsky, *The Garden of Love (Improvisation #27)*, 1912. (Alfred Stieglitz Collection, 1949. Image copyright © The Metropolitan Museum of Art. Image source: Art Resource, NY. © 2018 Artists Rights Society [ARS], New York.)

Plate 13. Arthur B. Davies, *Reclining Woman*, 1913. (Alfred Stieglitz Collection, 1949. Image copyright © The Metropolitan Museum of Art. Image source: Art Resource, NY.)

5

The Man Behind the Woman

In 1915 Alfred Stieglitz was America's best-known and most-respected photographer and a powerful figure in the art world. He had been famous for a lifetime, but he had not yet, at the age of fifty-one, even met the person who brought him new life, inspiring his art and joining him in a partnership that became legendary. In 1915 Georgia O'Keeffe of Wisconsin and Virginia was in New York, getting certified to teach art at Teachers College of Columbia University. It was her second stay in the city. During the first, in 1908, she worked at the Art Students League with the great William Merritt Chase. She went to 291 with classmates to see the Rodin show but abstained from the popular sport of conversing with Stieglitz. She went back several times to Stieglitz's gallery, but always quietly, to look at the art. She left New York and moved to the South to earn her living as a teacher without registering on the famous man.

The shows at 291 were part of the education of art students in New York in those years. To see Stieglitz through the eyes of these students is to see him at his best. Their regular teachers gave them prudent instruction, but Stieglitz infused them with spirit, making them believe in Art (with a capital A) and in themselves as artists. "He's a great man Pat," one art student wrote to another after a visit to Stieglitz in 1915, "and it does me good to breathe his air for a little while. . . . He has the right stuff & I tell you when I left . . . I felt like I counted & could do something, & if I didn't I had only my self to blame."[1]

The "Pat" of this letter is Georgia O'Keeffe, called Patsy by a few of her New York school friends in a nod to her Irishness. The writer is Anita Pollitzer, a classmate at Teachers College, seven years her junior, who began a correspondence with her when Georgia left New York to teach at a Methodist training school in South Carolina. Anita, more outgoing than Georgia, had no problem addressing herself directly to Stieglitz during visits to his gallery, and she made herself familiar to him.

It's hard to say whose letters are more loveable, O'Keeffe's or Pollitzer's. They are both so full of life, so unstudied, frank, and youthful, savoring whatever comes their way. They write each other every few days, as people did then, when postage was cheap, delivery quick, and other options for long-distance communication nonexistent. They encourage each other to keep at their work. They urge each other through tedium (life in the boonies for Georgia, a required course in mechanical drawing for Anita) and buck each other up in the face of intimidation. They discuss the purpose of art. Anita believes it is self-expression—"to live on paper what we're living in our hearts and heads." Georgia responds wryly, "I don't know that my head or heart or anything in me is worth living on paper," and "We ought to be as busy making ourselves wonderful— according to your theory—as we are with expressing the self."[2] But she is saying that just for the sake of argument. She, too,

wants to believe that lines and colors can express inner states, and that this is art's purpose.

Only when Georgia falls in love with a professor of political science at the University of Virginia, Arthur Macmahon, does she go silent. It's an experience she cannot talk about, for it verges on the "slushy," a word she uses to hold emotional experience at a distance. You might think that this young woman, nearly thirty, almost a spinster, would be desperate for love, but she isn't. On the contrary, she distrusts strong emotion. "You wear out the most precious things you have by letting your emotions and feelings run riot." Love threatens the clear-mindedness O'Keeffe values above everything. "I almost want to say—don't mention loving anyone to me. It is a curious thing—don't let it get you Anita if you value your peace of mind—it will eat you up and swallow you whole."[3] Always wary, always protecting herself, O'Keeffe thrust an uncompromising face at the world, nothing girlish in her looks, nothing feminine in her attire, her hair pulled back tight, her clothes uncolorful, her feet literally on the ground in flat shoes.

But all the while, Anita, an innocent and unwitting pander, is preparing her for Stieglitz and Stieglitz for O'Keeffe. She mentions Stieglitz repeatedly in her letters to O'Keeffe: "a great man he," "always something new there—always an idea." She took her physician brother on a tour of New York galleries and ended with 291. "Stieglitz was great! He talked a blue streak & his hair was extra bushy!" She also talks about O'Keeffe to Stieglitz: her friend in the wilderness, a great talent forced to work in the most sterile of circumstances. "Pat I told him where you were & that I hated you to be there & he said—'When she gets her money—she'll do Art with it—and if she'll get anywhere—its worth going to Hell to get there.'" Naturally, O'Keeffe thinks Stieglitz is the ultimate arbiter of talent. "Anita—do you know—I believe I would rather have Stieglitz like something—anything I had done—than anyone

else I know of—I have always thought that—If I ever make any thing that satisfies me even ever so little—I am going to show it to him to find out if it's any good."[4]

Nothing she made satisfied her until 1915, when the utter tedium of her life in South Carolina forced her to focus on her work. It evolved quickly from derivative, tasteful, beautifully composed student work to unusual abstractions. She expressed herself in a vocabulary of circles and ovals, swirls and tendrils, ripples, waves, and jagged lines that had nothing to do with representation, inspired by Arthur Dove, whose work she had seen reproduced in a book about cubism, and by Arthur Wesley Dow's Japanese aesthetics. At first she was crazy about color and worked in pastel. Then she rejected color entirely and worked in charcoal on big pieces of paper. Content with what she had accomplished, she rolled some of these drawings up and sent them to Pollitzer in New York.

Pollitzer saw the excellence of the work and, acting on O'Keeffe's almost subliminal instructions, took the drawings to Stieglitz. It was New Year's Day 1916, Stieglitz's fifty-second birthday. Pollitzer took the bundle with her first to a matinee of *Peter Pan* and then to 291, where Stieglitz, despite its being New Year's Day and his birthday, was conducting business as usual. He invited her into the decorator's office at the back of the gallery and spread the drawings out on the counter. "Why these are genuinely fine things," he said. "You say a woman did these? She's an unusual woman. She's broad-minded. She's bigger than most women, but she's got the sensitive emotion. I'd know she was a woman. Look at that line." He called one of the gallery regulars, the painter Abraham Walkowitz, to look at them, and Walkowitz, too, according to Pollitzer, was impressed. They spent a while with the drawings, then Stieglitz said, "Are you writing to this girl soon?" and Pollitzer said yes. "'Well tell her,' he said, 'they're the purest, finest, sincerest things that have entered 291 in a long while.'" He gave the

drawings back to Pollitzer before she left but also said he might be willing to show them at 291.

Stieglitz's enthusiasm, reported by Pollitzer, raised O'Keeffe's spirits and gave her faith in what she was doing, but she wanted to hear more exactly what it was he liked in her drawings. She was suffering the insecurity of all abstract artists: did abstract forms really convey a personal meaning? What feelings was she communicating? Although she wrote to Stieglitz directly and asked this, he could reply only that her drawings were surprising and delightful. When he ran into Anita Pollitzer on the street, he told her that he felt he had failed O'Keeffe: "I have to talk to people. Letters don't do it."[5]

In the spring of 1916, Stieglitz asked for the drawings back from Pollitzer and without consulting O'Keeffe, assuming she would be thrilled, showed them at 291 along with the work of two other young artists, Charles Duncan and René Lafferty. If the story Stieglitz told in later life is true, she came into the gallery that spring, identified herself as the artist, and demanded that the work be taken down. He refused: "You have no more right to withhold these pictures than to withdraw a child from the world, had you given birth to one."[6] Perhaps the only person in Stieglitz's experience *not* to be eager for a show at 291, she aroused his interest. As for her, how can you resist a man who tells you that the world has a right to see your work? She was muted and self-contained by nature: Stieglitz was a born bullhorn waiting for a cause.

Recent scholarship sees in the charcoal drawings of 1915 O'Keeffe's establishing a personal abstract style on the basis of a decorative arts sensibility.[7] The curving, swelling, bending, wavelike forms of the charcoals derive from organic forms like ferns, which had become stylized art nouveau motifs. Guided by Stieglitz, people saw them as unmediated products of some female essence and were shocked by their sexuality. Stieglitz's publicity machine—the statements he arranged in the press,

the things he himself said in *Camera Work*, his on-the-spot lectures at the gallery and those of his understudies—shaped this reception. When he introduced O'Keeffe to the readers of *Camera Work*, he said that her drawings, "besides their other value, were of intense interest from a psychoanalytic point of view." That was code for their being about sex, and he underlined the connection, writing that he had "never before seen [a] woman express herself so frankly on paper." The phrase "Finally. A woman on paper" became mythic.[8] Stieglitz and his circle always attached it after the fact to the moment when he saw O'Keeffe's work for the first time.

Stieglitz had been trying to find a woman on paper for a long time. There was Pamela Colman Smith, whose show had opened 291, and, closer to his heart, there was Katharine Rhoades. Rhoades was the friend of Agnes Meyer and Marion Beckett—all three stunning women, known at 291 as the Three Graces. Rhoades was the daughter of a banker, an Upper East Sider, a Brearley graduate, and socially of the same class as Stieglitz, although not Jewish. She painted portraits in a post-impressionist style like that of Arthur Carles or of the English Bloomsbury group. Her work was competent but not daring and original. Still, Stieglitz gave her and Marion Beckett a show at 291 in early 1915. For a year he had been trying to get Rhoades to go to bed with him.[9]

It was the beginning of the D. H. Lawrence years, a period of radical change in middle-class sexual behavior, in many ways a time of liberation for women—and in some ways, a time of new demands. People wrote about the importance of sex, equating it with the élan vital that Bergson had celebrated. In the modern estimation, Freud, with his scientific background and tragic view, is the most important of the sexologists, but from the 1890s on, Havelock Ellis, with his *Studies in the Psychology of Sex*, and Edward Carpenter, another Englishman, put

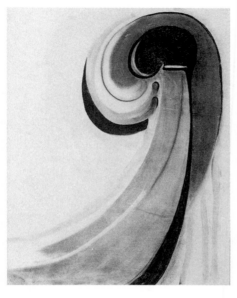

Georgia O'Keeffe, *Early Abstraction*, 1915. (Gift of Jane Bradley Pettit Foundation and the Georgia O'Keeffe Foundation. Photographer credit: Malcolm Varon, © Milwaukee Art Museum. © 2018 The Georgia O'Keeffe Foundation/ Artists Rights Society [ARS], New York.)

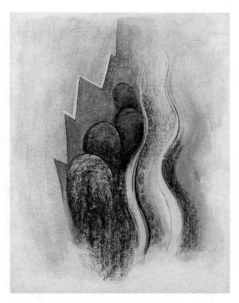

Georgia O'Keeffe, *Drawing XIII*, 1915. (Alfred Stieglitz Collection, 1950. Image copyright © The Metropolitan Museum of Art. Image source: Art Resource, NY. © 2018 The Georgia O'Keeffe Foundation/ Artists Rights Society [ARS], New York.)

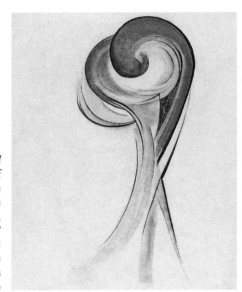

Georgia O'Keeffe, *Special #12*, 1916. (Gift of The Georgia O'Keeffe Foundation. Digital Image © The Museum of Modern Art/Licensed by SCALA/ Art Resource, NY. © 2018 The Georgia O'Keeffe Foundation/Artists Rights Society [ARS], New York.)

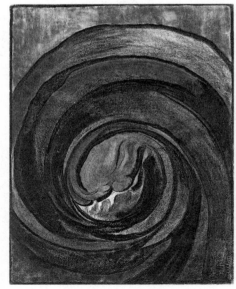

Georgia O'Keeffe, *No. 8— Special (Drawing No. 8)*, 1916. (Whitney Museum of American Art, New York, purchased with funds from the Mr. and Mrs. Arthur G. Altschul Purchase Fund 85.52. © 2018 The Georgia O'Keeffe Foundation/ Artists Rights Society [ARS], New York.)

sexual energy at the heart of human activity for a wider audience.

Stieglitz read the sexologists and welcomed the idea that creativity and sexuality were allied. *Love's Coming of Age* by Carpenter would have touched him to the quick in asserting that the useless, frivolous, consumerist middle-class "lady" was a symptom of the disease of civilization. The emptiness of his marriage to Emmy, therefore, was neither his fault nor hers. Western commercial civilization was the villain.

Ellis held that women had strong sexual urges and deserved to be sexually fulfilled; it was the job of the male lover to satisfy them, which Stieglitz was also happy to hear. He tried to tutor Katharine Rhoades in the new thinking, pressuring her to "give" and "open up." He wanted "absolute frankness—no repression."[10] To open up would prove her womanliness, her strength of feeling, and her creativity, and to do so would feed that creativity as well. But Rhoades said no, insisting on autonomy, although it made her feel miserable and inadequate.[11] Much later Stieglitz would tell a confidante that if he had been a real man—which, he said, he wasn't—if he had been six feet tall, all strength and sinew, he would have "carried Rhoades off to some mountain top, built them a little house, given her children, and let her paint."[12] In retrospect, he believed that Rhoades had prepared him for O'Keeffe. It's more accurate to say that Rhoades was his first try at creating a woman artist.

He had to find a woman capable of becoming mythic, and O'Keeffe proved to be exactly what he needed. In no way bourgeois in her tastes and desires, non-Jewish like Rhoades but more radical, less tainted by New York, she was completely Other to Stieglitz. Her style was midwestern, her clothes austere and androgynous. Self-reliant, strong-minded, tart and snappy, she was the free American Girl who had never been to Europe and had no interest in going there. Although she looked like the provincial schoolteacher she was and might

have remained, Stieglitz found her sexy in her person and sexy in her art.

Stieglitz and O'Keeffe began an intense correspondence when she moved to Canyon, Texas, from South Carolina for a better teaching job, but it was not yet a love affair. He was still pursuing Katharine Rhoades, and O'Keeffe had several boyfriends, including Arthur Macmahon, the professor, and a Texan named Ted Reid, a former student eight years her junior who was eager to marry her. She was also deeply attracted to Stieglitz's newest protégé, the photographer Paul Strand, three years younger than herself, whom she met in the spring of 1917 when she went to New York on a whirlwind trip. She and her art school friend Dorothy True visited 291 and there encountered Strand. She and Dorothy both "fell for him," she reported to Anita. He showed O'Keeffe lots of his photographs, and "I almost lost my mind over them."[13]

Stieglitz had taken up Strand as quickly and with as much determination as he had O'Keeffe. He was a New York boy from a Jewish family who had been educated at the Ethical Culture School on the Upper West Side, where Lewis Hine, the great documentary photographer, taught him photography and first brought him, on a field trip in 1907, to see a Photo-Secession show at 291, setting his life's course. In 1915, when Strand was twenty-five, he brought Stieglitz a portfolio of his work, and Stieglitz encouraged him to an extent that almost embarrassed Strand. The early work he showed Stieglitz and that Stieglitz showed at 291 in the spring of 1916 was, according to Sarah Greenough, nothing special—mere pictorialist prettiness, if marked by an especially fine sense of composition. "I started with a soft focus lens," Strand later reported, "and Stieglitz was very helpful in showing me that I was destroying the individual qualities of the life of things I was photographing." Water looked like grass and grass looked like tree bark.[14] Taking Stieglitz's advice, Strand changed the lens opening he

routinely shot with so as to produce more clarity and depth of field in his prints and lose the pictorialist look.

In the summer and fall of 1916, at his parents' house in Connecticut, Strand made a revolutionary series of images of everyday objects—a table on the porch, bowls from the kitchen—arranged and lit so as to de-emphasize the object and create an abstract pattern, playing with space and dimensionality. The images were at once literal and nonrepresentational, a fulfillment of Stieglitz's dream of having photography match what was newest in painting. These were probably the prints O'Keeffe saw and lost her mind over in the spring of 1917. She described them to Pollitzer as "photographs that are as queer in shapes as Picasso drawings."[15] They made such an impression on her that, as she made her way back to Texas, she wrote to Strand that she was seeing things as she thought he might photograph them.[16] Strand's work seems to have shown to both O'Keeffe and Stieglitz, among other things, the abstracting potential of the close-up.

When Stieglitz showed Strand's work in March 1916 at 291, it was the first time he had hung photographs in the gallery since his own retrospective at the time of the Armory Show in 1913. No photographs had been shown in all that time, Stieglitz announced in *Camera Work*, "because '291' knew of no work outside of Paul Strand's which was worthy of '291.'"[17] He also devoted *Camera Work*'s last issue to Strand, again anointing his heir. Partly under the influence of this new ally, his own work changed. He stopped waiting for scenes to compose themselves and began to cut pieces from the flow of time, whether of the city or the sky or a woman's body. In this sense *The Swimming Lesson*, that snapshot of Kitty in Lake George that meant so much to him, presaged the future.

On the spur of the moment, O'Keeffe came from Texas to New York in the spring of 1917 to see her first one-person show at 291. This was the flying visit on which she met Strand,

and it was the last show at 291 before it closed for good. Stieglitz had already taken the show down when she reached New York, but he rehung everything for her. He also photographed her. These first images in what would turn into a twenty-year project were comparable to the ones he made of his other artists, Marin, Hartley, Walkowitz, Dove, and Picabia—the foreground the face, the background the work. He photographed her in front of one of her large watercolors in a prim black dress with a white organdy collar, with hat and without hat, and made three close-ups of her hands.

The hands were something new. When he sent prints to her, she was astonished and showed them to her students at the West Texas Normal School. They had never seen anything like them, portraits in which the part, if not expected to stand for the whole, was all you got, and the human body became a subject for abstraction.

That summer and into the fall and the new year of 1918, O'Keeffe kept up an intense correspondence with both Strand and Stieglitz. She was attracted to both. To Stieglitz she wrote, "When I finished your letter this morning—I banged it down on my desk in the office—. . . And what I said to myself was "GOSH BUT I LIKE HIM."[18] She said to Strand, adopting Stieglitz's way of talking about himself, "291 having come into a person's life makes one wonder how on earth the folks who haven't known it have been able to grow up." But, lest he be hurt, she assured the younger man, "You are great too."[19] Her correspondence with Strand has a touch of secrecy and guilt about it. She doesn't want Stieglitz to know how close she is getting to Strand. Her sense of primary obligation is to Stieglitz, her desire to keep him thinking he is at the center of her world, as she is increasingly in his. To Stieglitz she wrote, "You are more the size of the plains than most folks." To Strand, "You pull me in spite of myself."[20]

With 291 now closed and *Camera Work* no longer in exis-

Alfred Stieglitz, *Georgia O'Keeffe at 291: A Portrait*, June 4, 1917.
Platinum print, 9 5/8 × 7 5/8 in. (The J. Paul Getty Museum, Los Angeles.
© J. Paul Getty Trust.)

Alfred Stieglitz, *Georgia O'Keeffe—Hands*, 1917. (Gift of Georgia O'Keeffe, through the generosity of The Georgia O'Keeffe Foundation and Jennifer and Joseph Duke, 1997. Image copyright © The Metropolitan Museum of Art. Image source: Art Resource, NY.)

tence, Stieglitz had the time to rededicate himself to photography, but he did not. He spent the days talking and writing letters. From May 1917 to May 1918, he threw himself into the correspondence with O'Keeffe. The letters poured out every day, spontaneous, immense—once a letter of forty pages. The postmaster in Texas asked Leah Harris, a friend with whom O'Keeffe stayed for a while, who was sending her so many fat letters. Leah told him they were bills.

The imaginative component so important in a great romance was in the case of Stieglitz and O'Keeffe fueled by distance and the disconnect from conventional conversation that letter writing provided. Stieglitz was developing his idea of her, nourishing fantasies of what he could do for her and she could do for him, as people in love will do, making ever more symbolic the commitment to each other and the break from the past their union would represent. With Kitty about to go to college, Stieglitz could begin to imagine a future without Emmy, to summon his will to leave her, and to fabricate a dream of the relationship that would replace it.

His growing obsession with O'Keeffe expressed itself in a fetishizing of her work. He mounted some of her watercolors on black paper and actually carried them around with him. One evening, spent with Marsden Hartley, Paul Strand, and Donald Davidson, he took O'Keeffe's work to dinner and to the theater, where he placed it at his feet. He showed the work to people in his tiny office as a mark of special favor. Hartley called this intense engagement with O'Keeffe's art "Stieglitz's Celestial Solitaire."[21]

In the spring of 1918, Stieglitz began to worry about O'Keeffe's health. She was sick, and the catastrophic postwar flu epidemic had started to kill people with terrifying swiftness. Whether O'Keeffe had the flu or the onset of tuberculosis, from which her mother had died, or something else entirely was unclear to her friends. Fearing for her life, Stieglitz wanted

her to come to New York for medical attention. She had become central him, central to his vision of American art. "I want her to live. I never wanted anything as much as that. She is the spirit of '291'—not I," he wrote to Strand.[22]

Although Stieglitz wanted O'Keeffe to give up teaching and move to New York, he refused to say he would support her, either out of delicacy, not wanting to seem to be asking her to allow herself to be kept, or out of his deep fear of taking on responsibility for a woman. He found allies in his niece Elizabeth, Lee's daughter, who had become O'Keeffe's pen pal, and, bizarrely, in Paul Strand. Someone had to go to Texas and bring her back, and it couldn't be Stieglitz himself, who was— of all the obstacles to romance—on jury duty. Like King Marke sending Tristan to bring him Isolde, Stieglitz sent Strand.

Strand, however, was no Tristan. After spending day after day with O'Keeffe, he irritated her with his slowness, indecisiveness, and ineffectuality. This was not what she wanted in a man.

O'Keeffe had always supported herself, and she worried about how she could earn a living in New York. Strand reported this to Stieglitz, who continued to insist that it had to be her decision, meaning he would promise nothing. He instructed Strand to tell O'Keeffe that she should come only if she felt she must, "for no particular reason, expecting nothing, hoping for nothing, just coming. Whatever happens then will happen naturally."[23] To her he wrote, "I know you are a woman. First & always. I know you need a home, a child. Those take a man to give you. I am not a man. That's my curse. . . . I do not know how to be part of the big game."[24] But thanks to his niece Elizabeth and his brother Lee he could offer her a place to live, Elizabeth's two-room painting studio on the top floor of a brownstone on 59th Street between Park and Lexington Avenues.

Finally, bravely, O'Keeffe decided to take the leap. She gave

up her job with no assurances of support from Stieglitz—merely his belief in her as an artist. Strand escorted her back to New York, and soon after she got there, Stieglitz told her that he would support her for a year so she could paint. He installed her in the studio on East 59th Street. It was tiny but it had good light from windows and a skylight. The walls were painted yellow and the floor was orange, odd for a studio, but O'Keeffe found it cheerful. The bathroom was across the hall, shared with the landlady and her family; the small dark back room had a basin for washing. O'Keeffe put the bed under the skylight so she could look at the stars at night.

She and Stieglitz were now madly in love. They spent rapturous time together, although they were not yet lovers. He made love to her with his camera and she made love to him by allowing herself to be seen and photographed naked. When Strand stayed with her in Texas, he had asked her to pose nude and she had said no.[25] But she said yes to Stieglitz. She believed in him both as a photographer and as a creator of creators. "The trust I have in you is the finest thing I've ever known. . . . The woman you are making seems to have gone far beyond me."[26] He began to generate the series of photographs of O'Keeffe that are among his greatest works.

Breaking all conventions of portraying nudes, he focused on sections of her body, the neck, the torso, and especially the hands, never arranging the whole into an expected pose, but surprising the viewer in some way with every shot. The Portrait of O'Keeffe series eventually grew to consist of over three hundred images made over the course of twenty years. The majority, however, were made at the start of their love affair, in their first two years together—ninety-five finished prints in the intoxicated summer and fall of 1918 alone.

One day, recklessly, he took her to his and Emmy's apartment on Madison Avenue and photographed her there—quite decorously, in a hat. But Emmy came home to find O'Keeffe

and gave her husband a dangerous ultimatum: give up O'Keeffe or move out of the apartment. Jumping at the chance to leave Emmy at her own request and then to complain about being unjustly evicted from his home, Stieglitz immediately moved out and into the top-floor studio with O'Keeffe. They lived there in intimacy and love for a year and a half, at first with a blanket hung between their beds for propriety.

One expects sympathy for an abandoned wife, but little has ever been expressed for Emmy. Even Hedwig Stieglitz didn't like her, never had. Maggie Foord had been her choice for Alfred's wife. She actually barred Emmy from Lake George after a series of hysterical outbursts on Emmy's part. When Alfred went to the family compound in midsummer of 1918, O'Keeffe came with him at his mother's invitation, and Mrs. Stieglitz welcomed her wholeheartedly, unbothered by the irregular circumstances. Soon after their arrival, Stieglitz went away to confer with Emmy and Kitty at Kitty's summer camp in New England. When he had convinced himself that they accepted his new relationship (they did not), he allowed himself to commit himself body and soul to O'Keeffe.

They finally became lovers in August, and Stieglitz would continue to mark the day forever, August 9, the day, as he put it, she gave him her virginity, Virginity Day. It was a sacred anniversary for him.[27] An ecstatic time followed. Georgia said she was the happiest she had ever been in her life. Alfred was reborn, as a man and as an artist. Like teenagers, they could not keep their hands off each other.

Back in New York in late September 1918, Stieglitz continued photographing O'Keeffe in the studio, all his passion for her evident in his obsessive exploration of her body. "Oh my America, my new-found-land." Along with John Donne and every other infatuated lover, he clearly felt "how blessed am I in this discovering thee." The 1918 photographs chronicle Stieglitz's enraptured examination of his treasure. Through

the camera lens, he savors her hands, her neck, her breasts, her torso, her face. He gives her detailed directions on how to pose, asking her to cup her hands in different ways, to squeeze her own breast, to throw her arms over her head. She was to sit and to stand, to arch and to hug herself, to splay herself out with open legs.

However intense and possibly erotic the experience was for O'Keeffe, it could not have been easy to be photographed this way. Posing for Stieglitz was never fun—he was too much the perfectionist—and the making of these images was especially hard on the model. He was using his large view camera on a tripod with very slow eight-by-ten-inch glass plates. The poses had to be held for as long as three to four minutes. For some shots, she stood on the radiator in front of the window, and as she later remarked dryly, mocking Stieglitz's artistic demands and her youthful compliance, radiators are not meant for standing on.

Yet one sees her belief in him in the photographs. She holds the poses, even the most unnatural. She allows herself to be just a body, an object. A woman trying to please her lover whom she knows to be a great artist, she allows his camera to pry into the most private of spaces. One of these photographs actually shows her vulva, one of very few such images in high Western art apart from Courbet's *The Origin of the World* and the Rodin drawing *The Satyress*, which was probably an inspiration.[28] There seems to be no reluctance on her part. She gives him total access, the ultimate gift.

It is modish now to say that O'Keeffe "collaborated" in the portraits and to present them as a joint work.[29] As years went by and O'Keeffe took charge of her own image, this became true to some extent. But in the early images, from 1918 to 1920, the collaboration amounted to little more than her willingness to be a model. The artist was Stieglitz. O'Keeffe took exactly the poses that he found beautiful or interesting and instructed her

Alfred Stieglitz,
Georgia O'Keeffe, 1918.
(Alfred Stieglitz Col-
lection, 1949. The Art
Institute of Chicago/
Art Resource, NY.)

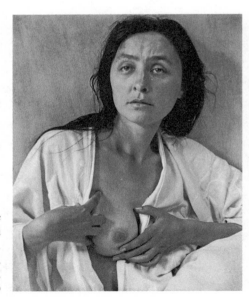

Alfred Stieglitz, *Georgia
O'Keeffe*, 1918. (Alfred
Stieglitz Collection.
© Board of Trustees,
National Gallery of Art,
Washington.)

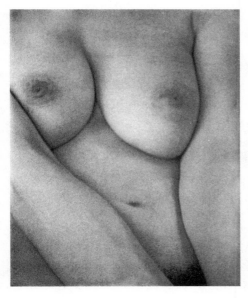

Alfred Stieglitz, *Georgia
O'Keeffe—Breasts*, 1919.
(Gift of Georgia O'Keeffe
through the generosity
of The Georgia O'Keeffe
Foundation and Jennifer
and Joseph Duke, 1997.
Image copyright © The
Metropolitan Museum
of Art. Image source:
Art Resource, NY.)

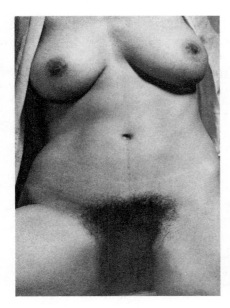

Alfred Stieglitz, *Georgia
O'Keeffe: A Portrait*, 1918.
Palladium print, 9 13/16 ×
7 7/8 in. (The J. Paul Getty
Museum, Los Angeles.
© J. Paul Getty Trust.)

to take—sometimes very stilted and unnatural ones, sometimes wholly unguarded.

Most of the early portraits of O'Keeffe show her dreamy, serious, chin lifted, gazing into the distance. Yet we know from other photographs how impish she could be. Stieglitz was not after variety of expression. He was interested in the abstract shapes and lines created by the body. The impact of the ex- tended portrait of Georgia O'Keeffe is not how amazing is this woman to have all these feelings and expressions, but how amazing is the eye of Alfred Stieglitz to see so much in so small a space, to create so many great photographs from one model, one body, even at one sitting, perhaps within the same hour.[30]

Few women have the privilege of studying their own pri- vate parts. Although this has never been suggested and is wholly speculation, it seems likely to me that Georgia O'Keeffe, with her immense curiosity and matter-of-factness, learned from these pictures and others even more intimate that would never have been displayed in public. Stieglitz's photographs showed O'Keeffe something she could see in no other way except through the distastefully self-involved stratagem of using a mirror. These views, in turn, may have influenced the imagery of her flower paintings of the later twenties.

"I was photographed with a kind of heat and excitement and in a way wondered what it was all about," she recalled as an old woman, continuing to disown her own involvement. The heat at the time of the sessions was both metaphoric and literal. That summer into September was extraordinarily hot, and the top-floor studio was stifling. You can see both kinds of heat in many of the images in which O'Keeffe looks wilted, the sexiest of the series to my mind, exhausted as though by lovemaking— or the weather. Her skinny body looks so luscious that you wonder if the humidity didn't puff her out, or if Stieglitz was using a wide-angle lens. When the prints were displayed pub- licly, many men approached Stieglitz to ask if he would photo-

graph their wives or girlfriends in a similar way. Stieglitz and O'Keeffe both found this very funny. "If they had known what a close relationship he would have needed to photograph their wives or girlfriends the way he photographed me—I think they wouldn't have been interested."[31]

The nude photographs were exhibited at the Anderson Galleries in February and March 1921 in Stieglitz's first show of his own work since the retrospective at the time of the Armory Show. It consisted of 145 prints, over half of which had been made since O'Keeffe entered his life in 1918. Forty-five were portraits of O'Keeffe. Only seventeen of the prints had ever been seen before, and the rest were radically new. They included a wonderful series of photographs of Ellen Koeniger, Frank Eugene's niece, in the water of Lake George. These in some way presage the O'Keeffe portraits, especially one, tightly cropped, that focuses on Ellen's wet bathing suit plastered to her buttocks.[32] In others, we see her body in extreme and unusual poses—in one of the greatest, her knee is lifted as she seems to climb from the water, joyous, her arm radically foreshortened. In her goddess-like dishabille, she appears like something primeval emerging from chaos, the whole bottom half of the photo a kind of magnificent mess.

Stieglitz had developed a new sense of time and photography's relationship to it. Reality was different every moment. No one image could represent the whole of a person. To expect any portrait to be a complete representation was as futile as to demand that a motion picture be condensed into a single shot. To capture the feeling of life, which was always changing, the photographer needed to work serially. Stieglitz no longer waited for the moment in which all the elements of an image lined up as he had imagined them—as he had done, for example, when he made *Winter—Fifth Avenue*, waiting in the snow for a carriage to appear and snap the whole composition into place. In his early photographs, even in *The Steerage*, he found

Alfred Stieglitz, *Ellen Koeniger, Lake George,* 1916. Gelatin silver print, 4 3/8 × 3 9/16 in. (The J. Paul Getty Museum, Los Angeles. © J. Paul Getty Trust.)

Alfred Stieglitz, *Ellen Koeniger, Lake George,* 1916. Gelatin silver print, 3 1/2 × 4 3/4 in. (The J. Paul Getty Museum, Los Angeles. © J. Paul Getty Trust.)

structure in the relation of one object to another, stopping time in the fashion of a tableau vivant. Now, relishing the flow of life, he sought structure only in the four sides of the print.

In addition to proving that Stieglitz was back as an artist, the 1921 show at the Anderson Galleries made O'Keeffe a celebrity. The nude pictures of her were shocking, and it was even more shocking that the model's identity was known, although her name was not announced. This woman, seemingly without inhibitions, free, modern, unrepressed, was Georgia O'Keeffe, the painter, the new addition to the Stieglitz circle, his girlfriend. She became a Kardashian of her day, the star of a reality show called the love affair of Alfred Stieglitz and Georgia O'Keeffe.

From the beginning, Stieglitz sexualized her work and she allowed it. She had made a little sculpture in clay shortly after her mother's death in May 1916, which she later cast. It was a memorial piece, a way of mourning her mother. Insofar as it represented anything, it represented, in the symbolist style, a hooded female figure with head bent in grief, an elongated form, slightly curved at the top, perhaps influenced by Steichen's great photograph of Rodin's Balzac statue in the moonlight. She and Anita Pollitzer called it "she" and saw it as a female form, "your clay friend," "the lady."[33] But Stieglitz saw it as phallic. He included it in her 1917 show at 291, placing it near one of the charcoal drawings. He turned it sideways to de-emphasize its frontal composition and highlight its phallic profile. Later, he photographed it in front of O'Keeffe's painting *Music—Pink and Blue, No. 1* in an arrangement so explicit it borders on vulgarity.[34] In his *Portrait of Georgia O'Keeffe*, he has her variously caressing the sculpture, grasping it, and fondling it with her feet. It has been seen as "a totemic symbol of her union with Stieglitz," but it's doubtful it seemed that way to her.[35] She allowed this because his photographs were his busi-

Alfred Stieglitz, *Georgia O'Keeffe—Installation at 291*, 1917. Gelatin silver print, 7 1/16 × 8 7/8 in. (The J. Paul Getty Museum, Los Angeles. © Georgia O'Keeffe Museum.)

Alfred Stieglitz, *Interpretation*, 1919. (Alfred Stieglitz Collection. © Board of Trustees, National Gallery of Art, Washington.)

ness, and perhaps, if we want to be cynical, because she understood how much it worked to her advantage.

The notoriety Stieglitz arranged for her prepared the success of her show of paintings in 1923, which bore the heraldic name *Alfred Stieglitz Presents One Hundred Pictures: Oils, Watercolors, Pastels, Drawings, by Georgia O'Keeffe, American.* Five hundred people a day came to see her work, and many pieces were sold. The publicity he had arranged predisposed people to view her work as quintessentially female, even though there was nothing especially feminine about these pieces, many of which were drawings or paintings of Palo Duro Canyon that O'Keeffe had made in Texas. Stieglitz was instantly successful with his "public invention of Georgia O'Keeffe: the Woman who embodied sexual freedom, spontaneity, and intuition; the unspoiled, unintellectual artist whose visually expressed emotions represented nothing less than universal truths; 'The Great Child' who was uncorrupted and unfettered by the past; the American who was an artistic law unto herself."[36]

For twenty-five years the commercial success of the Obermeyers, and to a lesser extent that of Edward Stieglitz, had allowed Alfred to rail against commercialism and accumulate a staggering collection of art. This irony could not have been lost on him. One of his most astonishing photographs is of the interior of the Stieglitz summer house at Lake George, Oaklawn. It astonishes us because the interior is so dark, so furnished, so unlike the airiness we expect in summer homes. Visitors to his and Emmy's apartment on Madison Avenue noticed the same discrepancy: they expected Stieglitz to have created an airy, modern environment, but he had not. The apartment was filled with dark furnishings, parental tchotchkes, and creepy symbolist paintings. So modern in his conscious choices, in his heart there was still something Victorian. After the war and with the beginning of the relationship with O'Keeffe, it was time in every way to strip down.

Alfred Stieglitz, *Oaklawn, Lake George*, 1912–13. (Alfred Stieglitz Collection, 1949. The Art Institute of Chicago/Art Resource, NY.)

Alfred Stieglitz, *Judith Being Carted from Oaklawn to the Hill: The Way Art Moves*, 1920. Gelatin silver print. (Alfred Stieglitz Collection, 1949. © Board of Trustees, National Gallery of Art, Washington.)

In the summer of 1920, the family sold Oaklawn and moved to a simpler house up the hill. All the Victorian clutter his father had considered art had to be hauled away and stored. Stieglitz made a picture of it called *Judith Being Carted from Oaklawn to the Hill: The Way Art Moves*. In it, Moses Ezekiel's *Judith*, a sculpture revered by Edward Stieglitz and mocked by his progeny, is carried off ignominiously in an old wooden wagon, along with the Venus de Milo and another female bust.[37] It took two days of carting and then another day to move the stuff into the attic. Stieglitz thought it all junk. "Think of having to handle hundreds of pictures and books and statuary etc etc. Each piece. And feeling as I do about it," he wrote to Strand. "Handle each piece at least twice. The Vanity. Ignorance. Hope. Time. Money. And so little of any value of any kind."[38] All just "space-eaters," dead vestiges of past values, which family sentimentality required him to save.

Having moved up the hill in Lake George, he set to work preparing prints for the show he would have at the Anderson Galleries at the start of the following year, 1923. It is bracing to realize that in producing some of the most beautiful photographs in the history of photography he had no dedicated darkroom. He developed and washed the prints in a bathtub and dried them on a clothesline hung over the kitchen stove. He and O'Keeffe stayed in Lake George through December, with Stieglitz working seven or eight hours a day printing. Back in the city, they moved into Lee and his wife Lizzie's large brownstone at 60 East 65th Street, occupying separate floors in order not to offend the proprieties of Lizzie's aged mother, who lived in the townhouse as well. They ate breakfast there but dined out every night, hosting a weekly dinner for friends at a Chinese restaurant on Columbus Circle.

Stieglitz's 1923 show at the Anderson Galleries was as stunning a display of renewed vitality as his 1921 show had been. Again he could boast about how much work was new. Of 116

prints, 115 had never before been seen. In high middle age, he was in an intensely creative stage of his photographic career, no longer carrying his camera to distant villages or out in storms to find a subject worthy of shooting, as he had in his youth, but seeing interest in whatever was around him.

He concentrated on what he saw at Lake George: the people, the lake, the sky, the trees, the apples, the wooden houses and barns. O'Keeffe conveyed the exquisite beauty of some of these prints when she said that one of them "looked like a breath laid down on paper." Apple trees were favorite subjects, for to Stieglitz apples were a symbol of art. He was fond of comparing the American artist to an apple tree whose fruit was inevitable, and he incorporated apples into many of his portraits of this period. One of his favorite images was *Gable and Apples*, a photograph that shows how Paul Strand's abstracting close-ups of everyday objects changed Stieglitz's vision and how his own mastery of depth of field and focus allowed him to make that vision into a work of art. "There was never truer seeing," he wrote of this photograph.[39] No fisherfolk. No urban machinery. Just a wood-shingled house as American as apple pie—and apples.

Increasingly, he turned toward the sky. He had been photographing clouds since 1922 and would continue to do so for years. At first he called them *Music* or *Songs of the Sky*, later *Equivalents*, meaning that they were equivalents for his inner states. These tiny images, from four-by-five-inch negatives and printed at that size, were intended to be like musical preludes or nocturnes, "played" one after another, so that small changes in mood have a large effect. In the first cloud photos he retained an orientation to the ground—hills marked the bottom of the picture. Later he abandoned this grounding and turned the clouds wholly into patterns. He was trying to be as abstract in his photography, as independent of subject matter, as it was possible to be, perhaps, as he claimed, because he wanted

Alfred Stieglitz, *Gable and Apples, Lake George*, 1922. (Anonymous gift.
Digital Image: © The Museum of Modern Art/Licensed by
SCALA/Art Resource, NY.)

to show he didn't need any special subject—nude women, for
example—to make great photographs, perhaps because photo-
graphing nude women was getting him into trouble.[40]

The most striking new subject for his camera proved to
be Paul Strand's wife, Rebecca, called Beck, who at this time
replaced O'Keeffe as the nude model of choice. Strand had
met Beck in 1920; they married in 1922; the two couples, the
Stieglitzes and the Strands, became close and strangely en-
twined. Strand started doing pictures of his wife that Stieglitz
and O'Keeffe both felt impinged upon their territory. Ostensi-

bly to show how Beck could be photographed without copying what he had done with O'Keeffe, Stieglitz started photographing her at Lake George, often naked, with parts of her body underwater. She was, Stieglitz said, a first-rate model, and this is clear in the photographs, which seem less posed than the ones of O'Keeffe, with more of an emphasis on tactile values and the body's movement. Stieglitz told Beck that he did not know if she would like the portraits of her as portraits, but he could assure her that they were great photographs. As Geoff Dyer wryly puts it, "Stieglitz is not the only great photographer to have made erotically charged pictures of his wife but he is, perhaps, the only great photographer to have made erotically charged pictures of another great photographer's wife."[41]

Although she noted and resented Stieglitz's wandering eye, O'Keeffe did not mind that Beck Strand replaced her as his go-to nude model. She preferred to spend her time doing her own work rather than posing for Alfred's. Besides, she already wanted people to stop seeing her work with sex at the forefront of their minds, to stop considering her as a woman artist and view her just as an artist. The nude pictures of O'Keeffe taper off radically after 1922. It's tempting to think that this represents some fading of eroticism between the couple. Stieglitz, however, insisted that the opposite was true: the longer they were together, the more he saw how fragile O'Keeffe's health was and the less willing he was to risk her catching a chill by spending long periods of time naked, especially outdoors. To photograph her in the cold water of Lake George, as he had Beck Strand, was unthinkable. But even in head shots, fully clothed, O'Keeffe begins to look skeptical in his photographs of her, sometimes even hostile, refusing him the dreamy expression he favored in the early portraits.

There was, indeed, trouble between them. By the summer of 1923, O'Keeffe was feeling the whole weight of Stieglitz's needs. He was always sick, always complaining. He never

Alfred Stieglitz, *Rebecca Salsbury Strand*, 1922. (Alfred Stieglitz Collection, 1949. The Art Institute of Chicago/Art Resource, NY.)

Alfred Stieglitz, *Rebecca Salsbury Strand*, 1922. (Alfred Stieglitz Collection, 1949. The Art Institute of Chicago/Art Resource, NY.)

Alfred Stieglitz, *Rebecca Salsbury Strand*, 1922. (Alfred Stieglitz Collection, 1949. The Art Institute of Chicago/Art Resource, NY.)

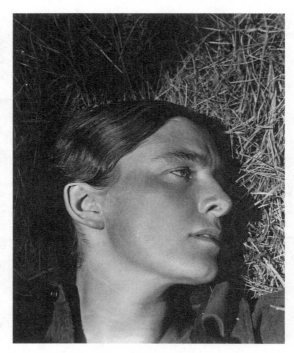

Alfred Stieglitz, *Rebecca Salsbury Strand*, 1922. (Purchase and gift of Georgia O'Keeffe, 1974. Courtesy George Eastman Museum.)

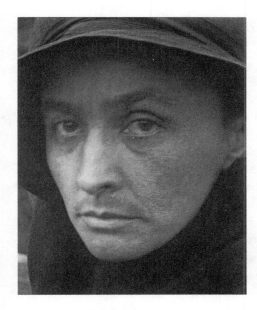

Alfred Stieglitz, *Georgia O'Keeffe*, 1922. (Alfred Stieglitz Collection, 1949. The Art Institute of Chicago/Art Resource, NY.)

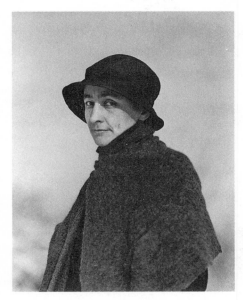

Alfred Stieglitz, *Georgia O'Keeffe: A Portrait*, 1924. Gelatin silver print, 4 1/2 × 3 1/2 in. (The J. Paul Getty Museum, Los Angeles. © J. Paul Getty Trust.)

wanted to travel, insisting they spend every summer at Lake George, where they were afflicted by his too-large family and too many visitors. He flirted openly with other women, like Beck, and then insisted O'Keeffe was crazy to object because he hadn't really "done" anything. He expected a great deal of emotional support from her, which she was not temperamentally suited to give. In addition to helping him sustain the usual round of insults from artists and collectors and an uncomprehending public, O'Keeffe was expected to provide sympathy for the disaster his own family had become and the guilt he bore for it. The summer of 1923 was especially bad. In the spring, his daughter, Kitty, who had married and had a baby, was seized by a catastrophic depression that was never successfully treated and required her to live in therapeutic facilities for the rest of her life. That summer, too, the issue of whether or not he and O'Keeffe would have a child together came to a head. O'Keeffe wanted one, but Stieglitz did not, claiming that (1) it would hurt O'Keeffe's work, and (2) he was cursed—a reference to Kitty.

When Stieglitz's secretary from 291, Marie Rapp Boursault, brought her little girl for an extended stay at the Lake George compound, Stieglitz loved having a child around, but O'Keeffe did not. The child's crying drove her crazy and made her realize that work, not family, was what she wanted. She therefore came to accept Stieglitz's wish not to have children, but it had not been a small thing between them.

The story of their relationship from then on is one of devoted attachment and unity of purpose but ever increasing physical distance. Georgia, with the help of Elizabeth and Donald Davidson, built herself a studio, the Shanty, on the Lake George property and didn't allow Alfred to share it. At the end of the summer she left the family compound to visit some friends in Maine. She had started to feel as oppressed by

the enclosed landscape of Lake George as by Stieglitz's hovering protectiveness. She yearned for open spaces, physically and emotionally. Maine's large views of the ocean and its undemonstrative people refreshed her.

Although the relationship had started to cool, they married in 1924, when his divorce from Emmy finally came through. The marriage was Stieglitz's idea and took place at his insistence; O'Keeffe did not want to be married to him, for whatever reason. It was another thing that came between them, another instance of having to do things Alfred's way. She cried the night before the wedding. Afterward, she never allowed herself to be called Mrs. Stieglitz and could be quite prickly about maintaining her separate identity. When her young niece Sue Davidson was introduced to her and called her "Aunt Georgia," O'Keeffe actually slapped her and said never to call her that.

There were practical advantages to being married. They could sign a lease and live together openly in the city, as they began to do in 1925, moving into the Shelton Hotel for the winter. In this newly built, up-to-date thirty-story building on Lexington Avenue between 48th and 49th Streets, they occupied two rooms on the twenty-eighth floor. Now the East Side Marriott, across from the Waldorf Astoria, it was the tallest residential building in the world when built. Originally just for men, it became open to all in 1925 and featured a swimming pool, reading rooms, and solarium as well as a cafeteria. It was thus a kind of club for living, representing a model of residential life that has since disappeared.

Staying in a hotel periodically cost less than renting an apartment year round, and this appealed to the couple's shared frugality. Furthermore, in their high-up aerie with spectacular views of the city, Georgia had the openness she needed, and Alfred had the superior position that suited him. She began a new series of paintings of New York, hoping to show that a woman could take on that heretofore masculine subject, the city. They

spent their days mostly apart, she at the Shelton, he at the Intimate Gallery, "the Room." Although she helped him there, especially with the initial décor and with hanging shows, it was basically his province. They met for dinner, which they took at the hotel cafeteria. There was no kitchen in their suite. This way of life completely relieved O'Keeffe of domestic burdens and allowed her to concentrate on her painting. It also relieved her of Stieglitz's family. They had been living together by this time for almost eight years, but now for the first time they were on their own.

An end to the ecstatic mutual discovery of the years 1918 to 1922 was inevitable. Their relationship was marked now by happy reunions, a continual swearing to each other of the deepness and importance of their bond and, underneath it all, recurrent dissatisfaction on both sides. Their letters to each other are those of a couple used to being in love but starting to realize that they do not make each other happy. He was constantly hurting her feelings, and he did not see what he was doing wrong. He could not stop himself from showing his attraction to younger women, and he could not admit that his flirtations were anything more than inconsequential. But O'Keeffe, who needed to feel that she was the only woman in Stieglitz's life, felt repeatedly betrayed—by reports that he had been seen kissing the cook at Lake George, by his eagerness to photograph naked some of the young women who visited the compound, and finally, most devastatingly, by his genuine love for another woman, Dorothy Norman.

All the more because their relationship was so much a partnership, spiritual as much as physical, O'Keeffe could not bear to see or even to think of him with someone else, and he was equally jealous—of her ability to do without him. Constantly coddling her and trying to protect her, he liked to think of her as frail. She proved herself to be in fact a sinewy creature who thrived outdoors and in solitude and didn't get enough of ei-

ther in her hothouse life with Stieglitz. The life he offered—
tied to Lake George and his family for half the year, tied to
New York by his galleries—seemed fearful and elderly. In their
room you might see a truss for Stieglitz's hernia on the bed and
a nose suction machine on the side table. He was in his mid
sixties. O'Keeffe, still only in her forties, craved adventure—
space, freedom, travel. Their erotic connection was intense and
remained central for both of them. They called it fluffing and
wrote frankly to each other about its pleasures. She had Miss
Fluffy and he had the Little Man. Miss Fluffy and the Little
Man liked to visit each other in the early morning. But even
in sexual abandon, there was something fussy and protective
about Stieglitz: he refused to make love to her outdoors, he ex-
plained, because he was afraid of getting dirt inside her.

In the summer of 1928, O'Keeffe took a trip to the Mid-
west to visit the part of her family that had not left Wiscon-
sin, where she was born. Sometimes a person makes this kind
of journey when she is trying to reconnect with who she used
to be before she married and became half of something else.
Then, in April 1929, she set out for New Mexico, accompanied
by Beck Strand. She had been to Santa Fe once and loved the
high desert landscape. Beck had been there more recently with
her husband. New Mexico was already a magnet for artists.
D. H. Lawrence, his wife, Frieda, and their friend Lady Dor-
othy Brett had lived there; Marin had visited. Mabel Dodge,
the wealthy avant-garde *saloniste*, had married a member of the
Taos Pueblo, Tony Luhan, and had built a twelve-acre com-
pound in Taos. She freely offered the guest rooms and houses
of Los Gallos to visiting friends. Beck and Georgia settled
there for several months, with a house to themselves and a stu-
dio for Georgia.

The change in O'Keeffe was obvious to everyone. She
quickly got suntanned and healthy. She ate enthusiastically.
She bought herself a Ford, and Beck and Tony Luhan taught

her to drive it. If Virginia Woolf had been in New Mexico in the 1920s she might have written that the true symbol of female independence was a car of one's own. O'Keeffe wrote home to Stieglitz, "I feel so good I can scarcely believe it." He wrote back that he was glad she had found a place she loved: he could tell she was in her element. "This here in a way is rather awful," he wrote about their life at Lake George. "Don't think I don't know that."[42] She kept the car a secret from Stieglitz, knowing it would upset him.

She continued to thrive and he continued to tell her how happy he was about it—until he fell apart. He was desolate without her. At Lake George, he did a series of dark cloud pictures, verging on tragic in feeling. He spent a lot of his time throwing out and burning up old clippings, prints, magazines, even negatives that no longer meant anything to him. He was realizing that he couldn't hold on to everything, that he might even lose O'Keeffe. He was by turns angry, apologetic, and self-pitying. He could not see what he had done to deserve her decamping. "I had complained about you in minor ways," he wrote. "But my God—I was canonizing you day and night—for thirteen years—as no woman living or in the past was ever canonized."[43] He began to mistrust her and doubt her judgment. If she was having so much fun, she couldn't be working seriously! She was probably undermining her health. By July (she had been away since late April), he was in such a state that his brother was worried about him and contacted O'Keeffe. She said she was willing to come back if he needed her, and that promise kept him going a little while longer.

When she finally did come back at the end of August, they had an ecstatic reunion, happy to have each other's company again, convinced of the fundamental solidity of their union. In this second phase of their marriage, they entered upon a new understanding of who they were in relation to one another:

they were no longer impresario and discovery; she was an artist in her own right with her own needs and he was a great but frail and aging man. She needed stimulation and big spaces; he needed familiar rooms and a woman who was always there. If they could not fulfill each other's needs, they would allow each other the freedom to fulfill them by other means. Only by defining their marriage as a higher, more abstract partnership could they stay married.

From 1925, a gallerist once more, Stieglitz put on shows of the work of the small group of people he had chosen to devote himself to: O'Keeffe and Marin principally, and secondarily Hartley, Dove, and Strand. Now and then he offered shows to others, including Charles Demuth, Gaston Lachaise, Oscar Bluemner, Peggy Bacon, and Picabia. The Intimate Gallery had a different vibe from that of 291. With so many of his new young friends writers, like Paul Rosenfeld and Waldo Frank, it became less of a locus for art experiments and more, in Stieglitz's mind, a place where artists and public could meet, the focus of a community. Frank was a combative left-wing journalist, supporter of strikes at textile mills and coal mines, fan of Communist Russia. Rosenfeld was originally a music critic, but his friendship with Stieglitz drew him increasingly to write about art and American culture in general.

Stieglitz insisted that the Intimate Gallery (like 291 before it) was not a business in the usual sense, since its purpose was to make money for only the artists he showed, and not for him. He put a percentage of sales into a fund that supported them through hard times. Wealthy people, like Eugene Meyer's sister Aline Meyer Liebman, Stieglitz's brother Lee, and Alma Wertheim, a family friend, contributed directly to this fund as well. The way to "buy" a Stieglitz photograph was to contribute money to the artists' fund. Then Stieglitz would thank you

for your donation with the "gift" of a photograph. From the end of the 1920s, O'Keeffe's income was regularly higher than Stieglitz's, and she paid their rent and living expenses.

A young Ethical Culture– and Harvard-educated writer, Herbert Seligmann, was a regular of the Intimate Gallery, serving as assistant to Stieglitz in any way he could. With the reverence for Stieglitz's wisdom typical of this new group of friends, he faithfully recorded conversation in the galleries day after day, showing the effect Stieglitz had on people and the kind of talk he encouraged. For Seligmann, Stieglitz was a Socrates, and the gallery was a forum for debate and education.

Everyone went to the Intimate Gallery, from Sherwood Anderson to the man who invented the safety razor. With the latter Stieglitz companionably grumbled about the evils of American business but never held it against him that he didn't buy. He could be harder on people who did buy, thinking that their purchase gave them any right other than custodianship, than he was on people who had the money to buy but did not or those who didn't have the money to buy at all.

A woman came to the Room to buy an O'Keeffe painting and innocently asked if she could also see some of Stieglitz's photographs, as though her money would allow her to buy those, too. Seligmann recorded Stieglitz's reaction to what he perceived as her arrogance: "What did people do to make possible for themselves a continuance of the privilege of coming into the Room? . . . The doors were open, and for some reason people took it all for granted. But suppose he were to stop. Suppose for some reason he could not go on with what he was doing, would anyone make a continuance of the Room possible, would it be made possible for O'Keeffe to make more paintings? No, there was none who cared enough."[44]

The poor woman said something about wanting to do good and provoked another tirade from Stieglitz. In Seligmann's words, "When people spoke of doing good he wanted

to dedicate himself and his work to the devil. That had nothing to do with him or the work or the room. He was not trying to do good. . . . What had people done, what were they prepared to do to protect this thing about which they professed to feel so strongly? It was as if there were a miraculous child in the midst of street traffic on Fifth Avenue and crowds of people kept exclaiming, 'What a marvellously beautiful child!' but did nothing as the automobiles bore down on the child, until a traffic policeman told the crowds to move on and arrested the child for obstructing traffic, no one having raised a hand on the marvellous child's behalf."

Stieglitz's outpourings sometimes seem closer to demented rants than to Socratic dialogue, and Seligmann was remarkably patient at hearing the same themes and anecdotes invoked day after day. But his Boswellian record, most of which dates from 1926, conveys the day-to-day diligence of Stieglitz's devotion to his mission.

All day long he was in that little room, talking to everyone, not knowing who most of them were, sometimes surrounded by a group of as many as eighteen, sometimes engaged with one person. He was capable of focusing all his attention on one person and ignoring everyone else, even if the others were potential buyers. He was especially kind to young people, taking them seriously and drawing them out.

A young woman came in one afternoon to see the Marins. "You like these?" Stieglitz asked her.

"I just love them."

"Are you a painter?"

"No, but I wish I were."

"You'd better not wish that. It is a difficult life."

"Yes, but I'm not expressing anything. I am only absorbing and not giving out. That seems so selfish."

"But how do you know you are not expressing anything? Be thankful that you can see. The true artists are the seers. And

perhaps you give out in your intercourse with people what you have received."

Why was she interested in modern art?

"Well, it's part of the world today, and it's beautiful."

"Why not use the word *true*? It is a shorter word."

"Yes, perhaps these things are beautiful because they are true."

"But when you think of an apple tree, you do not think it is true. You think of its appleness."

"Yes, the apple tree never tries to be anything but its own self."

Now, whatever the merits of this conversation, it is certainly no way to sell a painting. At the end of it, the girl reached the proper conclusion: "Perhaps the Marins belong more to us because we've really seen them than to the people who 'own' them."

"They think they own them," Stieglitz said. "But there is something there that cannot be owned."[45]

One day, discussing Dove's pastel *The Cow*, he said, "It is not for sale—that is, I would not let it go, since it is at work here." (Stieglitz liked to think of his galleries as laboratories, where works were hung to test their power.) "Unless a man gave me such a sum that I would have to accept it. If Mr. Adolph Lewisohn, for example, gave me eighteen thousand dollars for it, I would deposit that sum and then draw upon it for the artists working, Marin, Dove, O'Keeffe, and possible others. Mr. Lewisohn pays that sum for a Henri Rousseau."[46] A Stieglitz leitmotif was anger at wealthy Americans who sent their money to France to buy Cézannes and Matisses and would not pay as much for Marins, Doves, or O'Keeffes.

He insisted that the Room was not a business, but never before had he tried so hard to make money, especially for O'Keeffe. He carefully tended the prices of her work, driving them ever higher. In 1928 he arranged a sale on O'Keeffe's be-

half that made the newspapers. He sold a group of her calla lily paintings, two large, four small, for $25,000 (over $1 million today). The purchaser was anonymous, but in fact it was Mitchell Kennerley, buying on the strength of his engagement to an heiress. The wedding never took place, however, and so neither did the sale. Some writers think the transaction was invented solely to raise O'Keeffe's prices and therefore constituted fraud, but such a stratagem is at odds with what we know of Stieglitz's character.[47]

He made Marin financially independent as well, obtaining record-breaking and news-making prices through complex combinations of sales and gifts. He wanted to have watercolors be as respected as oil paintings and knew that the way to ensure that respect was through pricing. Duncan Phillips, the Washington collector, wanted to buy Marin's watercolor *Back of Bear Mountain* from his 1926 show, and Stieglitz asked $6,000 for it, an astonishing price for a watercolor, three times what most Marins were selling for. When, reluctantly, Phillips agreed to the price, encouraged by his wife, Stieglitz gave him another Marin as a present to his wife and a third at half price, so the average price paid for the three Marins was just under $2,350. But the $6,000 record price for one watercolor made the news.

Promoting O'Keeffe and Marin, both of whose works were popular, was easier than promoting Hartley and Dove. Stieglitz had met Dove through Maurer as far back as 1909, but Dove's career as a painter was interrupted for years by his effort to make a living by farming. He was a humble, straightforward man whose fundamental solidity and honesty seems expressed in the powerful, simplified forms of his paintings. When he returned to art in 1921, Stieglitz's support became essential: Stieglitz gave him his first show, at the Intimate Gallery, in 1926, and then annually showcased his work at An American Place. "I couldn't have existed as a painter without that super-encouragement," Dove said.[48] He eked out a living through illustration work, but

in 1925 told Stieglitz that he would go crazy if he couldn't take a year off from illustrating simply to paint. Stieglitz, presumably from the artists' fund, came up with the $500 he needed. Eventually he got Duncan Phillips to start collecting Dove's work. Dove never had another dealer than Stieglitz for his whole life.

Hartley, cravenly grateful one minute, outrageously ungrateful the next, tried Stieglitz's patience. Still, Stieglitz never abandoned him, and when he desperately wanted to return to Europe after the war, Stieglitz had the novel idea of arranging an auction of all the works Hartley had in storage in America. It was held at the Anderson Galleries and was quite successful, raising three times the amount Hartley had said he needed, enough to subsidize years abroad. Stieglitz wrote the catalogue copy, made sure there would be bidders, bought for himself and others. "Hartley from absolute poverty and despair—has suddenly become a capitalist and free to really work." Stieglitz was rightfully proud. "A miracle really happened. My faith remains unshaken—and bears fruit."[49]

The system worked fine as long as everyone, patrons and artists, had total confidence in Stieglitz and were willing to let him control everything. But the system could break down, as it did with Gaston Lachaise. Stieglitz had loaned him $1,000 in the fall of 1928, presumably out of the artists' fund, and Lachaise had left sculptures with him as collateral. When Stieglitz reminded Lachaise of the loan the following spring, Lachaise wrote back asking for a receipt for the sculptures. Stieglitz was horrified. "I told you that such a request had never been made by anyone from me; that the Room was not in business, that I was not in business, that the things the artists brought were brought at their own volition and left in the Room at their own risk."[50] He returned the sculptures to Lachaise and told him he could keep the $1,000. He would consider it the cost of a lesson. The lesson was one Stieglitz ought to have learned by

then—that people were never grateful in exactly the way he wanted them to be.

Even O'Keeffe had to be reminded of his work on her behalf: "I insisted on setting you free economically—even from me. If I had done anything else I would have been untrue to what made 291 what it was. Of course I know money means nothing to you—but you need it a thousand times more than I do."[51] He had first set the goal of accumulating $30,000 for her so she would receive, at the 5 percent interest he seems to count on, $1,500 a year. Living with her, worrying that she was sometimes ill and unable to work, he thought $30,000 was inadequate and raised the sum to $50,000, then $70,000. He was aiming to put together $100,000, to produce an income of $5,000 a year, but by the summer of 1929, just before the stock market crash, he had "only" put together $80,000. That is about $5 million in today's money. The yearly income he thought she needed in contemporary dollars was $250,000.

And so he devoted himself to supporting artists and in doing so, as he saw it, drove O'Keeffe away. He had to stay in the Room and be serious; she needed space and adventure. He was self-sacrificing, working on behalf of others at the cost of his own career. She, distancing herself from him emotionally, denied him the support he had to have from a woman. Of course it looked different to her. He smothered her and held her back—his family, his friends, his ideas, his plans, his sicknesses, his requirements—and he withheld something essential to her—primacy. As she saw it, he spent all his time at the Room in order to have his ego boosted, especially by pretty young women. She worried that she was getting older and was no longer as attractive to him as she had been. Her need for independence bumped up against his need for constant attention, as her need to be first with him conflicted with his need to be the center of a crowd of worshippers.

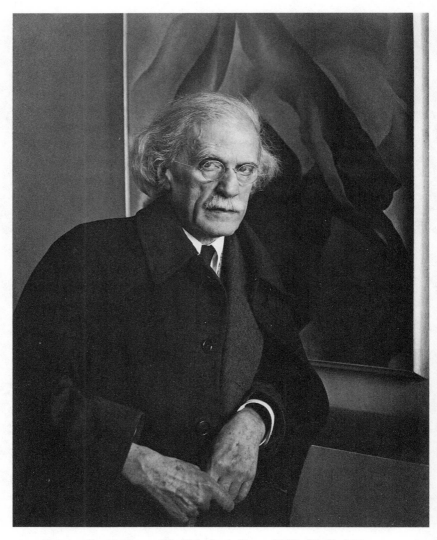

Imogen Cunningham, *Alfred Stieglitz in Front of O'Keeffe's Black Iris*, 1934.
(Gift of Robert M. Doty. Digital Image © The Museum of Modern Art/
Licensed by SCALA/Art Resource, NY. © 2018 Imogen Cunningham Trust.
All rights reserved.)

More and more as time went on there was one worshipper in particular, a young woman named Dorothy Norman, wealthy, married, a mother, forty years younger than Stieglitz, seven years younger than his own daughter, who attached herself to him starting in 1926, treasured every word he uttered, and eventually became his mistress. The transcendent relationship he had envisioned between himself and O'Keeffe, in which the two of them were fulfilled individually yet perfectly merged into something new, was proving very hard to realize.

In order to become her own person, O'Keeffe had to get away both from Stieglitz and from mainstream American life, creating a refuge for herself in New Mexico, transforming herself into a painter of skulls, bones, and desert landscapes, posing for photographs with a nun-like austerity far from the intoxicated display of the early Stieglitz portraits. Initially a willing participant in his creation of her, she freed herself eventually. But she always realized how lucky she was to have been promoted by Stieglitz and never ceased to be grateful to him for enabling her to support herself through art, to be collected, respected, and even revered.

Indeed, we must include among Stieglitz's successes—getting photography recognized as an art form, bringing European modernism to America, gaining respect for American art—the specific creation of the first self-sufficient American woman artist. Of course he could not have done it if she had not had the potential for greatness. She did, and she gave Stieglitz what he needed to create for her an exalted status: Georgia O'Keeffe, American artist, may be his most consequential and unselfish accomplishment.

6

Ripe Apples

ARTISTS HAVE a tendency, as they age, to narrow their focus. One is naturally less likely to race around in search of material but, at a deeper level, one tends, aging, to see more in less. Steichen spent his last years photographing one shad bush in his backyard. Some artists—Monet comes to mind—move gently toward abstraction. As he got older, Stieglitz wanted increasingly to de-emphasize the subject and concentrate on the interaction of darkness and light in his prints. That is one among many reasons he turned to photographing clouds.

Although he continued to make portraits, especially of young women, of friends, and above all of Georgia O'Keeffe, the major new projects of his later years were the photographs of Lake George, especially the clouds, and photographs taken from windows in New York City. Both depend on the immobility of the photographer and the constant motion of the world beyond. Both show Stieglitz fascinated by change from mo-

ment to moment and with the drama of light. The movement of the clouds, the intensity of sunlight behind them, the shadows on the facades of skyscrapers, the rhythm of lit and unlit windows—all condensed visual life to a pleasure that was essentially musical. Every change in momentum between light and shade pleased him in a way that seemed related to his inner states.

At first, he used his beloved view camera to photograph the sky, but this presented him with difficulties. First of all, the clouds had to be framed and focused on the viewing glass, to be followed by the insertion of a film plate and removal of the cover plate. By the time the emulsion was actually exposed, the clouds would have moved from where he had first seen them. We are talking of seconds: the time it took to expose a plate with a view camera would produce a completely different configuration of clouds. The view camera's other problem was that it could be tilted only slightly. You could not simply pick it up and aim it at the sky. It had to be on a tripod. The total disorientation Stieglitz sought in photographing clouds could not be achieved that way. What the big camera did provide were eight-by-ten-inch negatives, but eventually he decided to give up that nice size for flexibility.

When in 1923 he switched to his handheld (but still fairly cumbersome) Graflex, he could point his lens directly at the sky and eliminate all signs of terrestrial orientation, creating images that read as considerably more abstract. The Graflex was a single-lens-reflex camera, meaning the image stayed in the photographer's view until the shutter was tripped: Stieglitz could see on the glass exactly what image he would be capturing. Even with that, photographing the fast-moving clouds was tricky business. Stieglitz did not have a telephoto lens to size and frame them. He had to wait until exactly what he wanted appeared on the viewfinder. The technical challenge was great. Either the brightness of the clouds and of the sky was very

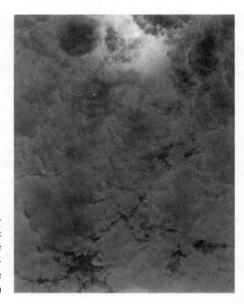

Alfred Stieglitz, *Equivalent*, 1925. (Alfred Stieglitz Collection, 1928. Image copyright © The Metropolitan Museum of Art. Image source: Art Resource, NY.)

nearly the same or, even harder to work with, the range of brightness was extreme, perhaps including the disk of the sun itself. This was the kind of problem—technical—that Stieglitz had loved from his earliest days as a photographer. Photographing clouds must have been fun for him—although he never would have admitted to having fun. As John Szarkowski said, it was "similar to, but better than, shooting clay pigeons, since in that game one scores a simple yes or no (the clay saucer is either broken or not); whereas in photographing clouds the result falls on a long and open-ended scale from tedious to electrifying."[1]

In 1928, the Metropolitan Museum of Art, which had been hoping to acquire some Stieglitz prints for a while, finally got them, but it was not a simple transaction. While another person might have felt honored that the great institution wanted his work, Stieglitz took offense at the museum's reluctance to

pay. The Metropolitan wanted a donation. For Stieglitz it was a matter of principle: payment meant respect, and his work deserved respect. He had been battling museums, trying to get them to value living artists, for all his adult life. So what to do? Because he certainly wanted his work in the Met's newly inaugurated photography collection.

It happened that David Schulte, a tobacco magnate, had recently made a large donation of stock to Stieglitz's artists' fund. This time, in addition to giving prints to Schulte, he decided to give seven prints to the Met in Schulte's name. Not technically the donor, he could feel he had outwitted the curators. The whole business was typical Stieglitz—high-handed, complicated, self-interested, calculated, but underneath it all immensely generous to all concerned. He enjoyed it so much that he added another fifteen prints, some in the names of other artists' fund patrons—Beck Strand, Alma Wertheim, and Paul Rosenfeld. Puckishly he gifted two raunchy nude O'Keeffe images in the name of the socially prominent matron, Mrs. Wertheim. Others were given anonymously, that is, by Stieglitz himself.

Seven of the twenty-two were portraits of Georgia O'Keeffe from the greatest period of the series. One was the Dada portrait of Dorothy True, her face superimposed on her calf. There were also portraits of Waldo Frank the journalist and Charles Demuth the artist—both from the wonderful ongoing project of photographing his friends in front of their own work, if possible. Frank was photographed with apples on the porch of the house at Lake George. The barn, trees, and grass at Lake George inspired other images. By far the most—nine images—were from the series he called at first Music, then Songs of the Sky, but ultimately Equivalents, because he believed that he found in the clouds equivalents for his own emotions.

Wanting the prints in the Met collection to represent his finest work, he labored on them to achieve perfection. In the

quality of the printing, the delicacy of rendering and tonality, they may very well be the most beautiful prints this mad perfectionist ever made. Anyone who has had the privilege of seeing this collection in the museum study room, the matted prints displayed on a railing without any glass hiding their subtle beauty, readily sees the difference between this specially selected group and, for example, a group donated by Georgia O'Keeffe after Stieglitz's death. For the average viewer of a photograph, subject matter is primary, but to the artist and connoisseur it is matched in importance by the quality of the print. As Ansel Adams put it, "The negative is the equivalent of the composer's score, and the print the performance." The cloud pictures have a hard time living up to the weight of meaning Stieglitz imposed upon them; he presented them as "*equivalents* of my most profound life experience, my basic philosophy of life."[2] In claiming so romantic a justification for his work, Stieglitz unwittingly threw down a gauntlet to critics and photographers who value photography for its objectivity and consider pompous and ridiculous the pretense of spiritual content in a photograph of clouds.

One young photographer went to the print room of the Met to see the Stieglitz pictures shortly after they arrived there. He found three or four of them very exciting, including an O'Keeffe print he called "one of the best things I'll ever see." This young man, Walker Evans, had paid visits to Stieglitz at the Intimate Gallery, the first time bringing with him a box of his early work in the form of two-and-a-half-by-four-and-a-half-inch snapshots. When he arrived, Stieglitz was out, but Georgia O'Keeffe was there, and she spent some time going over Evans's work, to his immense satisfaction. She showed a great understanding of photography and told him he could get more out of some of the negatives. But when Stieglitz came in, perhaps unhappy to find O'Keeffe tête-à-tête with a young man, perhaps unimpressed with a box of small snapshots pre-

sented as photographic work, he was not encouraging. He told Evans his work was "very good" and to "go on working," but he was not particularly warm and he did not buy anything as a gesture of support, as he frequently did with young artists.

Evans reciprocated the disdain, turning Stieglitz into someone he could usefully reject, defining himself by his difference from a Stieglitz he simplified into a romantic pictorialist. He especially hated Stieglitz's personal manner—his Old World affectations like the loden cape he often wore, his aestheticism, his philosophizing. He went back to the Intimate Gallery a few times but with a marked lack of sympathy for the proprietor. He wrote a friend, "Saw Stieglitz again. He talked at length. He should never open his mouth. Nobody should, but especially Stieglitz." On that visit, Stieglitz showed Evans some photographs the young man considered excellent—clouds, grass, the rump of an old white horse, the bark of a tree. But he hated the pretentiousness of what Stieglitz said about his work—for example, that it was years before he dared to do the pictures of the tree bark. He also hated Stieglitz's "caption" for the picture of the horse, "Spiritual America." For Evans, Stieglitz was history. "Oh my God, clouds? Or O'Keeffe's hands, breasts—I was doing junk cars."[3]

Evans was in the vanguard. American photographers would increasingly see themselves as cool recorders of fact, emphasizing their lack of emotional reaction to what they photographed and photographing subjects that were not conventionally beautiful: Evans's sharecroppers, Diane Arbus's dwarfs and giants, Irving Penn's aborigines, Robert Frank's Americans, to mention just a few. Reality was to be found in the tossed away, the rejected, the offbeat, precisely in what was not routinely valued, whereas Stieglitz was still making love with his camera in a giant Whitmanesque embrace of the universe. "Oh my God, clouds?"

But that was only one young artist's reaction. For Arthur

Dove and O'Keeffe, the Equivalents were revelatory, showing how even photographic images could be abstract and still have emotional power. Dove, who had almost no money, bought two of them.

Isamu Noguchi, as an unknown twenty-one-year-old, also reacted to them strongly. He came into the Intimate Gallery one day when O'Keeffe's work was on the wall and spoke to Stieglitz about the "wonder" of her paintings. "They are born in wonder, just as there is wonder in us as you and I discover each other," said Stieglitz, showing why young people liked him and older people found him annoying. Impressed with his visitor, Stieglitz brought out some cloud photographs. Noguchi looked at the tiny prints—the ones Stieglitz showed him were printed on postcard paper—and said, "That is art." Stieglitz told him he was the first of the "youngsters" to understand the prints, to which Noguchi replied "that nature was like a huge keyboard of a musical instrument and that the man who could pick out the chords, could see the relationships, was the artist."[4]

The account of Noguchi's visit, besides showing Stieglitz's way with the gifted young and testifying to the impact these photographs had when they were first made, also suggests how they were meant to be seen, intimately, passed from hand to hand, as part of an ongoing discussion of art or in some other way that allowed for intense personal engagement.

Nancy Newhall, the photography curator and writer, recorded how deeply skeptical she had been of the cloud photographs as a young woman. "Frankly, I thought they were mostly humbug, and Stieglitz at his romantic worst." Stieglitz tried to explain to her what each one meant to him. One was the Immaculate Conception, another a prayer, another "death riding high in the sky." Another was "reaching up beyond the sun, the living point, into darkness, which is also light." They all had death in them, he said, because he started to do them

after he realized that O'Keeffe could not stay with him. This was no help to Nancy Newhall. His "dramatic anecdotes" did not move her.

Then one afternoon he turned her loose with several boxes of Equivalents. She was one of the only people he trusted to handle his prints unsupervised, a privilege he did not accord even to Dorothy Norman. After a couple of hours, she rejoined him in tears and in despair about how to make others feel their power. For her that power had to do with the series as a series, the pieces rearranged to produce different resonances.

"You will have to make your own Equivalents," Stieglitz said, and Newhall took this as encouragement to arrange photographic sequences, sometimes with text, sometimes without, for exhibitions and for printed books, as she went on to do, with Paul Strand and Ansel Adams. "Behind all of us stands Stieglitz," Newhall said. "Without the Equivalents and the sequence concept . . . we might never have done what we have."[5]

In 1929, two months after the stock market crash and one month after the opening of the Museum of Modern Art, Stieglitz began his work at An American Place. Finally he had a gallery that was worthy of the art he showed there, roomy and airy, with city views from the corner of Madison Avenue and 53rd Street. Instead of cloth on the walls, there was white paint or a light gray especially chosen by O'Keeffe to show off the art. The cement floors were kept uncarpeted and painted gray. Here Stieglitz dedicated himself to showing the work of Marin, Dove, and O'Keeffe. He showed the work of others, too—Paul Strand, Demuth, once George Grosz, once Ansel Adams, once Eliot Porter, now and then Hartley, sometimes his own—but every year he showed Marin, Dove, and O'Keeffe. Dove's belief that a painting was made not by what was painted but how it was painted became the American Place credo. Modernity, American-ness—whatever quality it was one sought had noth-

ing to do with the object or spectacle depicted. "Am more interested now than ever in doing things than doing something about things" was how Dove put it, in language worthy of Gertrude Stein.[6]

An American Place existed in counterpoint to the Museum of Modern Art, the gallery's very name a rebuke by Stieglitz to the pretensions of the museum, which was, he felt, the opposite of everything he stood for. The opening show had been of work by Cézanne, Van Gogh, Seurat, and Gauguin. *That* was modern art? Cézanne? Van Gogh? They were Old Masters to Stieglitz, and French to boot. What was the museum doing, with all its enormous resources, for living American artists, the ones he supported? The cost of running a museum— the staff, the upkeep—was outrageous. Look at what he could do on almost no money. The museum's backers, especially Abby Aldrich Rockefeller and Lillie Bliss, he regarded as dilettantes, along with Gertrude Whitney with her little collection. Furthermore, he disapproved of art institutions run by committee. Perhaps he disapproved of all art institutions that he did not run—and all women patrons.

Both from his new gallery and from his apartment at the Shelton Hotel, Stieglitz photographed the new New York City. When he and O'Keeffe moved into the Shelton, the Waldorf Astoria across the way was under construction. So was the huge Rockefeller Center complex. The GE Building, an art deco masterpiece at 570 Lexington Avenue, rose just in front of them to the north. In the late twenties and early thirties, before the Depression took hold, New York experienced a burst of construction that produced many of its iconic buildings. The Chrysler Building was finished in 1930, the Empire State Building in 1931, and the Waldorf-Astoria opened that same year.

It's uncertain whether Stieglitz saw the great buildings of New York that he photographed in the early 1930s as majestic

monuments, urban equivalents of the Rockies, or as evidence of a shoddy and rapacious capitalism. By the time the catastrophic effects of the Depression were clear, these expensive buildings, begun in a different mood and at a different economic moment, seemed to some people deeply ironic. Stieglitz's friend Lewis Mumford, the radical architecture critic, considered the new buildings "the architectural bluff and fraud of the boom period."[7] Visitors to An American Place often heard Stieglitz carry on about "the empty, overornamented skyscraper across the street, built while artists starve; at the building of Rockefeller Center while the Detroit Art Museum has been closed."[8] But this was the man who had compared the Flatiron Building to the Parthenon, the first photographer to demonstrate the beauty of New York's skyline and waterways.[9] His photographs, captions aside, are not ironic or satiric. What he said might go in any direction, sometimes taking potshots at the inferior and commercial, but what he photographed, he savored.

To see New York from the top of skyscrapers was a new and thrilling experience to people in 1930. Both Stieglitz and O'Keeffe were dazzled by living high up, keeping their rooms utterly bare in order to focus on the views, each of them stimulated by the Olympian position to produce art. O'Keeffe's New York paintings were instantly popular, and the photographs Stieglitz made from the windows of his various perches in the 1920s and 1930s are some of his most appealing work.

New York from on high inspired him the way street-level, gas-lit, horse-filled, turn-of-the-century New York had earlier. His taste had become more abstract, more hard-edged, more attuned to the rhythm of inanimate things, drawn to the tense boundary between darkness and light rather than to highlights at play on a dark field in the pictorialist manner. The windows of buildings became notes in a composition, whether the windows were bright with electric light, darkened by night or shadow, or marked by Xs of protective tape to be removed

when the building was finished. Greenough sees these photographs as "having some of the sheer delight in form and chaos that you find in Mondrian's Broadway Boogie Woogie."[10] Stieglitz had seen and liked Mondrian's diamond paintings at the Brooklyn Museum in 1926, and his New York photographs also bear comparison with the jazzy 1930s paintings of Stuart Davis.

Through his lens, Stieglitz was actively engaged with a great city under construction. The contrast between the finished and the unfinished, the skeletal structure that could be seen through and the massive structure that conceals so much—this had always fascinated him in the city and it fascinated him still. In every way these pictures are about movement and change, not only recording the growth of the buildings to completion but tracing how they are marked by time as sunlight and shadow pass over their facades. Although many of Stieglitz's finest critics see the city photographs as evidence of sadness and isolation, I see them as evidence of continued involvement.[11]

The mark of a person who stays alive his whole life is, even more than his ability to start new projects, his capacity to make friends with younger people. Stieglitz never lost this ability. Of the younger photographers who brought their work to him in his later years, Stieglitz did not respond to Walker Evans or to André Kertesz, but he did respond to Ansel Adams, Edward Weston, and Eliot Porter, among others. Especially Ansel Adams.

Gifted and likeable, Ansel Adams came to New York from California in 1933 in order to meet Stieglitz. Stieglitz immediately endorsed his work and in 1936 gave him his first show. He came to hope that Adams would be his successor, continuing his fight for photography in the same way he had conducted it—in New York, through a gallery. But Adams was too much a Californian, and although he deployed a technical expertise

Alfred Stieglitz, *From My Window at An American Place, North*, 1930–31.
(Alfred Stieglitz Collection, 1949. The Art Institute of
Chicago/Art Resource, NY.)

Alfred Stieglitz, *Looking Northwest from the Shelton, New York*, 1932.
(Ford Motor Company Collection, Gift of Ford Motor Company and
John C. Waddell, 1987. Image copyright © The Metropolitan Museum of Art.
Image source: Art Resource NY.)

and perfectionism equal to Stieglitz's own, sharing his obsession with tonality and taking to another level his love of clouds, monuments, and changing light, he continued the fight for photography in his own way.

The greatest new "friend" of Stieglitz's later years was Dorothy Norman. This young wife and mother began going to the Intimate Gallery in 1927 and by 1928 was there almost daily, helping Stieglitz run it. When Stieglitz had to give up the space at the Anderson Galleries, Norman, along with the Strands, was instrumental in finding money and new rooms so Stieglitz could continue his ministry. The Normans contributed $500 a year to the American Place rent fund, making them Stieglitz's major backers, and Dorothy Norman spent much of her day there helping him. Although O'Keeffe had no interest in the role of assistant to Stieglitz that Norman was eager to play, Norman's constant presence and Stieglitz's increasing infatuation with her were part of what drove her to New Mexico.

A thoughtful and rebellious girl raised in a well-off Jewish family in Philadelphia, Norman couldn't wait to get away from home and get a decent education. She went to Smith College, which she found too conventional. In any case her career there was cut short by illness. She transferred to the University of Pennsylvania, furious to find herself back in Philadelphia and living at home. Many of her classes at Penn were required courses in education, and she hated them, too. Luckily, she discovered that Penn students were allowed to take a class on modern art at the Barnes Foundation, and it was here, viewing paintings and sculpture that spoke to her freedom-loving soul, that she really began her education.

She completed her escape from conventional life in Philadelphia by falling in love with and marrying Edward Norman, who worked for a New York–based magazine called *Survey*. This earnest left-wing publication used sociological research to

aid reform, covering issues like labor conditions, race relations, and housing. *Survey* had been the only required reading Dorothy liked in a sociology course she took at Penn, so when she met a young man who worked for the magazine, she was immediately impressed. He spoke to the side of her that wanted to do good, and he was in a position to do it: a member of the Jewish family that acquired Sears Roebuck in 1895, when it was grossing $800,000 a year, and turned it into a company grossing $11 million annually by 1900. His father, Aaron Nusbaum, who later changed his name to Norman, was the person Richard Sears approached when his company needed capital. Nusbaum brought in his brother-in-law, Julius Rosenwald, who eventually bought Nusbaum out because he was so difficult to deal with, as his son would prove to be.[12]

Dorothy moved from the charity work that was considered appropriate for middle-class women of her generation to something broader based and more political. In New York, she worked for the American Civil Liberties Union as a researcher, while her husband devoted himself to promoting consumer cooperatives, the solution, he believed, to many of the ills of capitalism. Later in life, she founded a magazine called *Twice a Year*, devoted to modern art and civil liberties, her twin passions.

She was too busy with her job and her marriage to follow up on her love of art until 1927, when she became pregnant and her doctor made her stop working. She began going to museums and galleries near her home on East 52nd Street and so, eventually, wandered into the Intimate Gallery, that "shabby little room," and met Stieglitz. She was twenty-two. He was sixty-two.

He was the wisest and most energizing person she had ever met, the perfect person both to continue her education in modern art and to help her reconcile her passion for art and for social justice. Stieglitz focused her, encouraged her, enlarged

her. She did not see him as an older man but as a "sensitive, passionate man." He had "a youthfulness, vigor, and a sense of fullness about life unlike anyone I have ever known," she wrote. "His experience and wisdom are qualities of a mature man, but not of a father. I have no daughterly feelings towards him."[13] She placed him at the center of her life, along with her husband and family.

Working with him daily, she answered the phone, kept the books, helped him with inventory and correspondence. He began to tell her that the gallery was as much hers as his. When she got interested in doing photography herself, he taught her, loaned her cameras, critiqued her work. The friendship deepened. She began writing down everything he said in the hopes of producing an article about him, soon realizing that an article could not contain everything she wanted to say. For the next eighteen years, until Stieglitz died, she collected material that she would put into a book, *Alfred Stieglitz: An American Seer*, published in 1973, whose preposterous reverence for Stieglitz damaged his reputation for a generation to come.[14]

Norman served as a megaphone for the old-fashioned moral thematics that have worn so much worse than Stieglitz's actual images. For example, she believed in his description of the New York skyscraper photographs as a drama of darkness and light. "Man is faced by inevitable choices," he told her in his most oracular style, and she recorded every word. "He is forever being asked in one way or another whether he believes in white or in black. But how is he to choose one above the other? . . . How conceive of black without white? Why reject either since both exist? Indeed, it is at the very point where black and white form a positive manifestation of life that I am most aroused. There is within me ever an affirmation of light."[15]

But Norman was right in trying to make people see that

Stieglitz was more than a photographer. "Like some great force of nature," she wrote, "he has attracted to him and helped generate much of the most vital and life-enhancing work of our time."[16]

Stieglitz's circle had increasingly been joined by literary people. Sherwood Anderson, Hart Crane, Harold Clurman, and William Carlos Williams had become good friends, in addition to Lewis Mumford, Waldo Frank, and Paul Rosenfeld. Rosenfeld had published in 1923 a collection of essays called *Port of New York*, connecting the birth of American modernism with the cultural life of the city—specifically to fourteen figures, including Stieglitz and four of his artists, O'Keeffe, Hartley, Dove, and Marin. Carrying on Stieglitz's project of putting these artists at the center of a distinctively American art, Rosenfeld wrote that a "new spirit" was "dawning in American life." "For the first time, among these modern men and women, I found myself in an America where it was good to be."[17]

What he said about O'Keeffe made O'Keeffe cringe, purveying the view of her as ultimate female that Stieglitz liked and she detested. "Essence of womanhood impregnates color and mass, giving proof of the truthfulness of a life. . . . She is the little girl and the sibyl, the wild, mysterious long-haired one and the great calm rooted tree."[18] Although his subject is modernity, his overheated symbolist prose now seems decidedly unmodern. But Susan Sontag, an unlikely enthusiast, saw in Rosenfeld's florid piece on Stieglitz in *Port of New York* "the finest essay ever written in praise of photography."[19] According to Rosenfeld, Stieglitz found his perfect instrument in the camera and the camera found its perfect practitioner in Stieglitz, allowing him to "draw" fleeting images faster than the human hand could do it, opening up a whole new realm for awareness and appreciation. Rosenfeld's Stieglitz embodies Whitmanesque

inclusion. He has "cast the artist's net wider into the material world than any man before him or alongside him."[20]

In the mid-1930s, as Stieglitz approached his seventieth birthday, some of his new acolytes decided to honor him with a collection of essays. The festschrift is an old academic tradition. On the occasion of a scholar's retirement or a special birthday, his students publish a book in his honor, showing his influence. Often it is subtitled something like "Essays in Honor of X." *America and Alfred Stieglitz: A Collective Portrait* was a festschrift raised to the nth power. Instead of merely showing his influence on a small group of students, it aspired to show Stieglitz at the heart of the modern American enterprise. The editors were Frank, Mumford, Norman, Rosenfeld, and Harold Rugg, a professor at Columbia's Teachers College whose writings on education and social change were respected in the 1920s and 1930s but attacked in the 1950s as too socialist. This was a politically engaged group of people, several of them progressive Jews, and they were presenting Alfred Stieglitz as the leader of a cultural movement with political implications.

The quality of many of the essays is high. Mumford can be a dazzling writer, and Rosenfeld's "Boy in the Darkroom" is a splendid piece of condensed biography, laying out the myth of Stieglitz's growth as a photographer that would ever after be copied: the toy horses brought to the tintyper, and so on. But the volume as a whole cannot transcend its origin as a tribute. It recalls the "What Is 291?" issue of *Camera Work* in which Stieglitz, doubting the success of his mission, invited many friends to testify to its importance, but the *Camera Work* issue at least had the grace to publish negative views, like that of Steichen. The unmitigated reverence for Stieglitz permeating the 1934 volume made it seem "the breviary of some ecstatic cult," in the words of the *New York Times* reviewer, who singled out Dorothy Norman, who compared An American Place to a church, as especially lacking in perspective.

Whatever the book's faults, it filled a need the Literary Guild happened to have for a Christmas offering of an illustrated book about culture, and when Norman brought it to the attention of Carl Van Doren, the Literary Guild's editor in chief, he seized on the essays, with photographs by Stieglitz and reproductions of work by some of his artists, as the very thing he was after. The Literary Guild's publisher, Doubleday, printed thirty thousand copies, an extraordinary print run, and by Christmas of 1934 *America and Alfred Stieglitz* was in thirty thousand American homes. Stieglitz was introduced to middle America as the father of American modernism.

The political resonance was not lost upon some people whom it greatly offended. Just before *America and Alfred Stieglitz* appeared, the right-wing art critic Thomas Craven, in a volume called *Modern Art*, had called Stieglitz "a Hoboken Jew without knowledge of or interest in the historical American background." Craven belonged to a nativist tradition that did not want to see America become, in the words of Faulkner's Quentin Compson, "the land of the kike the home of the wop." Craven loathed anything that smacked of Europe. Modernism was "a horror practiced by every 'Jean, Jacques, and Judas.'" The artists who best represented American values for him were realists and regionalists like Thomas Hart Benton and Grant Wood.

In a piece titled "America and/or Alfred Stieglitz," Benton himself reviewed the tribute book. Although he and Stieglitz had been friends and the Bentons had visited the Intimate Gallery repeatedly, Benton now accused Stieglitz of "a mania for self-aggrandizement" and classed him with demagogues like Father Divine and Aimee Semple McPherson. His piece in turn provoked a "rejoinder" from Stuart Davis, who was at the height of his political activism, which linked Craven and Benton to the fascist view of abstract art as Jewish and degenerate. The Nazis had already invented the concept of degen-

eracy, weakness, and racial impurity in art, and the notorious Degenerate Art Exhibit, marking the cleansing of modernist filth from German museums, would take place in Munich in the summer of 1937.

John Gould Fletcher, a Pulitzer Prize–winning southern poet who was on the side of Craven and Benton, also weighed in on *America and Alfred Stieglitz*. In the same way the Nazis refused to accept modernist artists as real Germans, Fletcher refused to accept Stieglitz as a real American. He was instead a New Yorker, with "Manhattan contempt" for the heartland. Fletcher went beyond merely hinting at anti-Semitism, berating Stieglitz for using his "Jewish persuasiveness" in the service of "metropolitan charlatanry."[21]

Under the question of whose art was healthier and more American, there were deeper questions. Were Jews a part of the American story? Who was to control the story of American identity? Who was to decide which people were central and which outliers? Was America the land of the Puritans or a country of immigrants? Waldo Frank, whose Jewishness was central to him in a way that Stieglitz's was not, published a controversial piece in the *New Republic* in 1933 called "Why Should the Jews Survive?" His answer was because they had produced, among others, Freud, Einstein, Bergson, Marx, and Stieglitz. Frank had been metaphorically fighting for years to wrest America from its Anglo-Saxon founders and claim it for its immigrants.[22]

In 1933, when Hitler became chancellor of Germany and while *America and Alfred Stieglitz* was being prepared, there was already a huge bibliography of work documenting Germany's disowning of its Jews.[23] Could what was happening to Jews in Germany happen to them in the United States?

Just as the photographs of O'Keeffe between 1918 and 1922 show Stieglitz's infatuation with her, the O'Keeffe portraits

from the late 1920s and early 1930s show his recognition of the person she had become. No longer just the object of his gaze, she is allowed to project feelings of her own: she is self-contained, self-possessed, sometimes impish, sometimes mocking, a person not so much responding to the photographer as putting him in his place. He sometimes photographs her from below, increasing her stature. She often keeps her head covered by a scarf, as though her hair is nobody's business but her own. She had bought another Ford to use at Lake George, and he photographs her framed by a window or caressing the bodywork. In some photographs, she wears a blanket, as the Indians of the Taos Pueblo did, beads, or silver jewelry. In some she fondles bones and skulls she had shipped back from New Mexico. All were ways of insisting on her new identity as a painter of the Southwest. The place has become the person, the person the place. In Stieglitz's correspondence with Dorothy Norman, they refer to her as "SW." Georgia O'Keeffe and New Mexico were as married as she and Stieglitz, or as Stieglitz and his "Rooms."

"Though her beauty was feminine, her manner—neither coy nor artificial—had about it a directness and self-containment that was expected of men, not women," writes Roxana Robinson, O'Keeffe's biographer. "This strength and conviction became part of the aura of potency, of strangeness, that had begun to take shape around O'Keeffe."[24] The person she had made herself was folded into the person he made of her and presented to the world.

Her art became a part of his. Nowhere is this clearer than in his photographs of O'Keeffe with her skulls and bones. He understood that in these hard fragments, which she had shipped back in a barrel from the Southwest to Lake George, she had discovered imagery unique to her to which she would bind her art, imagery that could in no way be seen as conventionally feminine.

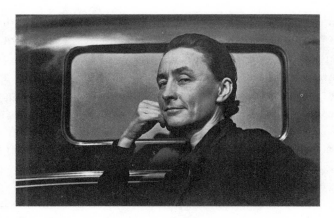

Alfred Stieglitz, *Georgia O'Keeffe—After Return from New Mexico*, 1929.
(Alfred Stieglitz Collection, gift of The Georgia O'Keeffe Foundation, with
funds from Mr. and Mrs. John J. F. Sherrerd, Lynne and Harold Honick-
man, John J. Medveckis, M. Todd Cooke, 1997. The Philadelphia Museum
of Art/Art Resource, NY.)

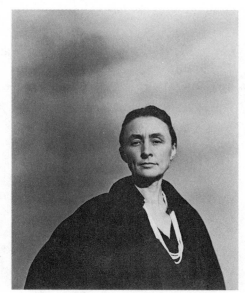

Alfred Stieglitz, *Georgia
O'Keeffe: A Portrait*, 1929.
Gelatin silver print, 4 1/2 ×
3 1/2 in. (The J. Paul Getty
Museum, Los Angeles.
© J. Paul Getty Trust.)

Alfred Stieglitz, *Georgia O'Keeffe—Hand and Wheel*, 1933. (Gift of Georgia O'Keeffe through the generosity of The Georgia O'Keeffe Foundation and Jennifer and Joseph Duke, 1997. Image copyright © The Metropolitan Museum of Art. Image source: Art Resource, NY.)

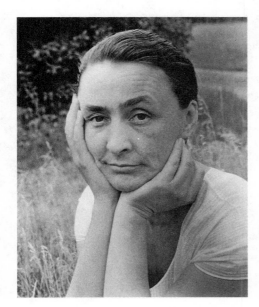

Alfred Stieglitz, *Georgia O'Keeffe*, 1933. Gelatin silver print, 4 1/2 × 3 1/2 in. (The J. Paul Getty Museum, Los Angeles. © J. Paul Getty Trust.)

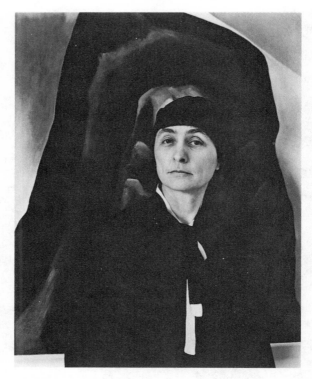

Alfred Stieglitz, *Georgia O'Keeffe at An American Place*, 1930. (Gift of Georgia O'Keeffe through the generosity of The Georgia O'Keeffe Foundation and Jennifer and Joseph Duke, 1997. Image copyright © The Metropolitan Museum of Art. Image source: Art Resource, NY.)

At the same time, Stieglitz had a new woman to photograph intensively, Dorothy Norman, and the photographs he made of her in the early 1930s unsurprisingly but revealingly differ from his photos of O'Keeffe. The pictures we have of Norman, for one thing, show only her face. The look Stieglitz responds to in her is consistent: she always seems slightly worried, a little dependent. However beautiful, Norman seems too conventionally feminine, too well-behaved and anxious to please to anchor an extended portrait with the impact of Geor-

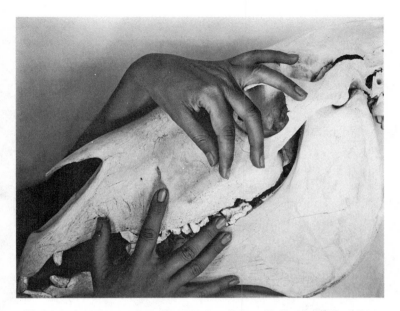

Alfred Stieglitz, *Georgia O'Keeffe—Hands and Horse Skull*, 1931. (Gift of Georgia O'Keeffe through the generosity of The Georgia O'Keeffe Foundation and Jennifer and Joseph Duke, 1997. Image copyright © The Metropolitan Museum of Art. Image source: Art Resource, NY.)

gia O'Keeffe. We see in her none of that guarded sense of self that generates so much of O'Keeffe's magnetism. On the other hand, the portraits of her have a formal beauty, an elegance and stateliness that will not be appreciated if we look in them for the qualities of the O'Keeffe pictures. With Norman, Stieglitz does not try, as in the pictures of O'Keeffe, to see varieties of line and pose or, as in the later pictures, to capture different moods. Her head in his photographs is, if one can use this word for a head, statuesque—like a Brancusi sculpture. He seems unable to tear himself away from her face, as though he wants to sit across from her for ever and ever, as though he can't get enough of her magnificent eyes, the sculpted nose and mouth. He locates something archetypal and iconic in Norman, which

cannot be said of O'Keeffe, who was nothing if not individual. Drama critic Harold Clurman wrote to Stieglitz about Norman's appeal, "I can readily understand why such a girl might at first (superficial) sight be overlooked. She presents no problems, no burden of personality to be dealt with. One can be with her and at the same time alone with oneself."[25] She is a fact of nature, as endlessly interesting to him as the sky and clouds.

If the first infatuated pictures of O'Keeffe show a man eager to explore every inch of the body of his new treasure, Stieglitz's photographs of Dorothy Norman show a man trying to convince himself that the beautiful thing he is lucky enough to have is really there in front of him. At the height of their love for each other, they had to see each other every day, repeat the magic words over and over. Sometimes he used merely the initials of his message of love: ILY, ILY. He wrote it all over one photograph he gave her.

Because Norman was herself a photographer, we have her pictures of him as well as his of her, and hers show a love that is deep and mutual. He is old now, and in many of the pictures he seems simply worn out. But every now and then a look comes into his eyes that brings him back to life. From youth to age, Stieglitz was photographed by just about every great photographer alive at the same time he was, but no one captures the look of adoration we see on his face when he stares into Dorothy Norman's camera. One feels sorry for O'Keeffe, now herself the spouse betrayed, but there is sympathy, too, for an elderly man experiencing the ultimate joy—that of romantic love—one last time. Consciously, Stieglitz felt guiltless about his romance. He was married. Norman was married. Neither intended to leave their marriage. Their affair, they believed, only made both marriages better. That they may have been fooling themselves does not cancel out their love or the good they did one another.

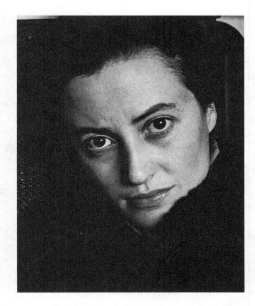

Alfred Stieglitz, *Dorothy Norman*, 1936. (Alfred Stieglitz Collection, 1949. The Philadelphia Museum of Art/Art Resource, NY.)

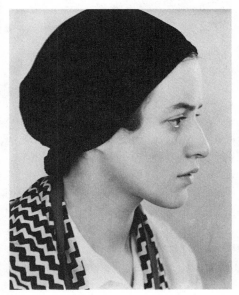

Alfred Stieglitz, *Dorothy Norman*, 1931. (Alfred Stieglitz Collection, 1949. The Philadelphia Museum of Art/Art Resource, NY.)

Dorothy Norman, *Alfred Stieglitz XXII, New York*, 1944.
(The Philadelphia Museum of Art/Art Resource, NY.)

Georgia O'Keeffe, eager to assert her new independence, accepted a painting commission in 1932 without consulting Stieglitz. She agreed to paint a mural in the powder room of the new Radio City Music Hall. The room's completion was delayed again and again, throwing O'Keeffe's schedule completely off, and the canvas began peeling away from the wall when she started to paint. Stieglitz was furious at her. She had agreed to do the work for too little money. It would keep her from doing paintings that sold for much more and on which they and An American Place depended. Adding insult to injury, the venue was part of the hated Rockefeller Center. Acting on

her own, O'Keeffe had gone astray, and with Stieglitz for the first time totally hostile to her, she lost confidence in herself—to the extent that she had what was called a nervous breakdown and she stayed in care at Doctors Hospital in New York for months. Roxana Robinson suggests that Stieglitz's fury was prompted not so much by rational objections to the commission as by his own guilt about the affair with Dorothy Norman. To legitimize the cruelty of his withdrawal of affection, "the cooling lover seeks just cause."[26] Still, it's possible his anger was the anger of a manager frustrated by a client who evaded his control and made a foolish move.

O'Keeffe spent most of 1933 unable to work, afraid to go out. What always helped to bring her back to herself was sun and warmth, only fitfully available at Lake George, and the steady admiration of a man who seemed calm and strong. Certainly not her husband, who could help only by staying away. At the hospital he had been allowed just ten-minute visits once a week; her sister had been her primary visitor. Once, she had found the soothing presence she needed in Mabel Luhan's Native American husband, Tony, whose steady calm was the reverse of Stieglitz's neurotic energy. In the winter of 1933–34, she found the same tonic in the African-American writer and poet Jean Toomer, who stayed and looked after her for a while in Lake George. Friendship, verging on the erotic in the case of Toomer, with these quiet men who were not always badgering her allowed her to rebuild herself. "What you give me," she wrote to Toomer, "makes me feel more able to stand up alone—and I would like to feel able to stand up alone before I put out my hand to anyone."[27]

Her breakdown was severe and horrible, and it scared both her and Stieglitz into change. Stieglitz realized how fundamental she was to him and backed off slightly from Norman; O'Keeffe realized she had to stand alone before she could help Stieglitz, as he would increasingly need her to do. In 1934, the

year that *America and Alfred Stieglitz* was published (with no contribution from O'Keeffe), she discovered Ghost Ranch in one of the most spectacular landscapes of America, the multicolored mesas and canyons of northwestern New Mexico on the eastern edge of the Colorado Plateau. From now on her time was as fixed as Stieglitz's—part of the year spent in New Mexico, alone, and part with Stieglitz in New York City or Lake George. Stieglitz never joined her in New Mexico, officially because his weak heart made the altitude dangerous for him. But they both realized that having it all to herself was part of the place's magic effect. "Me at my best," he told her, "would spoil what you are enjoying and receiving."[28]

Stieglitz ended his photography career in 1938. He had suffered a major heart attack and believed that the tension and excitement of taking a picture would be too much for his heart. He must have been tired. His life as a photographer had begun in the 1880s. He had lived long enough to see his own youthful work and that of others he had championed, like White and Käsebier, viewed as dated and empty. In 1933 he had started to throw out as garbage his entire collection of Photo-Secession photographs. Fortunately someone intervened, calling a curator at the Metropolitan Museum who sent a van that, with Stieglitz's permission, hauled the work off to the museum instead.

He lived six more years after laying aside his cameras, repeatedly saying that he wished he had died in 1938, at the time of his heart attack. He went every day to An American Place. A cot had been installed there so he could rest. He liked to complain that "everyone" had abandoned him—first Steichen, then O'Keeffe, then Dorothy Norman. Strand had turned in his key to An American Place and walked away years before. But feeling misunderstood, unappreciated, abandoned, and betrayed was Stieglitz's way of sucking oxygen. In fact he was

hardly alone. Dorothy Norman was still there often. He still attracted visitors and worshippers. He was a celebrity who made himself constantly, generously available. If Charlie Chaplin was in New York, Charlie Chaplin visited Stieglitz at his gallery. So did Henry Miller. So did the young, the old, the silly, the astute. He was open to all comers.

Beaumont and Nancy Newhall became the point people for his care. Beaumont Newhall, a Harvard-educated art historian who had been interested in photography from childhood, had begun working at the Museum of Modern Art in 1935 as librarian but gradually came to specialize in photography. He organized the museum's first photography show, the first American exhibition to trace the whole history of photography, from 1839 to 1937. His catalogue for this show was the first concise history of photography. Although Newhall had wanted to dedicate both the show and the catalogue to Stieglitz and to feature his work in the show, Stieglitz—motivated as ever by obscure resentments and snobberies, triggered so often by the name Rockefeller and by the Museum of Modern Art—refused to allow the dedication and even refused to allow any of his prints to be included. The catalogue was immediately successful and for decades became the standard textbook for the history of photography. Newhall begged Stieglitz to allow himself to be represented in the revised edition.

In the spring of 1938, in the immediate aftermath of the heart attack, Stieglitz was so sick that he was not expected to live, but he nonetheless obsessed about whether to allow his work to appear in Newhall's catalogue. O'Keeffe called the young man. "You must come. He's fussing and fretting about that photograph you want for your book. Of course you won't get it, but come take it off his mind." Stieglitz, however, had even more on his mind than that picture. He wanted formally to hand over to Newhall and to Ansel Adams his leadership of photography. Newhall, according to his wife, received this bene-

diction in "deep humility, almost in tears." But Stieglitz recovered, "to be as exasperating, frail, and wonderful as before."[29]

When a department of photography was formed at the Museum of Modern Art in 1940, Newhall was made the first head, but World War II cut short his tenure. He left to serve in the military, and the museum trustees turned his work (with reduction of title) over to his capable wife. Ironically, she relied on Stieglitz to learn how to navigate her job—how to manage a committee, for example. "Think it through yourself," he told her, "in all its possible permutations. Esthetic, financial, and so on. At that point, you propose your solution, which is often accepted out of sheer relief."[30]

Nancy Newhall was a lively, likable, intelligent woman, and in due course Stieglitz tried to annex her. At a moment when he was on the outs with both O'Keeffe and Norman, he suggested to Newhall that he move into her place. "My God," she reported, "it seemed to me like being appointed guardian to the Holy Grail." But she did not want to take on responsibility for this fragile and difficult man, no matter how much she loved and admired him. Nor did she want to rouse the anger of O'Keeffe. "It was with sorrow that I had to tell him I could not, under the present circumstances, offer mere physical shelter to him, who had so often been my spiritual shelter in time of trouble."[31]

Stieglitz kept going to An American Place until his death. He worried about how "his" artists would manage after he was gone. In fact, he had set them up nicely. Marin and O'Keeffe were prospering. Even Dove was getting by. Hartley had another dealer and was not his problem anymore. O'Keeffe had a retrospective at the Museum of Modern Art in 1946, arguably the pinnacle of a contemporary artist's career, and both of them, she and Stieglitz, saw it as the museum's triumphing over An American Place, making the Place irrelevant. His artists would do fine on their own.

O'Keeffe was in New Mexico when, in July 1946, Stieglitz had a massive stroke. By the time he died in the hospital four days later, she had flown to New York to be with him. Soon after his death, she went to An American Place and told Norman to clear out: the gallery belonged to O'Keeffe now; she didn't want Norman anywhere near it.

And now O'Keeffe showed exactly how grateful she was to Stieglitz for helping to make her who she was. She suspended her own work for three years in order to arrange the distribution of his work and collections. She consulted with museum curators in New York and Chicago. With an assistant, Doris Bry, she catalogued the mountains of material of all sorts that he had accumulated, thought through where things should be placed, and created a set of instructions for their care. He had believed that after his death she would destroy the nude photographs he had made of her, but this admirable woman did nothing of the sort. Meticulously, she set out to preserve his work as he had fostered hers. Dividing his prints into sets so that the range of his work could be studied at each institution, she gave sets initially to the Metropolitan Museum, the Philadelphia Museum of Art, the Boston Museum of Fine Arts, the Art Institute of Chicago, the Library of Congress, the National Gallery of Art, and Fisk University in Nashville. Later sets of his prints went to the San Francisco Museum of Art, because of Ansel Adams, and to the George Eastman House when it came into being with Beaumont Newhall as its first director. Each print had to be considered individually because Stieglitz, she knew, thought of each print as a separate work of art. She wanted the complete range of his work available at each institution. Her plans did not allow for loans.

Everything Stieglitz did was on a large scale and, despite his occasional impulses to clear, burn, and throw away, there were masses of material left. She gave all his papers, including his letters to her and hers to him, to Yale's Beinecke Library.

These letters have been published in a book of seven hundred pages that includes only a tenth of the letters exchanged before 1933. His correspondences with Dove, Hartley, Marin, and Kuehn are just a few of the extraordinary written exchanges he conducted. His collection of paintings, drawings, photography, and sculpture was vast. He had acquired a piece from almost every show he had mounted over the years. The largest part of this collection went to the Metropolitan Museum of Art because, as O'Keeffe said, he was "so definitely a New Yorker," but she tried to spread the work out both geographically and culturally.[32] Thus ninety-seven works went to the African American Fisk University in Nashville, including Cézannes, Picassos, O'Keeffes, Marins, Doves, Demuths, Hartleys, and African sculpture as well as the set of Stieglitz's own prints. It is worth taking a moment to consider how unusual this campaign of reasoned dispersal was. In most cases, a collector's death is followed by an auction. But O'Keeffe remembered how horrified Stieglitz had been by what happened to the collection of John Quinn upon his death. It was as though a great work of art was dismembered. One of the many reasons Stieglitz contrived to dislike the Museum of Modern Art was that the founders had, in his view, cannibalized the Quinn collection to start the museum, although another way to look at this is that the Museum of Modern Art was formed to preserve some of Quinn's collection.

When Stieglitz's works were distributed in 1949 and 1950, not much was known about the conservation of photographs. A multipage document prepared by O'Keeffe and Doris Bry, "Conditions for the Care of the Alfred Stieglitz Collection," served in effect to set standards, educating the first generation of photography curators in preservation.[33] The "Conditions," which were a binding part of the gift, specified requirements for storage, handling, reproduction, and exhibition, down to the thickness and quality of replacement mats. Under the orig-

inal provisions, loans were forbidden. There was to be no trav-
eling around of prints. The number of times a work could be
shown was specified. Even the replacement of matting had to
be cleared with O'Keeffe, Bry, or Newhall. Negatives were to
be destroyed or canceled. Reproduction was virtually forbid-
den. Only in catalogues accompanying shows or with special
permission could Stieglitz's photographs be reproduced.

The intention was to respect and preserve, but the effect
was to stifle and hide. Neither O'Keeffe nor Stieglitz foresaw
the way in which photography would permeate public con-
sciousness in the future. For both of them the photograph was
an easel work, and their ideal viewing was the relatively inti-
mate setting of a gallery, especially one where matted prints
could be examined without glass and frames. Neither imag-
ined how photography books might supplement or even take
the place of exhibitions and how mass reproduction would be
essential to cultural impact. O'Keeffe renewed and expanded
the "Conditions" in 1972. Not until 1998, twelve years after
her death (at the age of ninety-eight), did a New York court
grant a petition submitted by the Metropolitan Museum, the
George Eastman House, and the Museum of Modern Art, with
the support of the Georgia O'Keeffe Foundation, to loosen the
restrictions on lending and reproducing Stieglitz's works. The
world he envisioned, with art an intimate part of personal in-
teractions, a world rooted in the radical thinking of the nine-
teenth century, aimed at a renewal of society through a renewal
of individual spirit—that world had been superseded by one of
foundations and institutions, mass media and social networks.

In announcing her gift to the public of what she called the
Collection, O'Keeffe wrote a piece called "Stieglitz: His Pic-
tures Collected Him" in which she presented him as a sports-
man, a horse racing fan, whose work with his artists was his fa-
vorite game. "He was a leader or he didn't play. It was his game
and we all played along or left the game. Many left the game,

but most of them returned to him occasionally, as if there existed a peculiar bond of affection which could not be broken, something unique they did not find elsewhere." The artists he chose to back were maybe good to start with, O'Keeffe said. "Maybe Stieglitz's interest made them better than they would have been without him." He believed in them fiercely and fought for them violently. You could not imagine the violence of his combat if you had not seen it, she said.[34]

Riveting and energizing, irritating and depleting in equal measure, he said about himself that he wished he had some lightheartedness but never had any. That didn't mean he had no sense of humor. The thought of Paul Strand's earnest film about Mexican fishermen striking for higher pay sent Stieglitz (and O'Keeffe) into gales of laughter. There is no question that O'Keeffe knew him best and revered him in her distinctively down-home and clear-sighted way, with no clouds of incense obscuring *her* vision. "Alfred always insisted on wearing a certain kind of tie, a particular type of sock and underwear and shirt. I used to have to walk all over town trying to find those special kinds. Stieglitz was a funny man—he was pretty special though. He was one of those people who enjoyed his gloom, but you could make him laugh about it. He ate almost nothing and all the wrong things. He lived on energy, on interest. I've listened to him in intense debate with someone and wound up feeling as if I'd been beaten about the body with sandbags."[35]

She was from Venus. He was from Mars. She was solitary. He was social. She was intuitive. He was methodical. She used words gingerly. He used them licentiously, flinging them in great numbers against any situation or idea, hoping some of them would hit the mark. His management was essential to her career, as essential as her talent. His belief in her gift and his love for her gave him reason to live a whole second life. But they could not live it together. Stieglitz and O'Keeffe are an endlessly fascinating couple because the forces of energy and

entropy in their partnership are so powerful. They were always pulling apart and yet always drawing back together, and their taste and vision matched and fed each other in ways that are not at all obvious.[36]

"For me he was much more wonderful in his work than as a human being. I believe it was the work that kept me with him—tho I loved him as a human being. . . . I put up with what seemed to me a good deal of contradictory nonsense because of what seemed clear and bright and wonderful." She helped him to be an artist just as he helped her to be an artist, enacting a new paradigm of the relationship between man and woman, united in mutual support, each with a goal of the other's self-fulfillment. Generosity on both sides was key. It really worked for Stieglitz and O'Keeffe, in strangely different ways, for the whole of their lives. Taken all in all, there is no greater proof of the power of the couple than the union of O'Keeffe and Stieglitz.

Afterword

STIEGLITZ BELIEVED the Equivalents were his most important works, but how would he have seen them had he lived another fifty or sixty years? How would he have viewed contemporary photography? Would the spectacular color routinely available since the 1970s have excited him as much as the autochrome process had in 1907? Would the movement toward ultra-large prints have seemed to him a great opportunity or perhaps an easy trick? Would he have wanted to see the Equivalents enlarged to room size? Could he have reconciled himself to the role that fashion photography has played in the careers of some great photographers? Indeed, could he have reconciled himself at all to the current values and uses of photography?

I don't think he would be surprised or anything but pleased that as an artist Georgia O'Keeffe has eclipsed him in popular esteem. He always thought she would. Once she was on

her way, once she had been given a chance—that had been his role, to give her the chance—nothing could stop her. "She is the spirit of 291. Not me." I can hear them both snorting with laughter at the idea of a museum putting on a show not just of her work but of her clothing, as the Brooklyn Museum did in 2017. I think, however, that O'Keeffe would have understood, in a way Stieglitz could not, that what is now called "lifestyle" is sometimes viewed as a work of art, and that she is revered for that as much as for her painting.

Nancy Newhall saw two creatures tragically at odds within him: the artistic genius who destroyed other people for his own needs and the self-sacrificing man who worked on behalf of others. Both characterizations are banal and the two together don't come near to capturing Stieglitz's magnificent complexity. His work on behalf of others was self-aggrandizing and self-reinforcing as much as it was self-sacrificing, and his own artistic work, his photography, only minimally depended on making use of other people. Never fussy about his "art," he required no sacrifices for it, however much he demanded on behalf of his galleries. His rhetorical stance, that he was making love with his camera, seems refreshingly direct compared to many recent theories about the relation between photographer and subject.

He was extraordinary at spotting talent and bringing it along. In the dark early landscapes of Hartley, he could not have imagined the visionary brilliance of the German paintings. But he had faith in Hartley and kept him going, despite the man's personality. In the swirly charcoals of Georgia O'Keeffe, he could not have foreseen the master colorist and painter of southwestern landscape she became, but he had faith in her and gave her, too, what she needed to grow and prosper. Stieglitz could not have guessed the revolutionary watercolorist Marin would become from the Whistlerian etchings he was doing when they met, but he fought for him and opened

the path to greatness. De Zayas called Stieglitz an *accoucheur*, a midwife. Hartley called him a "creator of creators." He himself singled out the quality of the "follow-through" as most important to what he accomplished. He focused on just a few artists so he could "follow through" on them. The metaphor was from baseball, and baseball may be a better metaphor for the team sport Stieglitz modeled his life on than horse racing.

He thrived on battles and ordered his life by them, as though they were innings of a ball game: the battle to get photography accepted as an art; the battle to get European modernism respected in America; the battle to get Americans to respect (that is, to buy) American art; the battle to establish O'Keeffe as the first great American woman artist and Marin, Dove, and Hartley as great American artists. The opposing teams were museums that were slow to realize the value of the new; philistines who pooh-poohed abstraction; George Eastman, who insisted on cheapening photography and turning out inferior goods; rich Americans who wanted to spend their money only on Europeans whose reputations were already established; and artists who wanted instant fame and fortune.

Stieglitz got energy from fighting. Mumford saw him for the cantankerous pain in the neck he was and yet understood why he was that way, noting an "astringent quality" in Stieglitz's work that was rarely appreciated. "He has been nourished by his hates as well as his loves; he has never cultivated that harmless good nature which is responsible for half the stupidities of American life. Stieglitz's demonic negations are part of his deepest vitality."[1]

Mumford observed astutely that other photographers undervalued Stieglitz because he had no one style they could copy. His career lasted almost sixty years and evolved continually, from his early pictorialist works influenced by the Europeans to the later works, at once more homey and more abstract, focused on his life at Lake George and in New York City. And

through it all the portrait of O'Keeffe, as intimate a part of his life as his actual relationship with the woman herself.

Stieglitz's creativity was unique to Stieglitz, moving between the solitary work of photography and the social work of impresario as other artists move between solitary sessions in study or studio and the social world of parties, entertainment, or political action. Still, the urge to nurture in this combative man is striking. He nurtured photographers, he nurtured European painters and sculptors, he nurtured Strand, Marin, Hartley, Dove, and O'Keeffe. Of the many ways in which Stieglitz and O'Keeffe square-danced with gender roles, this is perhaps the most remarkable: that much of his creativity expressed itself in the stereotypically feminine form of encouraging growth and much of hers in a cascade of objects indelibly imprinted with her own look and personality.

Whether we call it masculine or feminine, one facet of his nurturance should be underlined. Although at the same time he may have demanded their emotional dependence and personal loyalty, he sought the financial independence of those he championed. Stieglitz understood that it took money to allow artists to make art, but instead of supporting O'Keeffe, he enabled her to be self-sufficient—so much so that she ended up rich and supported him. His father's generosity set the pattern, but the goal—to set others free—is his own and quite rare. Stieglitz himself never minded living off others, even prided himself on not earning enough to support a family. His neurotic relationship to money enabled him to live his life as patriarch and dependent both.

Photography as a field has evolved since Stieglitz's time, and Stieglitz's role in its history may be forgotten by all but specialists. I asked a knowledgeable friend who he thought had gotten photography accepted as art, and he replied, "Cindy Sherman." Furthermore, in our age of mass digital diffusion, the whole notion of "fine art" is viewed skeptically: the goal of

pushing photography into the ranks of the fine arts seems irrelevant.[2] Since Stieglitz, we have transitioned from a literary to a visual culture. Photographs are our primary way of conveying thoughts, feelings, and information. Almost everyone walks around with a camera for most of the day, able to process an image in nanoseconds and send it out via the internet to an almost limitless world. Everyone with an Instagram account distributes his or her own Equivalents—photographs of what life means to that individual. In these radical new circumstances, Stieglitz's insistence on education about art as equal in importance to art itself seems all the more prescient.

He said he hoped Photography would say of him that he had treated her as a gentleman should. Perhaps he could be humble only in the face of abstractions. Service to ideals freed him from his own competitiveness. The mystery to me is why he was so convinced that he did not know "how to be a part of the big game." But his abdication from other people's games gave him all the more energy for the ones he made his own: taking pictures and making painters.

A NOTE ON SOURCES

I COULD not have written this short book if many longer books about Stieglitz did not exist. The difficulty in writing about him is not the absence of information but the abundance of it. The primary material, both visual and written, is massive. The task becomes one of synthesis, taking previous work and melding it into a new story.

O'Keeffe's letters to Stieglitz and his to her, sealed until twenty years after her death in 1986, alone form an Everest of correspondence, threatening to lead us into the death zone of too much information. More than twenty-five thousand pages of letters between them are archived. Sarah Greenough published a selection of the letters in 2011. This extraordinary compilation runs to almost 740 pages—and it is merely the first of two projected volumes. Another volume, containing the letters from 1933 to 1946, when Stieglitz died, is to come. These two books, Greenough says, will contain only about a tenth of the entire correspondence. Stieglitz and O'Keeffe wrote daily, sometimes several times a day.

It was their way of talking to each other constantly, even when they were not in the same place. In a marriage that saw them apart for half the year yet inextricably tied, their letters were the binding medium.

O'Keeffe deposited all of Stieglitz's correspondence and manuscripts in Yale's Beinecke Library, and his family members followed suit with their private papers. Because of restrictions, material has been available only on an incremental basis. Gradually, matters of speculation have become matters of fact. Since 2006, when the O'Keeffe-Stieglitz letters became available, we have known exactly, for example, the date on which Stieglitz and O'Keeffe went to bed together for the first time, August 9, 1918, and that she was a virgin before that. Because of restrictions on Stieglitz's letters to Katharine Rhoades, no scholar before Kathleen Pyne could go beyond a mere suggestion of the importance of the relationship between them.

Above all, I have reason to rejoice in the existence of Richard Whelan's comprehensive biography of Stieglitz. Whelan, an art historian who previously wrote a biography of Robert Capa, published his astute and detailed book in 1995, and I consider it still the best overall biography of Stieglitz. I rely on Whelan so much that he does not often appear in the endnotes, where I tend to note sources for points of contention. I have never found an instance in which Whelan is wrong or ungenerous, and if he does not know something, he does not speculate.

Stieglitz was equally fortunate in the member of his family who wrote about him, his grandniece, Sue Davidson Lowe, who produced a loveable and loving memoir of Stieglitz, mostly based on an intimacy with him acquired in their summers together in the family compound on Lake George. She spent over a year going through the Stieglitz archive at Yale. She found so many "variations on every story that she decided the sanest approach to a biography of Stieglitz was "to concoct a compound and hope for an essence." Lowe is a lively writer, and she looks at Stieglitz both with the fondness and familiarity of a young relative and with the wisdom of a mature woman who knows how to handle a difficult man when she meets one.

Much work on Stieglitz has been produced in reaction to *Alfred Stieglitz: An American Seer*, written by the adoring Dorothy Norman from the point of view of one who saw Stieglitz almost more as a prophet than an artist. Her worshipful attitude provoked a reaction against Stieglitz that continues in some circles to this day. Some feel that any attention to Stieglitz's ideas is misdirected. Some still feel he needs taking down a peg. But Norman's book has its uses. Most of the worshipfulness is in the first chapter. The rest is chockablock with information, reminiscences, and quotations.

As the curator of photography at the National Gallery of Art, Sarah Greenough produced *The Key Set*, an indispensable publication that reproduces each Stieglitz photograph in the gallery's collection (there are sixteen hundred, especially chosen for their quality by O'Keeffe); documents its publication, exhibition history, and location of prints; and supplies, along the way, original and crucial biographical information. She probably knows more about Stieglitz than anyone, and her massive knowledge and deep consideration of his life and work is evident in everything she writes and everywhere she comments, from a book about Stieglitz's New York galleries to the transcript of a wonderful conversation one afternoon at the Getty Museum, when Weston Naef, John Szarkowski, Emmet Gowin, and Charles Hagen joined Greenough in talking about Stieglitz.

In the same year that Whelan published his biography of Stieglitz, Szarkowski, then curator of photographs at MoMA, put on the first specialized show of Stieglitz's work, accompanied by the book *Stieglitz at Lake George*, setting a new standard for sophistication in writing about Stieglitz's art. Would that there were more shows (and books) like this, focusing on a small part of Stieglitz's oeuvre. On the whole, most recent attention to Stieglitz has not been on Stieglitz at all, but on Stieglitz in relation to the other artists he knew and helped and especially in relation to the one he married, Georgia O'Keeffe. Their partnership is so fascinating that this is understandable. The need for one to resist the dominance of the other goes on in the afterlife, with positions reversed.

NOTES

Prologue

1. Stieglitz, in his description of how he came to take this picture, called the thick structure a funnel, but it was a mast. The *Kaiser Wilhelm II*, like many early steamships, still carried masts for supplementary or backup sail power and to anchor the booms used for loading and unloading cargo. Stieglitz's account "How *The Steerage* Happened" was published and probably written in 1942, thirty-five years after the event, for Dorothy Norman's magazine, *Twice a Year*. Norman reprinted the statement in *Alfred Stieglitz: An American Seer* (New York: Random House, 1973). The fullest consideration of *The Steerage* is to be found in Jason Francisco and Elizabeth Anne McCauley's essays in *"The Steerage" and Alfred Stieglitz* (Berkeley: University of California Press, 2012) in the series Defining Moments in American Photography, edited and introduced by Anthony W. Lee.

Chapter 1. Continental Divide

1. Richard Whelan, *Alfred Stieglitz: A Biography* (Boston: Little, Brown, 1995). For other accounts of Stieglitz's early years, see Sue Davidson Lowe, *Stieglitz: A Memoir/Biography* (New York: Farrar, Straus and Giroux, 1983); Katherine Hoffman, *Stieglitz: A Beginning Light* (New Haven: Yale University Press, 2004); Nancy Newhall, *From Adams to Stieglitz: Pioneers of Modern Photography* (New York: Aperture, 1989), esp. "Alfred Stieglitz," 65–70, and "Alfred Stieglitz: Notes for a Bibliography," 97–134. Indispensable for any work on Stieglitz is Sarah Greenough, *Alfred Stieglitz / The Key Set*, 2 vols. (Washington, DC, and New York: National Gallery of Art and Harry N. Abrams, 2002). When O'Keeffe distributed Stieglitz's work, she chose the finest example of each print for the National Gallery of Art, which published this complete catalogue of what is called *The Key Set*. The most beautifully printed examples of the early work are to be found in Sarah Greenough and Juan Hamilton, *Alfred Stieglitz: Photographs and Writings* (Washington, DC, and New York: National Gallery of Art and Callaway, 1999).

2. *New York Times*, October 16, 1875.

3. See Leonard Dinnerstein, *Anti-Semitism in America* (New York: Oxford University Press, 1995), esp. 42. See also Jacob Rader Marcus, *United States Jewry, 1776–1985* (Detroit: Wayne State University Press, 1993), 2:18.

4. Quoted by Dorothy Norman, *Alfred Stieglitz: An American Seer* (New York: Aperture, 1973), 31.

5. Now called Technische Universität (TU). Hochschule was more than a high school but could not be called a university because it did not grant degrees.

6. I find Stieglitz's decision to switch to photography from mechanical engineering brave enough either way. But I believe he made that change and began working with Professor Vogel before he bought his first camera. We know that Stieglitz first worked with wet-plate collodion, in which the glass plate, immediately before use, has to be prepared in several chemical baths and then developed immediately after exposure. Vogel taught the wet-plate

process—what the polytechnic's labs were set up to handle—until 1887, when the school moved to new quarters. There, three of the five darkrooms were arranged for the recently invented dry-plate process and only one for wet-plate, which was on the way out. Dry plates could be prepared in advance of exposure and development postponed, giving photographers much more flexibility. (The fifth darkroom at the polytechnic was for the even newer gelatin-based process, which would lead the camera to its future alliance with film.) Stieglitz has said that the camera he bought in Berlin used dry plates. Swinging back a door in his room to create a triangular darkroom, he could not conceivably have created a large enough space to work with wet-plate collodion. If wet-plate collodion came first, then Vogel preceded the camera.

7. *New York Morning Sun*, 1908, quoted in Whelan, *Alfred Stieglitz*, 72.

8. An easy way to experiment on what is involved in translating color to black and white is to open a color photo in Photoshop, click on Image>Adjustments>Black and White, and play with lowering or increasing the color sensitivity in the black-and-white output. (See plates 1 and 1a.)

9. Martin D. Saltzman, "Morris Loeb: Ostwald's First American Student and America's First Physical Chemist," *Bulletin for the History of Chemistry*, no. 22 (1998): 10–15.

10. Quoted by Greenough, *Key Set*, 1:4 (cat. #4).

11. Alfred Stieglitz with Louis H. Schubart, "Two Artists' Haunts," *Photographic Times*, January 1895, reprinted in Greenough and Hamilton, *Alfred Stieglitz*, 178–81.

12. Stieglitz made this photograph in 1889 and may have shown it in 1891, but its significance in his body of work emerged only later. This pattern of turning back to old work and seeing it anew, sometimes refashioning it, recurs in Stieglitz's career.

13. Greenough's *Key Set* note to *Sun Rays—Paula* (1:61) assumes that Paula of Berlin is Paula Bauschmied and the mother of his child, but see Stieglitz's letter to O'Keeffe of January 30, 1917, mentioning his experience with a peasant girl in Munich. For fine distinctions about the sex trade in nineteenth-century Europe, see

Balzac's novels and *Splendours and Miseries: Images of Prostitution in France, 1850–1910* (Paris: Flammarion, 2016), catalogue of an exhibition at the Musée d'Orsay, Paris (September 22, 2015, to January 17, 2016).

14. Rosalind Krauss, "Stieglitz/'Equivalents,'" *October*, no. 11 (1979): 129–40. See also Anne McCauley, "Rethinking Woman in the Age of Psychoanalysis: Alfred Stieglitz's Photographs of the Female Nude," in *American Photography: Local and Global Contexts*, ed. Bettina Glockel with Patrizia Munforte (Berlin: Akademie Verlag, 2012); and Diana Emery Hulick, "Alfred Stieglitz's Paula: A Study in Equivalences," *History of Photography* 17, no. 1 (1993): 90–94.

15. Vermeer's painting was on view in Vienna in the 1880s at the Czernin Picture Gallery. Stieglitz certainly would have gone to the gallery when he visited Vienna. As Berenson wrote to Isabella Stewart Gardner in 1897, the Czernin was one of the great private collections of Europe, "visited like the Borghese or Doria by everybody." The painting then tended to be called *In the Artist's Studio*, but it had been known as a painting about the art of painting from Vermeer's time onward.

16. Paul Rosenfeld, "The Boy in the Darkroom," in *America and Alfred Stieglitz: A Collective Portrait*, ed. Waldo Frank et al. (New York: Literary Guild, 1934), 69.

Chapter 2. City of Ambition

1. Norman, *Alfred Stieglitz*, 35.

2. *American Amateur Photographer*, December 1894, 568.

3. Nancy Newhall, "Alfred Stieglitz: Notes for a Biography," in *From Adams to Stieglitz: Pioneers of Modern Photography* (New York: Aperture, 1989), 124.

4. Arthur Wesley Dow, *Composition* (New York: Baker and Taylor, 1899), 53.

5. Christian A. Peterson, *Alfred Stieglitz's "Camera Notes"* (New York and London: Norton and the Minneapolis Institute of Arts, 1993), 90.

6. There were few precedents for photographic portfolios, and one-man portfolios were reserved for painters.

7. *Camera Notes* 3, no. 2, 77.

8. Newhall, *From Adams to Stieglitz*, 119.

9. See Rachel Cohen, *A Chance Meeting: Intertwined Lives of American Writers and Artists* (New York: Random House, 2004) for a full and subtle account of this friendship.

10. Newhall, *From Adams to Stieglitz*, 128.

Chapter 3. The Everlasting Yea

1. *American Amateur Photographer*, August 1904, 358–59.

2. Whelan, *Alfred Stieglitz*, 53.

3. Lowe, *Stieglitz*, 113.

4. *American Amateur Photographer*, December 1904, 535–36.

5. Alfred Stieglitz, "Some Impressions of Foreign Exhibitions," *Camera Work*, October 1904, 34–37.

6. Monika Faber, ed., *Heinrich Kuehn and His American Circle: Alfred Stieglitz and Edward Steichen* (Munich: Prestel Verlag, 2012), 56.

7. Theodore Dreiser, "A Remarkable Art: The New Pictorial Photography," *Great Round World*, May 3, 1902, 430–34.

8. Gum bichromate is a way of printing an existing negative that allows a great deal of painterly expressiveness. A sticky light-sensitive solution containing water-soluble pigment is brushed onto paper. The artist's touch is already evident in the application of the emulsion as well as in the choice of paper, which must be heavy, like watercolor paper, because it is going to be washed many times. The surface will be very textured in the end, looking quite different from the glossy silver gelatin prints we are used to. Next, the emulsion-covered paper is placed under the glass negative and exposed to ultraviolet light. Where the light comes through the negative, it hardens the tinted chromate solution underneath; the more that's been applied and the lighter the negative, the deeper the layer of emulsion hardened and the darker the darkness. The solution that has not been hardened is washed away, leaving whites that are basically the color of the underlying paper. The pigments in the brushed-on emulsion could be of any hue, and the same image could be worked over two or three times with a different color in each go-round. Complex color effects

were possible. Steichen was drawn by that possibility, using three different layers of color in some of his prints. One of his multiple gum bichromates, *The Pond—Moonlight*, sold at auction in 2006 for $2.9 million, the highest price ever paid until then for a photograph. Heinrich Kuehn, more interested in scale than color, produced some gum bichromate prints as large as twenty by thirty inches. His works have soft, luscious richness and tremendous graphic appeal.

9. Quoted by Joel Smith, *Edward Steichen: The Early Years* (Princeton: Princeton University Press and the Metropolitan Museum of Art, 1999), 22.

10. Edward Steichen, *A Life in Photography* (Garden City, NY: Doubleday, 1963), unpaginated.

11. Ibid.

12. See Sarah Greenough, ed., *Modern Art and America: Alfred Stieglitz and His New York Galleries* (Washington, DC: National Gallery of Art, 2000), 543–47, for a complete list of the shows at 291. An essential account of the Photo-Secession is Weston Naef, *The Collection of Alfred Stieglitz: Fifty Pioneers of Modern Photography* (New York: Metropolitan Museum of Art and Viking, 1978).

13. "*The Manger*, by Gertrude Käsebier, generally considered the gem of last year's Philadelphia Salon, was recently bought by a New York lady for one hundred dollars. The purchaser had never taken any interest in photography, nor knew anything of the claims of pictorial photographers. She bought the picture as a picture, regardless of its means of production. This is the second time within a year that one hundred dollars has been paid for a pictorial photograph in this city, showing that exceptional work in that line occasionally does find appreciation of the right kind." *Camera Notes* 3 (April 1900): 218. Stieglitz prefers to ignore that the lady may have treasured this image for sentimental or religious reasons.

14. Steichen, *A Life in Photography*.

15. Greenough, *Modern Art and America*, 281. Of the burst of over 300, 190 were of Georgia O'Keeffe.

16. "Photographing the Flatiron Building," *Twice a Year*, nos. 14–15 (1946–47): 9–12.

17. Smith, *Edward Steichen*, 24.

18. Ibid.

19. *Camera Work*, January 1903, 63.

20. *Tout est bien sortant des mains de l'Auteur des choses; tout dégénère entre les mains de l'homme.*

21. She is perhaps best known now as the artist who illustrated the Waite tarot deck.

22. J. P. Morgan took control of the situation and ended the financial panic for the moment. The larger problem, the untrustworthiness of the American banking system, was supposedly solved in 1913 with the institution of the Federal Reserve system.

23. "How *The Steerage* Happened."

24. Allan Sekula reads Stieglitz's account of the photo's creation as a piece of symbolist autobiography. See "On the Invention of Photographic Meaning," *Artforum* 13, no. 5 (January 1975): 36–45. For why he paid no initial attention to *The Steerage*, see also Francisco and McCauley, *"The Steerage" and Alfred Stieglitz*. Francisco speculates that Stieglitz feared the negative was thin and required processing he could do only in New York to compensate for the incorrect exposure.

25. Steichen, *A Life in Photography*, 59.

26. Stieglitz, "The New Color Photography," *Camera Work*, October 1907, 20–25, reprinted in Jonathan Green, *Camera Work: A Critical Anthology* (Millerton, NY: Aperture, 1973), 124–29.

27. Ibid., 25.

28. "Writings and Conversations of Alfred Stieglitz," *Twice a Year*, no. 1 (1938): 81.

29. Alfred Stieglitz to George Seeley, quoted by Whelan, *Alfred Stieglitz*, 281.

30. Alfred Stieglitz to Ernst Juhl, January 6, 1911, reprinted in Greenough and Hamilton, *Alfred Stieglitz*, 192–93. The amount 1,200 marks was equal to about $300 at the time.

Chapter 4. Creator of Creators

1. Lowe, *Stieglitz*, 158.

2. Later in life Steichen pioneered the field of fashion pho-

tography and helped build the photography department at the Museum of Modern Art. Steichen came to seem to Stieglitz commercial, and Stieglitz seemed pretentious to Steichen.

3. *Camera Work*, January 1912, 18.

4. *Camera Work*, no. 37, 247.

5. According to Sue Davidson Lowe, Weber poisoned the air of 291 and was edged out by Steichen and de Zayas. Weber and Stieglitz never spoke again after 1911. Weber often cut off his nose to spite his face. When offered the chance to hang two of his paintings in the Armory Show, he took the limit of two as an insult and refused to participate at all.

6. James Timothy Voorhies, ed., *My Dear Stieglitz: Letters of Marsden Hartley and Alfred Stieglitz, 1912–1915* (Columbia: University of South Carolina Press, 2002), 131.

7. Ibid., 125.

8. Mahonri Sharp Young, *Early American Moderns: Painters of the Stieglitz Group* (New York: Watson-Guptill, 1974), 68.

9. Voorhies, *My Dear Stieglitz*, 39. Stieglitz had shown the first Rousseaus in the small room at 291 in 1910. They were a group of small paintings that belonged to Max Weber. In the meantime, Rousseau had died of an infected leg wound.

10. Ibid., 17.

11. Ibid., 117.

12. Ibid., 47.

13. Ibid., 18.

14. Ibid., 19.

15. Ibid., 115.

16. Frank et al, *America and Alfred Stieglitz*, 238.

17. Quoted by Ruth E. Fine, "John Marin: An Art Fully Resolved," in Greenough, *Modern Art and America*, 342. Whelan, *Alfred Stieglitz*, 343, offers a slightly different account with different figures. But the point is the same: Stieglitz accepted outrageous behavior from Marin he did not from others.

18. Lisa Mintz Messinger, ed., *Stieglitz and His Artists: Matisse to O'Keefe* (New York: Metropolitan Museum of Art, 2011), 50.

Like so much else owned by Stieglitz, Picasso's drawing *Standing Nude* was eventually donated to the Metropolitan Museum.

19. "What Is 291?" *Camera Work*, January 1915, 40. The Meyers' Asian art collection is now a major part of the Freer Gallery in Washington, DC.

20. Stieglitz to Muir, quoted in Whelan, *Alfred Stieglitz*, 317.

21. *Camera Work*, April–July 1913, 47.

22. Greenough, *Modern Art and America*, 284.

23. See Messinger, *Stieglitz and His Artists*, 86, for the story of Davies's double life.

24. The "What Is 291?" issue of *Camera Work* was published in January 1915, but with a date of July 1914. However, it's clear from Steichen's words that he wrote his contribution after August 1914. Perhaps Stieglitz backdated the issue to avoid exactly the kind of comment Steichen made, that it was inappropriate to be worrying about things like this in a time of war.

25. *Camera Work*, April–July 1913, 14.

26. This photograph, published in the Dada magazine *The Blind Man* (May 1917) with the article "Buddha of the Bathroom," is the only record in existence of Duchamp's historic piece, so Stieglitz may be credited with saving it. On the other hand, it's likely that it was thrown out as junk during the emptying of 291.

27. John Szarkowski, *Alfred Stieglitz at Lake George* (New York: Metropolitan Museum of Art, 1995), 17.

28. In 2016 one complete set of *Camera Work* sold at Sotheby's New York for $187,000. Individual copies are currently listed at auction for prices ranging from $3 to $20,000.

29. See Wanda M. Corn, *The Great American Thing: Modern Art and National Identity, 1915–1935* (Berkeley: University of California Press, 1999)

Chapter 5. The Man Behind the Woman

1. Anita Pollitzer to Georgia O'Keeffe, October 1915, in *Lovingly, Georgia: The Complete Correspondence of Georgia O'Keeffe and*

Anita Pollitzer, ed. Clive Giboire (New York: Simon and Schuster, 1990), 38–39.

2. Ibid., 68.

3. Ibid., 63.

4. Ibid., 52, 53.

5. Ibid., 75, 64, 39, 40.

6. See Norman, *Alfred Stieglitz*, 130–31. However, so many details are incorrect that few scholars trust this story.

7. Sarah Whitaker Peters, *Becoming O'Keeffe: The Early Years* (New York: Abbeville, 1991), 44–61, 125. Peters convincingly shows how O'Keeffe's early work employs motifs that derive from art nouveau and symbolist art. See also Barbara Haskell, "Making the Unknown Known," in *Georgia O'Keeffe: Abstraction*, ed. Barbara Haskell (New Haven: Yale University Press, in association with the Whitney Museum, Phillips Collection, and Georgia O'Keeffe Museum, 2009). "How she built a radical abstraction on the foundations of a decorative arts aesthetic . . . is the subject of this essay."

8. *Camera Work*, October 1916, 12. Laurie Lisle was the first to notice that Pollitzer had added the phrase "At last, a woman on paper," to a letter. See her *Portrait of an Artist: A Biography of Georgia O'Keeffe* (Seaview Books, 1980), 69; and Haskell, "Making the Unknown Known," 16n60.

9. Steichen had an affair with another of the trio, Marion Beckett, and in 1919 Clara Steichen named her as a correspondent in divorce proceedings.

10. Alfred Stieglitz to Katherine Rhoades, December 4, 1914, YCAL MSS85. In 1914 Stieglitz started putting pressure on Rhoades to have sex with him. See also Kathleen A. Pyne, *Modernism and the Modern Voice: Georgia O'Keeffe and the Women of the Stieglitz Circle* (Berkeley: University of California Press, 2007), accompanying an exhibit in 2008 in Atlanta, Santa Fe, and San Diego. Pyne was the first scholar to use the Rhoades letters to Stieglitz at Yale.

11. Rhoades went on to be the constant companion and assistant of industrialist Charles Lang Freer, Whistler's greatest patron

and a collector of Asian art. She helped him catalogue his collection. They never married, but he left her a large enough legacy so she didn't have to work. When he died in 1919, she and Agnes Meyer became trustees of his estate and oversaw the founding of the museum in Washington, DC, that bears his name, the Freer Gallery of Art, part of the Smithsonian.

12. Newhall, *From Adams to Stieglitz*, 124.

13. Giboire, *Lovingly, Georgia*, 256.

14. Interview with Lou Stettner, 1972, quoted in *Paul Strand: Sixty Years of Photographs; Excerpts from Correspondence, Interviews, and Other Documents*, profile by Calvin Tomkins (Millerton, NY: Aperture, 1976), 142, 20. See also Naomi Rosenblum, *Paul Strand: The Stieglitz Years at 291 (1915–17)*, brochure of exhibit, Zabriski Gallery, New York, March 22–April 23, 1983.

15. Georgia O'Keeffe to Anita Pollitzer, June 20, 1917, in Giboire, *Lovingly, Georgia*, 256.

16. Georgia O'Keeffe to Paul Strand, June 3, 1917, quoted in Whelan, *Alfred Stieglitz*, 387.

17. *Camera Work*, October 1916, 11.

18. Georgia O'Keeffe to Alfred Stieglitz, September 4, 1916, in Jack Cowart and Juan Hamilton, *Georgia O'Keeffe: Art and Letters*, with letters selected and annotated by Sarah Greenough (Washington, DC: National Gallery of Art, 1987). See also Sarah Greenough, ed., *My Faraway One: Selected Letters of Georgia O'Keeffe and Alfred Stieglitz*, vol. 1, *1915–1933* (New Haven: Yale University Press, 2011), 122.

19. Georgia O'Keeffe to Paul Strand, October 24, 1917, in *Georgia O'Keeffe: Art and Letters*, 165.

20. Georgia O'Keeffe to Paul Strand, November 15, 1917, in ibid., 165.

21. Alfred Stieglitz to Georgia O'Keeffe, May 3, 1918, in Greenough, *My Faraway One*, 282.

22. Alfred Stieglitz to Paul Strand, May 17, 1918.

23. Ibid.

24. Alfred Stieglitz to Georgia O'Keeffe, May 26, 1918, in Greenough, *My Faraway One*, 296.

25. Strand photographed Georgia's friend Leah Harris nude and reported O'Keeffe's refusal to Stieglitz, adding that he thought she would pose nude for him, to which Stieglitz replied, "Perhaps she would. I don't know." Stieglitz then reports this exchange to O'Keeffe and adds how glad he is that she hadn't let anyone else see and touch her before him. "The intensest of intense spiritual something" that is developing between them "through gradual discovery and gradual contact" would be different if she had posed for Strand. See Stieglitz to O'Keeffe, mid-June 1918, in Greenough, *My Faraway One*, 303.

26. Georgia O'Keeffe to Alfred Stieglitz, June 13, 1918, in ibid., 302.

27. Alfred Stieglitz to Georgia O'Keeffe, August 5, 1929, in ibid., 506. See also Sue Davidson Lowe's account of that summer in *Stieglitz*.

28. *The Satyress*, which Rodin called "Woman Supreme," was such a favorite of Stieglitz's that Rodin made him a gift of it. It's now in the Metropolitan Museum of Art. See Messinger, *Stieglitz and His Artists*, 65.

29. Tanya Berson, curator of the O'Keeffe show at the Tate in 2016, took this position, seeing the portraits as a collaboration, with O'Keeffe displaying her strength in her poses. The images could not have the power they do without her collaboration, says Barson: see Hattie Crisell, "A Collaboration Between Georgia O'Keeffe and Alfred Stieglitz, Captured over 20 Years," *New York Times Style Magazine*, July 6, 2016. Long before that, Sarah Greenough found the idea of a collaboration preposterous, akin to saying that Saskia "collaborated" with Rembrandt in his portraits of her. It seems likely to be a contentious subject for some time. For Greenough's position, see Weston Naef, ed., *In Focus: Alfred Stieglitz, Photographs from the J. Paul Getty Museum* (Los Angeles: J. Paul Getty Museum, 1995), 125–26.

30. See *Georgia O'Keeffe: A Portrait by Alfred Stieglitz* (New York: Metropolitan Museum of Art, 1978), with an unpaginated introduction by Georgia O'Keeffe. O'Keeffe pointed out that when she knew him Stieglitz never traveled to find a subject to

photograph. "His eye was in him, and he used it on anything that was nearby."

31. Ibid. This book accompanied the first showing of the nudes since 1921, arranged by the curator, Weston Naef. O'Keeffe's introduction is essential for re-creating the circumstances of the sittings and the feelings of the model, although the account was given sixty years after the event. As an old woman, she emphasized her disconnect from the person she was when young. Her passion for Stieglitz—as opposed to her respect for his talent—has to be intuited from the photographs themselves.

32. The Getty has five of these images. There are eleven in the *Key Set*. There is a brilliant discussion of the photograph of Ellen emerging from the water between John Szarkowski, Weston Naef, and Sarah Greenough in Naef, *In Focus*, 120–22.

33. Barbara Buhler Lynes, *Georgia O'Keeffe: Catalogue Raisonné*, 2 vols. (New Haven: Yale University Press, National Gallery of Art, and the Georgia O'Keeffe Foundation, 1999), 1:62 (cat. #66).

34. Greenough, *Key Set* #586, 1919, National Gallery of Art, palladium print, 1980.70.127. Another print is in the Yale Waste Basket Collection. See *Key Set* #584–91 for more of Stieglitz's photographs of the object.

35. Naef, *In Focus*, 58. For another discussion of Stieglitz's sexualization of this object, see Susan Danly, *Georgia O'Keeffe and the Camera: The Art of Identity* (New Haven: Yale University Press, in association with the Portland [Maine] Museum of Art, 2008).

36. Peters, *Becoming Georgia O'Keeffe*, 70–71.

37. Edward Stieglitz had been a patron of Moses Ezekiel, an American-born Jewish sculptor who lived most of his life in Rome and produced neoclassical works that were very much to the elder Stieglitz's taste. He had plaster copies of Judith made for each of his children (see Lowe, *Stieglitz*, 88). *Key Set* #791 is another photograph of Judith, made in 1922. She was a favorite butt of Alfred's jokes. He called the photograph of her being hauled uphill "just fun," yet he put it in his 1923 show. Judith was the heroine in the Old Testament account who lured an enemy general, Holofernes, into her tent and then beheaded him.

38. Alfred Stieglitz to Paul Strand, November 2, 1920, in Greenough, *Key Set* #623 (1:375).

39. Alfred Stieglitz to Hart Crane, 1922, quoted by Greenough, *Key Set* #777.

40. Since some people found it hard to separate the impact of his O'Keeffe photos from their subject, he determined to make photographs in which the sensibility of the photographer was all, the subject of no importance—pure visual music. See Szarkowski, *Alfred Stieglitz at Lake George*, for a smart discussion of Stieglitz's too many explanations of why he started photographing clouds and for a skeptical view of the impact of the prints.

41. Geoff Dyer, *The Ongoing Moment* (New York: Pantheon Books, 2005), 80.

42. Greenough, *My Faraway One*, 410, 418.

43. Ibid., 459.

44. Herbert J. Seligmann, *Alfred Stieglitz Talking: Notes on Some of His Conversations, 1925–1931* (New Haven: Yale University Library, 1966), 56–57.

45. Ibid., 107.

46. Ibid., 34–35.

47. See Whelan, *Alfred Stieglitz*, 498. The biographer who sees this transaction as an outright fraud is Benita Eisler in *O'Keeffe and Stieglitz: An American Romance* (New York: Nan A. Talese, 1991). She in turn cites Kennerley's biographer Matthew Bruccoli, but her biography is consistently sensationalist.

48. Quoted by William C. Agee, "Arthur Dove: A Place to Find Things," in Greenough, *Modern Art and America*, 421.

49. Alfred Stieglitz to Aline Meyer Liebmann, quoted in Whelan, *Alfred Stieglitz*, 423.

50. Greenough, *My Faraway One*, 420n25, 422n31.

51. Ibid., 461.

Chapter 6. Ripe Apples

1. Szarkowski, *Alfred Stieglitz at Lake George*, 28.

2. Norman, *Alfred Stieglitz*, 144.

3. See James Mellow, *Walker Evans* (New York: Basic Books,

1999). In 1983 Richard Prince did a "re-photograph" of Garry Gross's photograph of ten-year-old Brooke Shields standing naked in a bathtub, oiled, made up, being photographed for *Playboy* with her mother's permission. He called it *Spiritual America*.

4. Seligmann, *Alfred Stieglitz Talking*, 62–63.

5. Newhall, *From Adams to Stieglitz*, 107–8. Adams imagined the first portfolio he produced as *his* Equivalents and dedicated it to Stieglitz. Ansel Adams's photographs of the wilderness West, with their stately composition and their savoring of transitional states like clouds and waterfalls, achieved, via Stieglitz, the combination of meticulous rendering and aura of sublimity that Ruskin had wanted art to achieve.

6. Quoted by Agee, "Arthur Dove," 434.

7. "The Metropolitan Milieu," in Frank et al., *America and Alfred Stieglitz*, 50–51. In 1934 Mumford was well into his career as a respected writer on urban life, technology, and civilization. His early books, *The Golden Day* and *Melville*, helped establish an American literary tradition including Melville and stemming from Emerson, Thoreau, and Hawthorne. Mumford believed that practically all urban construction was a theft of space and of natural beauty belonging to the people. "The sterile dream of imperialist conquest externalized itself in that last gesture of the impotent: Rockefeller Center."

8. Greenough, *Key Set*, 1:xlvii, quoting "Stieglitz, at 70, Facing Loss of His Art Gallery," *New York Herald*, April 29, 1932, 50.

9. See Bonnie Yochelson, *Alfred Stieglitz: New York* (New York: Skira Rizzoli and Seaport Museum, 2010).

10. Naef, *In Focus*, 135.

11. Ibid. Sarah Greenough, who knows Stieglitz's work more intimately than anyone, found these "some of the most brilliant and sad photographs that I have ever seen. I think of Stieglitz sitting there at An American Place or at the Shelton Hotel, and he's so removed from it all." John Szarkowski agreed with her in conversation. "Absolutely, looking down from the top of the cliff into this crazy city that he doesn't understand anymore, that he's lost contact with." Even such knowledgeable viewers can't resist amp-

ing up the emotional power of these photographs by invoking the circumstances of Stieglitz's life, his age and isolation, assuming that old age is essentially a sad state to be in.

12. Rosenwald was one of the most conspicuously civic-minded and imaginative of American philanthropists, whose friendship with Booker T. Washington shaped his belief that work on behalf of African Americans, specifically in the areas of housing and education, was the most important philanthropic work to be done. See Hasia R. Diner, *Julius Rosenwald: Repairing the World* (New Haven: Yale University Press, 2017).

13. Dorothy Norman, *Encounters: A Memoir* (San Diego: HBJ, 1987), 73.

14. See Whelan, *Alfred Stieglitz*, 500–502, and her own account of her life in "The Dorothy Norman Papers," *Yale University Library Gazette* 42, no. 3 (January 1968): 131–39. Norman did an extensive interview with William McNaught, May–June 1979, for the Archives of American Art. Audio and transcript are available online at https://www.aaa.si.edu/collections/interviews/oral-history-interview-dorothy-norman-13154.

15. Norman, *Alfred Stieglitz*, 202.

16. Norman, *Encounters*, 60.

17. Paul Rosenfeld, *Port of New York: Essays on Fourteen American Moderns* (New York: Harcourt, Brace, 1924), v–vi.

18. Ibid., 210.

19. Susan Sontag, *On Photography* (New York: Farrar, Straus and Giroux, 1977), 118. Sontag cannot let pass the idea that "reality" is only fitfully available and waiting to be captured by the photographer or the contradiction between this idea and the notion that the photographer expresses emotion through photographs. Stieglitz's presentation of the Equivalents as statements of inner feeling she sees as another instance of photographers' efforts to "feature the benevolent character of picture-taking and discount its predatory implications" (123). For Sontag there is an aggressive act of appropriation at the heart of photography that photographers are always trying to hide.

20. Rosenfeld, *Port of New York*, 237.

21. John Gould Fletcher, "The Stieglitz Spoof," *American Review*, March 1935, 589. In 1920, writing to a friend about Picabia and the magazine *291*, Fletcher identified Stieglitz as "an eccentric Jewish photographer." See Fletcher to Frank Stewart Flint, November 23, 1920, in *Selected Letters of John Gould Fletcher*, ed. Leighton Rudolph, Lucas Carpenter, and Ethel C. Simpson (Fayetteville: University of Arkansas Press, 1996).

22. Waldo Frank, "Why Should Jews Survive?" *New Republic*, December 13, 1933. See also Helge Normann Nilsen, "Waldo Frank and the Idea of America," *American Studies International* 17, no. 3 (1979): 27–36. Frank's *Our America* had been published in 1919. The idea of the United States as a country of immigrants was just taking shape at this time, replacing theories that foregrounded the country's British connections or frontier experience. See David Hackett Fischer, *Albion's Seed: Four British Folkways in America* (New York: Oxford University Press, 1989), 5, for a discussion of the replacement of the "germ theory" of American identity by the Turner theory and then the immigration theory.

23. See Joshua Bloch, "Nazi Germany and the Jews: An Annotated Bibliography," *American Jewish Yearbook* 38 (1936–37): 135–74, a huge list detailing Jewish persecution by 1934.

24. Roxana Robinson, *Georgia O'Keeffe: A Life* (New York: Harper and Row, 1989), 424.

25. Quoted by Norman, *Encounters*, 99.

26. Robinson, *Georgia O'Keeffe*, 378–85.

27. Quoted in ibid., 401.

28. Alfred Stieglitz to Georgia O'Keeffe, June 25, 1929, in Greenough, *My Faraway One*, 444.

29. Newhall, *From Adams to Stieglitz*, 155.

30. Ibid., 129.

31. Ibid., 113.

32. Georgia O'Keeffe, "Stieglitz: His Pictures Collected Him," *New York Times*, December 11, 1949, 24.

33. O'Keeffe and Bry rematted many of the works before sending them off to museums. They noted some deterioration—excessive yellowing—in the palladium prints and asked Steichen

to deal with it. What he did to repair and arrest the deterioration is thought by some to have further damaged the prints—probably a kind of bleaching. The best account of O'Keeffe's handling of the estate and her agonizing about some of the decisions she had to make—especially how to deal with the negatives—is Therese Mulligan, ed., *The Photography of Alfred Stieglitz: Georgia O'Keeffe's Enduring Legacy* (Rochester, NY: George Eastman House, 2000). The work includes essays by Eugenia Parry, Laura Downey, and Therese Mulligan.

34. O'Keeffe, "Stieglitz: His Pictures Collected Him,"30.

35. Quoted in Dorothy Seiberling, "A Flowering in the Stieglitz Years," *Life*, March 1, 1968.

36. An imaginative book on Stieglitz and O'Keeffe pairs a work of his with a work of hers to suggest, rather than to analyze, the affinities. See Alexandra Arrowsmith and Thomas West, eds., *Two Lives: Georgia O'Keeffe and Alfred Stieglitz; A Conversation in Paintings and Photographs* (New York: Callaway, and Washington, DC: Phillips Collection, 1992). The work includes essays by Belinda Rathbone, Roger Shattuck, and Elizabeth Hutton Turner.

Afterword

1. Lewis Mumford, review of Stieglitz 1934 show, *New Yorker*, December 22, 1934, reprinted in *My Words and Days* (New York: Harcourt, Brace, Jovanovich, 1979), 219.

2. The art critic Jed Perl recently suggested that photography may now be even more prestigious than painting. "Peter and His Kind," review of *Peter Hujar: Speed of Life* at the Morgan Library and Museum, New York City, January 26–May 20, 2018, *New York Review of Books*, April 5, 2018, 67.

ACKNOWLEDGMENTS

DAVID SCHORR, professor of art at Wesleyan University, print-maker, painter, graphic designer, typographer, calligrapher, and all around master of the arts of life, tutored me in art, design, photography, Photoshop, printing, opera, musical comedy, clothes, food, travel, and just about everything else throughout my adult life. He encouraged me to write this book and discussed much of it with me. It will be the first book I have published on whose cover he did not put in his two cents. I will always see him as embodying the life-enhancing spirit of art.

Mary Ryan of the Ryan Lee Gallery and the Mary Ryan Gallery has shown me all the good that an art dealer can do, representing both David Schorr and my husband, Laurent de Brunhoff. She and her partner, Jeffrey Lee, along with Derek Piech and all the other people at the gallery, work in the finest spirit of enthusiasm for art and artists.

To say that Laurie Platt Winfrey of Carousel Research (New York) handled the photographic permissions is to give no sense of

the size of the job she took on or the meticulous care and generous devotion with which she executed it. She has been a real friend on this project.

Several people helped me enormously by checking my descriptions of print and photographic processes. They included David Schorr, Carol Munder, Curt Richter, and Jean-Yves Noblet. Any mistakes show my limits as a student, not theirs as teachers.

I thank Ileene Smith and Heather Gold of Yale University Press for their commitment and help in the editorial process. Ileene deserves special thanks for suggesting this project and arranging for me to do it. She is a great text editor, too. I cannot thank warmly enough the people who read and critiqued an earlier version of the manuscript, Rachel Cohen of the University of Chicago and Andrew Szegedy-Maszak of Wesleyan University.

Thanks to Jin Auh of the Andrew Wylie Agency, my stalwart and wonderful agent.

Thanks to Laurent and Nucky, who make me happy to get up in the morning, and to Ted Rose, Mari Brown, Eli Rose, and Beckett Rose, who make me look forward to the future.

A while ago, I siphoned off several years from writing for the sake of photography. I took some excellent classes at the International Center for Photography in New York from David Turner, Janusz Kawa, Ken Shung, Lou Benjamin, and Jean Miele. Miele's course, Black and White in Photoshop, was especially useful. As a photographer, I was far from adept technically, but Stieglitz would have been floored by the Epson color printers I could have in my own home.

INDEX

Page numbers in *italics* refer to illustrations.

JEWISH LIVES is a prizewinning series of interpretative biography designed to explore the many facets of Jewish identity. Individual volumes illuminate the imprint of Jewish figures upon literature, religion, philosophy, politics, cultural and economic life, and the arts and sciences. Subjects are paired with authors to elicit lively, deeply informed books that explore the range and depth of the Jewish experience from antiquity to the present.

Jewish Lives is a partnership of Yale University Press and the Leon D. Black Foundation. Ileene Smith is editorial director. Anita Shapira and Steven J. Zipperstein are series editors.